AMY GOLDIN
ART IN A HAIRSHIRT

Art Criticism 1964–1978
Edited by Robert Kushner

Hard Press Editions
Stockbridge, Massachusetts

in Association with
Hudson Hills Press
Manchester and New York

Front Cover: George Sugarman, *Two in One,* 1966, polychromed wood installation of nineteen
elements, 247.6 x 726.4 x 340.4 cm. (97 1/2 x 286 x 134 inches) (2003.154.1/19-19/19)
Blanton Museum of Art, The University of Texas at Austin, Gift of the George Sugarman Foundation, Inc., 2003. Photo by Rick Hall.

A hairshirt is a coarse garment, worn next to the skin, which keeps the wearer in a state of discomfort and constant awareness of the shirt's presence. Such garments were traditionally worn by some religious orders. The use of hairshirts is limited in the modern era, but the term is often used metaphorically, which is why someone might refer to wearing a hairshirt when they perform an act of self-imposed penitence.

Art is society's hairshirt—a reflection of all of our doings, right or wrong. Goldin's writing reminds us that meaningful art, particularly new art forms, should ask relevant questions, especially if they provoke the viewer to discomfort, like a nicely scratchy hairshirt. You may not like the way it feels at first, but you must try it on, and even leave it for a while to determine its broadest relevance.

Amy Goldin; Art in a Hairshirt, Art Criticism 1964–1978
Edited by Robert Kushner

Copyright © 2011 Hard Press Editions, complete.

Published by Hard Press Editions
Stockbridge, Massachusetts.

Managing Editor: Anne Bei
Designed by Michelle Quigley
Founding Publisher: Jon Gams

Published in association with Hudson Hills Press LLC
3556 Main Street, Manchester, Vermont 05254.

Publisher and Executive Director: Leslie Pell van Breen
Founding Publisher: Paul Anbinder

Distributed in the United States, its territories and possessions, and Canada
by National Book Network, Inc.
Distributed outside North America by Antique Collectors' Club, Ltd.

Printed and bound in China by Regent Publishing Services Ltd.

ISBN-13: 978-1-55595-342-3
ISBN: 155595-342-3

Library of Congress Cataloging-in-Publication Data

Goldin, Amy (Amy Genevieve Mendelson), 1926-1978.
 Amy Goldin and the art of art criticism : art in a hairshirt, 1964-1978 /
edited by Robert Kushner. -- 1st ed.
 p. cm.
 Includes bibliographical references.
 ISBN 978-1-55595-342-3
 1. Art. I. Kushner, Robert, 1949- II. Title. III. Title: Art in a hairshirt, 1964-1978.
 N7445.2.G55 2011
 700--dc23
 2011024030

Contents

In many ways I am the first victim of my critical nature. I don't think that critical equals 'hostile' but it does transform enthusiasm into something else, the intellectual complement of irony, saying yes and no simultaneously.... The nasty part of criticism is the smugness of that part of oneself that is gratified by having such high standards that you don't simply yield to love, all swoons. But only the more passionate states are really energizing and help you do things. There are times when any criticism is useful and times when it isn't: One should know for oneself when the times are—I count on that in others. But for myself, I feel helpless, being unable to turn it off.

— Amy Goldin
(Undated letter to George Woodman)

Amy Goldin: A Retrospective

By Elizabeth C. Baker

Active as an artist for a number of years, Amy Goldin was nearly 40 when she began to publish art criticism. She made a splash in 1965 with an ambitious reassessment of Dada written in the context of newly urgent attention to a movement that had become a source and reference point for so much of the advanced art of the '60s.[i] Her voice is confident, assertive and challenging, the prose witty and stylish, the art-historical grasp firm. In this longish essay, she confronts some big questions: "the relationship between history, novelty, creativity"; the way the Dadaists "changed the kind of experience that art can provide"; their "passionate muddling of artistic and moral values"; their "violent jumble of affirmation and negation"; and finally, in addition to scrutiny of such specifics as surface, space, illusion and typography in Dada works, she gives us Beauty, God and Death.

Only two months later, she takes on Harold Rosenberg. At the time largely at odds with new developments of the '60s, he was no longer the horizon-filling presence he had once been, but still, as the art critic of the *New Yorker*, a formidable authority figure. She gives her piece a title that drips with skepticism, "Harold Rosenberg's Magic Circle," and despite some elegantly couched faint praise and a good-natured tone, it is an out-and-out attack. The following spring, Greenberg and Fried get the brush-off in "A Note on Opticality," her consideration of space and surface in Op Art and Color Field painting. In the same issue of *Arts*—May 1966—she ventures into broader cultural territory in "McLuhan's Message: Participate, Enjoy!" *Understanding Media* had come out in 1964. Focusing on this influential analysis of the impact of electronic communication (primarily TV) on print technology, she finds McLuhan's theories to be based in part on a misunderstanding of avant-garde esthetics. Often very funny, much of what she has to say about this popular guru is perceptive, and very little of it is friendly.

As these articles indicate, she's often quite tough on writers, especially those with capacious theoretical programs. Artists tend to get more respect in the form of scrupulous accountings, frequently on their own terms. A good example is her extended consideration of the sculpture of George Sugarman.[ii] On the other hand, she takes an oppositional stance on Morris Louis,[iii] comparing his paintings, then widely acclaimed as the intellectually inevitable successors to Abstract Expressionism, to "birdsong," the implication of mindlessness being far from accidental.

Faced with the range of subject, rhetorical finesse, intellectual energy and bristling contrarian tone of these early essays, not to mention the rapidity with which they appeared, one is impelled to ask, how did this come about? In what circumstances did this sophisticated critical personality materialize, seemingly out of the blue? During her career as an artist, Goldin had painted in an abstract style.[iv] To supplement her income, she had freelanced from time to time as a ghostwriter, both on academic theses and—more surprisingly—sermons. How suggestive, how tantalizing! One longs to know the details. But both lines of work could well have fed her own developing critical skills—perhaps providing access to specialized academic knowledge beyond her own training in philosophy at the University of Chicago (doubtless the firm ground from which her skillfully constructed argumentation sprang), and perhaps contributing to the assurance with which she could deploy resonant Biblical allusions—a rarity, for a youngish critic, in those years when religion seldom raised its head in avant garde circles. When she started to write criticism, she pursued it with gusto. As she was bringing out these early, ambitious, rangy essays for several publications that are collected here, she was warming up with a torrent of short exhibition reviews for *Arts*. Not just two or three, or five or six, or even ten would appear in a single issue, but there were often more—at one point 13, then 14, and even 26![v]

I encountered Goldin in person in 1967 when she began writing for *Art News*, where I worked at the time. She published there frequently for several years, also contributing to *Artforum*, *Art in America* and other journals. After I moved to *Art in America* as editor in late 1973, she wrote for us regularly, though not exclusively. Working with her was a very intense process. It often seemed that every essay would trigger a swarm of new ideas and associations she had to pursue—and thus more articles would ensue. Issues of meaning—on many levels—engaged her constantly. She wrote about many established figures and mainstream topics—the Fauves, Fernand Léger, the German Expressionists, Matisse, Abstract Expressionism. But the world of contemporary art in the making—what was going on in the galleries and the studios—was her home territory, and she subjected every

aspect of it to questioning—not only the art, but its institutions, its politics, its critics and theorists, its gender and racial hierarchies. She wrote extended, rather contentious reviews of two major shows of black artists, one of them the Met's controversial "Harlem on my Mind."[vi] She examined the art world as a complex organism. She wrote brilliantly and analytically about New York's museums in an overview partly co-authored with Roberta Smith[vii] and art schools[viii]; the latter, published under the editorship of Brian O'Doherty, generated heated follow-up in the Letters pages over several months. She was interested in the business side of things as well: early on, her "Requiem for a Gallery" had appeared when Dick Bellamy closed his Green Gallery.[ix]

Goldin's ideas and her writing were a frequent catalyst to our editorial process. We built several special issues around pieces she was either working on or that she hastened to undertake when a thematic issue was in formation. Among these were "The Esthetic Ghetto: Some Thoughts About Public Art,"[x] "The Post-Perceptual Portrait,"[xi] and "Matisse and Decoration: The Late Cut-Outs."[xii]

As time passed, she tangled with an ever larger swath of art outside the contemporary framework as it was then identified. Amy needed to grapple with and understand art in its broadest and most diverse manifestations. Some of her most stimulating essays explore folk art and outsider art (then accorded little attention); she later investigated the art of Islamic cultures in considerable depth, taking a course with Oleg Grabar at Harvard, and traveling to Iran for a first-hand look (where she reviewed an exhibition of Qajar painting at the Iranian-American Cultural Center in Teheran).[xiii]

An intellectual powerhouse she undoubtedly was, and omnivorous in her curiosity, as the essays included here amply show. But she also loved being a *working* art critic—someone who willingly took on whatever came her way. Throughout her career, she never stopped writing exhibition reviews and book reviews. She enjoyed the review format and handled it inventively. She also did a couple of surveys of regional art scenes—a demanding amalgam of criticism and reporting on unfamiliar turf. In 1977, preparing for a Montreal/Toronto overview we had assigned her, she appeared in our office wearing a T-shirt emblazoned "Critic of the Year." She had recently received the College Art Association's Mather Award for criticism, and a friend had, in a teasing spirit, given her the shirt. Her assiduously maintained outsider stance did not prevent her from being pleased at this recognition by the art historians' professional organization.

Earlier in the '70s, a changing art world was soon reflected in her writing. In spring 1970 she co-authored "Conceptual Art as Opera," with Robert Kushner. Signaling yet another new interest is a short, probing essay (not

published at the time) confronting that perennial problem known as "the decorative"; the piece is a study of the use of patterning in kilim rugs (1972) and is included in this volume. The term "decorative" having long served critics as a multipurpose insult to convey superficiality or lack of seriousness, the broader concept of decoration was ripe for reassessment. An extended exhibition review[xiv] of work by the Paris-based American painter Zuka explicitly articulates Goldin's new interest. (The '70s was also the decade of feminist art; it's curious that, with the exception of Diane Arbus,[xv] Zuka is the only woman artist Goldin treats individually at substantial length.)

Pursuing a historical and theoretical framework for the burgeoning Pattern and Decoration movement, with which she was deeply involved, Goldin's explorations of the roots of the decorative ranged from Islamic art to Matisse to the American Prendergast brothers. Her articles on decoration, both historical and contemporary, were original, powerfully argumentative and controversial (one of her most provocative points was her elaborately reasoned insistence that decoration is essentially devoid of meaning), and these are the writings for which she is best known.

Goldin's collection ends with a lengthy essay on the art of Manny Farber, an influential film critic based in Southern California and a staunchly independent painter whose career strategy, not unlike Goldin's, was to energetically spurn prevailing expectations. Her article is filled with the kind of detail about procedure and its meaning that a (once) practicing artist could so well articulate. By this time she was already seriously ill, but she finished the piece with her usual meticulous attention and panache. She died in April 1978. The article was published in *Art in America* a month later.

The pieces in this collection provide a revealing and long-needed overview of her critical writing. The *Art Index* lists dozens more, but even that is not a complete tally of her articles. In addition there were some exhibition catalogues, and a comical cookbook called *The Wunnerful World of Food*, written with Robert Kushner. It was a short career—all this happened in less than 15 years—and an astonishingly productive run. Three decades after her death the essays come across with great acuity and freshness.

i *Arts,* September '65.
ii *Arts,* June '66.
iii *Art News,* April '68.
iv A review of one of her exhibitions appeared in *Arts* in May '65.
v *Arts,* September '65.
vi *Art News,* May '70.
vii *Art in America,* Sept./Oct. '77.
viii *College Art Journal,* Winter '72; Art in America, May/June '73.
ix *Arts,* Jan. '66.
x *Art in America,* May/June '74.
xi Jan./Feb. '75.
xii *Art in America,* July/August '75.
xiii *Art in America,* Sept./Oct. '74.
xiv *Art in America,* Jan./Feb. '74.
xv *Art in America,* March/April '73.

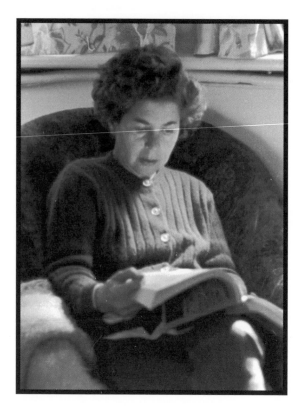

Amy Goldin, 1971, Neuilly-sur-Seine, France.
Photo courtesy of Naomi Schiff

Amy Goldin 1926–1978

By Robert Kushner

Amy Genevieve Mendelson was born in Detroit on February 20, 1926. Her parents, Harry and Jeanette Mendelson, were recent Russian Jewish immigrants. Her father, a contractor, established a comfortable life for Amy and her younger sister Ruth. Both sisters were well educated and passionate about art, literature, politics and cultural trends.[i] Amy's interest in art started early with children's classes at the Detroit Institute of Art.

After attending Central High School in Detroit, Amy enrolled in Wayne State University, Detroit, from 1943 to 1945 where she pursued a varied course of study. She transferred to the University of Chicago from 1945 to 1947 where she exclusively pursued philosophy. She took a heady mix of courses: the history of ideas, aesthetics, ethics, symbolic logic, philosophical of social science. Although she had studied art history at Wayne State, she did not register for any studio or art history courses at Chicago. In 1947 she took her exam for the Masters Degree in Philosophy but received a C. She withdrew before graduation.[ii] She often credited her philosophy training at Chicago as the basis for her intellectual tenacity and rigor. Amy always gravitated toward writers who encompassed a broad swath of the world for their intellectual pursuits. She returned repeatedly to the Austrian/English philosopher Ludwig Wittgenstein (1889–1951) with a singular passion for Philosophical Investigations. Wittgenstein's insistence on the complexity and uncertainty of our cognitive processes, and the open-ended nature of his questioning profoundly affected her approach to criticism. She was also interested in the sociologist Erving Goffman (1922–1982) whose theories of symbolic communication placed all exchanges of information (particularly visual art for Amy) firmly within an interactive social context.

Leaving Chicago and academia, Amy moved to New York in 1948, where she rented a top floor, cold water, painting studio on East 56th Street.[iii] She took classes at the Art Students' League in 1948–49, then a popular gather-

ing place for younger artists. Many of the Abstract Expressionists had studied there early in their careers before moving on. Amy moved on as well. In 1950 she enrolled in one of the most innovative summer art programs Black Mountain College. That summer, Theodoros Stamos taught life drawing and Clement Greenberg led a seminar in art criticism. She shared a large attic dormitory with two other women students. Jacqueline Hermann Gourevitch remembers heated discussions between Greenberg and Mendelson. She admired Amy's "aggressive confident way of showing what she was [intellectually] capable of" and found her to be "physically strong, articulate and smart, but not easy to get to know."[iv]

She next studied with Hans Hofmann (1950–52) whom she admired. Hofmann's composition principles and color theory were a strong influence on her paintings, even though expressionist rhetoric soon became an anathema for her. In 1955, Amy returned to Chicago to marry Morton (Moe) Goldin, a prominent, high society jeweler with a store on Michigan Avenue. She remained with Moe for two years. During this time there were frequent art viewing trips to New York art museums and galleries. Amy assessed the art at MoMA openings while Moe admired the good taste and suitability of the jewels worn by the society women.[v] According to Amy, Moe offered her a mink or a full edition of the Oxford English Dictionary as a wedding gift. She accepted the latter, which she revered the rest of her life.

The marriage did not last more than two years and Amy returned to New York City where she began exhibiting her work as Amy Mendelson. She rarely signed or dated her paintings, making it difficult to construct a definitive chronology. Most of her early paintings were executed in a fast, brushy-gutsy mode, often employing high key, Hofmannesque, color. Her loose brush work was vigorous and nervous, often creating the sense of a lively vortex broken by local incident. She worked on large sheets of paper, board or masonite with casein, tempera, charcoal, ink and oil. She kept many notebooks with ink and pencil drawings of both abstract and representational images: interiors, landscapes, and often her beloved cats. One of the few dated examples of her work was a 1960 series of drawings for *Trobar,* an independent poetry journal. Each black and white composition exhibits a flurry of marks with attention to density, attack, and composition. Although energetic and authoritative, the images remain somewhat generic. Given her future success as a writer, her artist's statement reveals a nascent attitude in formation: "The claim that nonobjective art objectifies the spiritual struggle of the artist is only one more attempt to justify the fiction that abstract art requires subject matter, one more instance of nostalgia for tales of action and romance. There are no stories left. Today, painting is

sensation and a tenuous conviction of meaning, Braille for the sighted. Upward and downward with the arts!"[vi]

Although an artist's statement is different from criticism, by 1960 Amy already demonstrated a well-tuned ear. Her close friendships and intellectual jousting with the Deep Image group of poets, particularly Robert Kelly, Jerome Rothenberg, David Antin and George Economou, provided a sophisticated playing field and a ready audience for her rapidly forming persona as an art writer.[vii]

In the early 1960s Amy's paintings underwent a transition from expressionism to a more considered hard edge abstraction with clear colors and geometric forms that reflected the changing dialog in the New York painting scene. She valued a book of Matisse's late collages and frequently referenced Matisse during this time. She worked on modestly sized, multiple panel paintings on masonite, in which implied movement and repetition of form was intended to bridge the gaps between the separate boards. She created a pair of sliding doors for her apartment in blue, black and white, strongly inspired by Matisse's designs for the windows of his Chapel in Vence. A selection of Amy's paintings were shown posthumously at AIR Gallery in Soho in July 1978 and was reviewed by Peter Frank in the *Village Voice*: "Goldin's spunky little Hard Edge works are her most original, but she was a skilled and—not surprisingly—highly intelligent painter before that. If her Abstract Expressionist works resemble de Kooning or Kline, they resemble *good* de Kooning or Kline, exemplary in their understanding of Action painting in the later '50s."[viii]

1965 was a year of significant change for Amy's public persona. Amy Mendelson, painter, became Amy Goldin, critic. That year, Amy Mendelson mounted an exhibition of her hard edge paintings at Brata Gallery, a well respected artists' cooperative gallery.[ix] This exhibition received a cursory review in *Arts Magazine.* "Amy Mendelson: A bouncy, often humorous show of brightly colored, near geometric paintings. Most interesting, if uneven in execution, is Miss Mendelson's idea of the multiple picture."[x] The perfunctory tone of this conspicuously brief review had to have been discouraging. Ironically, in this same issue of *Arts,* several reviews appeared by Amy Goldin. (She published under Goldin so that there would be no confusion or overlap with her other identity as a serious painter.) But once she started writing, the satisfaction and response was such that she never really returned to painting full time.

Even though she continued to create art objects sporadically, her life in the studio was always extremely fraught. She never seemed fully satisfied with her results and she once told me that she quit painting because it was too painful. "It's because it was so frustrating to find that my painting was

inaudible that I started writing,… I don't want to die without having made any trouble in the world at all. Minimally I want to attack the dopes, the smart, cultured ones. And I don't want merely to be bitchy, either. It's their idea of art I can't stand."[xi] Amy's years of hard work in the studio, offered her a unique degree of sympathy with artists and their individual processes. She had personally experienced how ideas assume physical form—sometimes successfully and sometimes not—and consistently brought this awareness to her writing.

Through criticism, her prodigious intellect took off with a vengeance. In writing, many facets of her existing interests aligned: her absorption with historical and particularly contemporary art, her study of philosophy and sociology, her argumentative nature, her empathy with paint and painters. The reviews were both adulatory and scathing, sometimes both simultaneously. She also began to write longer, thought provoking pieces which became her forte. She loved to chew on an idea, particularly one that had not received much attention, read what others had written, refute their positions, and then assert her own.

In 1972 Goldin received a National Endowment Critic's Grant which allowed her to commute to Harvard to take courses from noted Islamicist, Oleg Grabar. Through the vast diversity of Islamic art, she found a world of information as well as a conceptual foundation for an art form in which the term decoration was not pejorative, but the essential motivating factor. She also found a way out of the statis of the current art dialogue.

In the spring of 1974, I had the good fortune of accompanying Amy on an extensive tour through Turkey, Iran and Afghanistan. Professor Grabar supervised the itinerary and provided a letter of introduction that opened many doors. Pursuing Timur, or Tamerlane (1336–1405), and the Timurid period of art that he inspired was a particular focus of the trip, from looking for Timurid manuscripts in the Topkapi library in Istanbul to visiting remote sites in Iran that had surviving Timurid monuments, ending in Herat, Afghanistan, Timur's winter capital itself. Following this trip, Amy's published and unpublished writing on Islamic Art took on a new perspective and urgency. Given her instinctive attraction to visual complexity tempered by her need to locate clarity, pattern and the decorative presented Goldin a new arena of visual expression to explore.

Shortly thereafter, the College Art Association awarded Goldin the Frank Jewett Mather Award for "Distinction in Art and Architectural Criticism during the Year 1974–1975". The citation letter states: "Amy Goldin is a rare critic who has dared to venture off the all-too-beaten track in current art writing. She has systematically challenged entrenched establishment and orthodox positions of all sorts—aesthetic, ideological, political—in art. She

has examined subjects which other critics have not realized were important.… Ms. Goldin has written on these topics in a broad cultural, historical and social context with sensitivity, lucidity and verve."

Although Amy lived extremely frugally in a fifth floor walk up, by the mid seventies, a modest inheritance had run low. She had taught at University of California, San Diego, Northwestern University in Evanston, Ill., Queens College and Virginia Polytechnic and State University at Blacksburg. She did not really enjoy teaching. "What I can't stand is standing there talking with no response, as if you were addressing a hydra-headed dumb beast. It leaves me obscurely frightened."[xii] Instead of accepting more teaching assignments, she preferred to supplement her scant critic's fees with office typing jobs. As a typist, she could walk out the door at the end of the day keeping her mind free to dwell on her writing. During this time she produced some of her finest essays.

In 1976 she was operated on for a colon tumor. For a while she cut back on smoking, and even used a cigarette holder with a filter. By the winter of 1978, cancer had metastasized and she did not want to undergo aggressive treatment. She was "not going to go through all the hospital stuff again. Or hang around suffering."[xiii] She died as she had lived her life, on her own terms, at home on April 2, 1978. Although writing ostensibly about her friend and colleague Manny Farber in her last completed essay, she seemed to offer a rare introspective assessment of her own professional life. "Most artists, like most people, pursue messier, less coherent courses, with more or less zigzagging about in thought, feeling, behavior and style. Manny Farber's career belongs to that type, though his moves have been neither swift nor erratic. Responsive to the complexities of his own nature and to changes in the artistic currents surrounding him, he sometimes led and sometimes followed those tides. As a painter, he cannot be classified either as an oddball or as the typical representative of a style. This has had a bad effect on his reputation."[xiv] This could be read as a summation of Goldin's intellectual peregrinations, from prodigy to philosophy student to abstract artist to critic.

i Interview with Paul Huston, Queens, New York, April 3, 2009

ii Amy Mendelson transcript, University of Chicago.

iii Interview with Herb Bronstein. New York, August 3, 2008.

iv Interview with Jacqueline Gourevitch, May 28, 2009 and Jacqueline Gourevitch/ Biography/ Black Mountain College Project. bmcproect.org

v Bronstein interview.

vi *Trobar,* A Magazine of the New Poetry, edited by George Economou, Joan Kelly and Robert Kelly, 1960, Orion Press, Brooklyn, New York.

vii Interview with Jerome Rothenberg, May 23, 2007, New York.

viii *Village Voice,* July 31, 1978
ix (http://en.wikipedia.org/wiki/Tenth_Street_galleries)
x Jacqueline Barite, Amy Mendelson, *Arts Magazine,* Sept.-Oct. 1965, p. 76.
xi Letter to George Sugarman, Nov. 28, 1966. (Archives of American Art)
xii Letter to George Sugarman, 1969. (Archives of American Art)
xiii Undated letter to Robert Kushner, January 1978.
xiv Manny Farber: Reforming Formalism, *Art in America,* May/June 1978.

Arts Magazine, September 1965

The Dada Legacy

Are we back where we were a half-century ago?
Does our art belong to Dada?

There has been a good deal of talk lately about the baleful influence of art history on the artist. This was one of the innumerable propositions put forward by the author of *Le Musée Imaginare,* but then, the French are notorious for not knowing which way is up. (When pressed, they point to the top of the page.) More recently, Harold Rosenberg, in *The Anxious Object,* contrasted tradition, "the one-way push of the past," with the anarchic freedom of the art-historical approach. According to this view, the great tradition of Western painting once enforced a logical development of style. Now, whether it was pushed or whether it just fell, that tradition is dead. The history of art can no longer play its guiding role. For the modern artist it has become a rag-bag of tricks to which he can turn when invention fails him. A vivid interest in art history, Mr. Rosenberg says, engages the artist in a dialogue with his ancestors that turns art into a private conversation, and excludes the audience. The topic of this conversation, presumably, is "What's next?" The audience, straining to get into the act, learns to share a preoccupation with "What's new?"

Surely this is a rather bizarre interpretation of artistic engagement. It exaggerates the artist's freedom and suggests an unnecessarily disjunctive relationship between history, novelty and creativity. For an audience that identifies the new with the first creative step in a fresh direction, the consequence is a wildly hysterical notion of artistic development—every day a Bar Mitzvah!

It does not seem reasonable to consider novelty an artistic problem at all: artists are like beachcombers always picking up anything that looks use-

ful to them. The significance of a particular novelty in art is, however, a market problem and critical problem. The plethora of novelties practically requires that some discrimination be made between those that are worthy of financial and intellectual investment and those that are not. In fact, novelties may occur at any point in the sequence of activity that produces art, and their importance is gauged by the extent to which they shift the total artistic situation. The demand for novelty is itself a part of the artistic situation, and one, moreover, that has an unusually well-documented history. Like many other factors in the art world today, it is chiefly derived from Dada. It was Dada that taught us to say, "It's art, but is it new?"

The importance of the Dada movement is now generally conceded, but the way in which it is important is perhaps less well understood. The Dada artists were terribly verbal—the term locates a kind of poetry more clearly than it does a kind of painting—and their contribution to the history of painting is rivaled by their revision of aesthetics—our idea of what art is and should be. The Dadaists, intellectuals, poets and painters, spelled out the failure of "the great tradition" and articulated the conditions that art must meet in order to be modern. The demand for novelty is part of the aesthetic tradition that the Dadaists left us. It had been in force for fifty years, and there is no excuse for the continued critical failure to recognize its existence and to discriminate between contemporary theory, style and fashion. Once the Dadaist accomplishment is understood we may gain a view of the past which does not isolate the present in a limbo of anxiety.

There is no point trying to abstract a Dada style that would account for the very diverse work accomplished by the highly talented people who at one time or another worked under the Dada aegis. The cohesiveness of Dada was never great, and the movement quickly dissolved into groupings of artists with similar aims. From the beginning it was the motivation, explicit in a thousand sources, that provided the basis of Dada: outrage, disgust with the conventional idealism of middle-class culture. It was this common motivation that led the Dadaists to shift the rules of the game—in the mouths of poets and painters, anti-art propaganda must be interpreted as signifying a shift in artistic intentions. The Dadaists set up new formal situations. From a psychological point of view, they changed the kind of experience and meaning that art can provide.

One of the great fertilizing strains in Dada lay in its passionate muddling of artistic and moral values. By the end of the nineteenth century these values had been neatly isolated and distributed. The audience for "high" art knew what the proper aesthetic response should be: a judicious mixture of awe (for art's Truth) and tenderness (for its Beauty). Moral value was provided by the subject, aesthetic value by the form. Of course, this was

essentially the formula that had been worked out by the French Academy by the end of the seventeenth century, and two hundred years had enfeebled it considerably. The romantic notion of genius, however, which could magically "express" boring old truths in a uniquely inspiring way, had served to bolster the elevating aspect of art, which was now located in "content." "Content" had something to do with subject matter, but was not identical with it. The old moralization of subject matter was still vaguely felt to be relevant to artistic value, though, judging from the protests against the Impressionists. They threw the whole official hierarchy overboard and began to dissolve their subjects into something that quite blatantly appeared to be paint!

"Good" art and "good" artists, however, were duly paid the tribute of pious admiration. It was precisely this attitude, with its smugness and its claim to the complicity of the artists, that the Dadaists hated, vilified and renounced. Whatever they produced was designed to obliterate that response, to make it irrelevant and impossible. If art was the touchstone of culture, the flower in the buttonhole of civilization, they wouldn't be artists; they'd rather be idiots. At the same time they affirmed, equally hysterically, that the audience was as idiotic as they, and that real art and real humanity were buried somewhere *within* "idiocy" and that all three remained bound up with each other.

The violent jumble of affirmation and negation elided the distinction between morals and art almost completely. The Dadaists preferred to contrast the false and the real, the hypocritical and sincere–and these are still used as art-critical terms, one of Dada's more useful legacies. Nevertheless, the Dada repudiation of illusion, and its correlate call for art to deal with what is real rather than what is merely conventional and ideal, can be unraveled to reveal the creation of some of the central conditions of twentieth-century art.

Dada anti-illusionism meant a refusal to deal with the traditional Western artistic problem of representing three dimensions in two, and Dada repudiated Cézanne and the Cubists along with the Renaissance. What the Dada painters "discovered" was that the area of the painting doesn't have to be considered a space: the picture plane is a coded surface, and the "message" doesn't have to have a spatial reference. This picture is not required to be a coherent vision, complete with its own space, but can be interesting just as another surface in a world of surfaces. The surface that has to be made interesting is our aesthetic today: the picture as a window on an illusionary world, complete with painted atmosphere and painted things, is an irrevocably old-fashioned idea.

23

The de-spatialized surface permitted the inclusion in the picture of materials and subject matter that had previously been alien to it. Typography and mass-produced articles, either as constructive fragments or as themes, were incorporated into art by Dada. Duchamp's ready-mades took the final step, radically reorienting the definition of a work of art. Anything, regardless of the intentions of its maker, could become a work of art if isolated and presented in the institutional context of art. What were the consequences? Beauty, formerly a certificate awarded to the highest works of man and God, suddenly went berserk and recognized no class distinctions at all. If anything can be beautiful (and the Dadaists did, in fact, produce a lot of lovely work), beauty is trivial. The Dadaists didn't mind being trivial, but they were deeply unwilling to be ineffectual. They wanted at least to protest, "to make literature with a gun in one's hand." Their assumption of the revolutionary role led them to an enthusiasm for anything that could incorporate energy—noise, the subways, irrationality. Practically speaking, they took the position that art can afford to be ugly but not inconspicuous or decorous.

Again, that is where we are now. To say that a work is powerful is much higher praise than to say it is beautiful. The horrible, the tragic and the commonplace are again as artistically acceptable as they were when Christ sanctified all. The enormous reaffirmation of the rights of art, releasing it from the obligation to charm, flatter or seduce, is admittedly a primary theoretical gain—which is not to say that the gain is unreal or trivial, but merely to admit that the practical consequences are problematic. As long as the chief obligation laid on art is beauty, the artist is absolutely required to be charming. Isn't the commercial artist identical with the folk artist, making crowns and wreaths to decorate the local god and to celebrate the local institutions? Artists had repudiated the claims of their patrons before, but they did so in the name of God or nature; the Dadaists, repudiating everything quite indiscriminately, clung only to the practice of art (some of them) and the artistic relevance of power—that is, the idea that art that doesn't *do* something to its audience is a failure. This very up-to-date, extreme and unreasonable demand on art was first articulated by the Dadaists.

Today the artist is relentlessly challenged to produce something immediately interesting, to involve an audience that has (and this is a healthy, if unaristocratic situation) no vested interest in art. The Dadaists, confusing art with war, attacked the audience with an arsenal of humor, mechanism and austerity. And the audience has not sued for peace, but begs for more. Far from defending the tradition of a measured aesthetic distance, they look to art for almost everything: for amusement, for ideas, for a revelation of

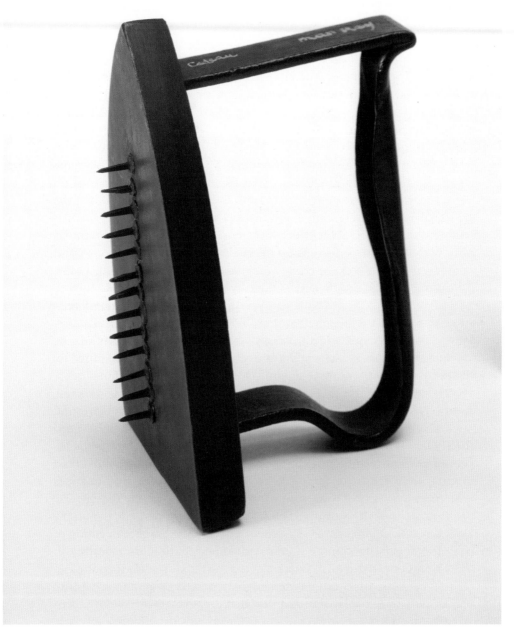

Man Ray (1890–1976) © ARS, NY. *Gift,* c.1958 (replica of 1921 original).
Painted flatiron and tacks, 6 1/8 x 3 5/8 x 4 1/2" (15.3 x 9 x 11.4 cm).

who they are and what they should do—and are bitterly disappointed to get only painting, sculpture and literature.

For artists who feel their production must be conditioned by art more than by the market, artistic problems today are much as the Dadaists left them. The mood, however, is quite different. Moral indignation seems to have been bleached out by two wars and prosperity. Artists today make no claim on the audience, but tend to withdraw into expressions of irony or radical innocence. In place of moral earnestness we have play and problem-solving as artistic motives. And an increasing number of artists are willing to assume the role of artisan if it is offered on reasonable terms.

Our society, on the other hand, seems to have become increasingly aesthetic and sometimes even Dada in tone. In 1918, Tristan Tzara's Dada Manifesto ended with a poem consisting of 147 roars and these words: "… who still considers himself very charming.… Supplement: How I became charming, delightful and delicious.… I consider myself very charming." In 1965, the world's heavyweight champion is equally charming; "I am the greatest, I am the fastest, I am the youngest, I am the prettiest." The plan to blow up the Statue of Liberty was a thoroughly Dada idea. When it becomes obvious that acts are performed for the sake of a broad general effect as well as for their specific consequences, aesthetic considerations become politically and socially important. Officially and unofficially, Kennedy's assassination was reported with a heavy emphasis on pathos that undoubtedly helped suppress factional disputes. Television has turned the citizenry into an audience more than any strictly verbal medium could hold, and the whole sequence of events from the assassination through Oswald's murder reached us as a happening, eerily projected through a variety of media.

This state of affairs is very far indeed from the Dada ideal of a society revolutionized by art. Our society seems more vulnerable than theirs and our artists are much less arrogant. They have not, however, radically restated the Dadaists' position. The problem of engaging the spectator remains paramount, and traditional expedients—visions of loveliness—still do not interest our artists. Impact is still considered not expendable, but it is achieved in a variety of ways, some of them very low-pressure indeed. Size and formal simplicity are important means. Emotional participation in the work is not based on the transcendence of uncertainty, or the resolution of complex formal situations, but on a wide range of stimulus or reference.

The American three-ring circus, in contrast to the single ring of older circuses or European circuses today, might be taken as a paradigm. Instead of formal mastery displayed in a context that supports and expands the central performance, we seem to have a taste for a multi-focus, mobile spectacle that underlies a sense of activity. If one grants the dethronement of figura-

tive painting in the sense of matter dominant over space or of figure dominant over ground, the development of highly unstable configurations becomes clearly possible. Images that require the spectator to shift his focus in order to grasp the totality are encouraged. The same dispersion of the audience's attention can be achieved in other ways. Op alternates the roles of figure and ground, Pop deals with multiple reference—the "subject" is both the public image (already a conceptualized theme) and the media that support it.

The artistic problems implicit in this fragmentation of focus are very great, possibly even insoluble. Perhaps the Dada equation of involvement with impact will have to be discarded. In that case, impact will no longer measure the force of artistic achievement—or artistic achievement will no longer be interpreted in such military terms. At the moment, however, the recent history of art suggests a new view of tradition: art as insidious war.

Amy Goldin: Pleasure's Muse

By Irving Sandler
—*In memory of George Sugarman*

I met Amy Goldin in the late 1960s in the company of George Sugarman, a close friend of hers and mine. I'm not sure that she and I perceived his sculpture in quite the same way. We both responded to its inventiveness, but Amy noted a decorative aspect, about which George himself was ambivalent. Amy and George were often at loggerheads and relished their verbal bouts. I sided with George. Amy would go on to become the art critical champion of Pattern and Decoration painting, publishing a series of articles on the tendency from 1975 to 1978.

Amy formulated a persuasive rationale for the new decorative art. She pointed out that in their search for new forms and content, a significant number of contemporary artists had turned for inspiration to the crafts and decoration, which in themselves she considered high art. She then provided their histories, from tribal design to Matisse's paintings. At the same time, Amy called into question aesthetic rhetoric that denied the validity of decoration as art, criticizing art history as it was taught in our colleges and universities. She put down art-historical surveys that purported to be general and inclusive, claiming that in actuality they were "histories of Western European art ... specialized and parochial, devoting little or no space to Islamic, African or pre-Columbian art," and other cultures, much of whose art was decorative. Amy also disapproved of Harold Rosenberg's angst-obsessed existentialist art writing and Expressionism's overwrought denial of pleasure as a legitimate end in art. She wrote:

As far as I'm concerned, Expressionist esthetics ... are pure Holly-wood, the stuff of which coffee-table books are made. The painter as yoyo artist, sending SELF our to the end of the line and then retrieving it, miraculously, loaded with transcendence, by a tricky flick of the wrist. The audience, sullen, yearning: "Sock it to me."

The artist, eyes glazed with looking into the void, leaps, flinging his all—*will he make it?* If *he* makes it, we've made it. Orgasms all around. Happy, happy.

Note the italicized *he*. Amy was a staunch advocate of the feminist conception of handicrafted decoration as the historic art of women, which, as Miriam Schapiro remarked, "speak[s] as a woman speaks."

The demand that art be anxious and tragic had gone out of fashion more than a decade before Amy's critique, but what made her interpretation different, indeed unconventional, was her bold denial that art had to have any "meaning" whatsoever. As she said, "decoration is typically … contentless." It only needed to please the eye. She even went further, chiding art critics for inventing inflated justifications for paintings that are primarily "for making you happy. [With regard to them] talk is irrelevant." Amy became a friend of the artists she championed, among them Robert Kushner and Kim MacConnel, who had been her students. Pattern and Decoration artists met frequently in the middle and late 1970s. The polemics were lively. I recall discussions on why their art was significant, on breaking down barriers between "high" and "elitist" art and "popular" and "folk" art, on the need for a "populist" art that would "communicate" to the general public, on the universality of decoration throughout history, and on how contemporary Western artists should relate to the decorative art of the past and of the third world.

Some art critics believe that contact with artists compromises their criticism. But I have found such critics particularly uninformative about the art they write about. So did Amy. She understood that to fully grasp art that is new it is necessary to frequent the studios where it is being made. She went further and became a kind of impresario of decorative painting, for example, organizing *Pattern and Decoration* at the American Foundation for the Arts in Miami. To broaden the range of the art in the show, she included works by Sugarman and Frank Stella.

Amy did not limit her criticism to Pattern and Decoration painting. She ranged widely in her writing about art. I recall puzzling over the question of quality in conceptual art and found the answer in an article she wrote with Robert Kushner. The advocates of conceptual art had proclaimed that "brush wielders were … afflicted by creative halitosis," as Max Kozloff observed. But that did not stop Amy and Robert from writing fairly and perceptively about it. They commented that conceptual art was "a matter of finding that idea butted up against this visual situation." A balance had to be struck between the idea and the object it yielded, "If the visual material is too complex or subtle, the message will not get across," and vice versa.

Finally, I recall with pleasure the elegance and clarity of Amy's prose. At a time when too much art writing is academic art theoryeze, this collection of her essays might prove to be a model for new critics.

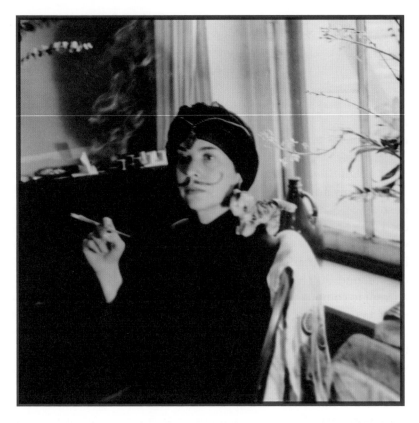

Amy Goldin, photo by Ruth Huston, courtesy of Paul Huston.

Arts Magazine, November 1965

Harold Rosenberg's Magic Circle

A younger critic finds in the methods of a senior colleague an abdication of critical responsibility.

Not many art critics have a world of their own. A modest observation post by the side of the road is the more usual thing, and some critics don't even have that. Harold Rosenberg, however, has a whole cosmos, complete with indigenous forces, presences, alternatives and pitfalls. It is a world that has been justly admired for its richness and brilliance. Dazzled, critics have often found difficulty in making out its structure. What follows is an attempt to compile a map of Rosenberg's world. For while it may be broadening to travel, it is also good to know where we are.

A map? No, it's not really quite so simple. A chemical flow chart would be more like it, or a diagram explaining the life cycle of an insect, one that successively appears as a worm, as a parasite in the bloodstream, as a moth. For art is not always the same. It appears in different forms at different times, and what interests Rosenberg is the life history of artistic creation. The empty chrysalis he leaves to the art historians and the pedants; his is a world of dynamic process. He presents it to us dynamically, in flashes of insight that continually seek to merge into a vision. The vision is that of art itself, arising from the general human condition as a crystallization of that condition, and then falling back into history. Six key terms define the magic circle of Rosenberg's art process: HISTORY, REVOLUTION, ACTION, THE NEW, THE ARTIST, and IDENTITY. Each of these has a way of being transformed into the next one in the series. HISTORY is a record of the forms of social and cultural existence. The most radical historical event is REVOLUTION, which annihilates or recreates institutions and values. Revolution buries the dead and inaugurates the realm of THE NEW. The new is the

consequence of THE ARTIST'S refusal to locate himself in the traditional (past, false) landscape. The artist creates the new by means of a heroic ACTION in which he affirms and defines his artistic and personal IDENTITY. His identity is verified by his incorporation into the future of art; his card of identity allows him to enter HISTORY.

Rosenberg's magic circle is also equipped for instantaneous shifts in tone. Affirmation and praise can be replaced by denial and disgust without any loss of momentum, for all his key terms have a dark underside. Thus a set of satanic doubles presents the false show of process: Art History without revolution is style, a shared illusion of reality. ("In art," says Rosenberg, "the alternative [to Revolution] is the Academy." The Academy is the purveyor of style, while the artist struggles with reality. This is a point that comes up repeatedly in discussions of American painting which Rosenberg originally described as a polarity between Coonskinism and Redcoatism. The Redcoats ignore the American reality and continue to put out stylish academic painting but are knocked off by our own revolutionary sharpshooters.) Revolution without the creation of New values and the transformation of reality is fraudulent. The Artist who relies on rehearsed techniques is a craftsman who makes pictures. He doesn't Act; he takes no risk of losing his artistic Identity and therefore he doesn't gain any—he effects no transformation of self, landscape, or History.

Rosenberg's magic circle serves four main purposes:

1. It accounts for art history as a process of continuing creation while leaving the act of creation suitably apocalyptic.

2. It locates art in the dramatic moral world of Existentialist values, Art becomes a matter of life-and-death, a question of whether we will accept the dead familiar world and die, or whether we can create a real new identity and live forever. (The anxiety of the Anxious Object is based on its knowledge of death.)

3. It drives other critics nuts. Faced with any of his imposing inconsistencies, Rosenberg immediately recognizes a paradox and leaps forward to embrace it. His magic circle makes him immune to logic. When Mary McCarthy said that a painting is the realm of deeds done, and that the critic was required to judge it, Rosenberg agreed. But, he said, " … in dealing with new things there is a question that precedes [judgment].… What is it?—The question of identity. To answer this question in such a way as to distinguish between the really novel and

the falsely novel is itself an evaluation, perhaps the primary one for criticism in this revolutionary epoch ..." (Note that "identity" here does not have Rosenberg's usual reference to personal identity. Similarly, "landscape" refers at various times to (a) scenery (b) the physical world, sometimes called "reality" (c) the social context (d) the specific artistic situation. It is usually unnecessary to know which meaning is predominant. Rosenberg's key terms are chords with overtones, not thin, abstract, tuning-fork notes.)

4. It confirms what everybody knows, such as:

a. *The most important thing to know about a painting is the name of the artist.* "In the art of our time, the identity of the artist is a paramount theme ... a work of art need consist of nothing more than an inscription of the artist's identity. In conceiving a distinctive way of signing one's name it matters little whether one stresses an exaggerated simplicity, a tangle, or an obsession, as long as the total effect is that of the unique signature."

b. *All paintings are ultimately representational, even if they don't look it.* Even the oddest abstract paintings can be considered as landscapes (inner) or portraits (inner). "In most of the abstract art, however,... the scene has not been extinguished.... Among Pollock's later paint-tracking extravaganzas, *Blue Poles* evokes the ubiquitous American weed-patch bordered by a rusted-out barbed wire fence—the artist bringing to the canvas an inter landscape that is part of himself...."

c. *Painting is no fun and real artists suffer terribly.* Creation is lonely, anguished, private, etc. "The tension of the painter's lonely and perilous balance on the rim of absurdity.... On the one hand, a desperate recognition of moral and intellectual exhaustion; on the other, the exhilaration of an adventure over the depths in which he might find reflected the true image of his identity...."

d. *Paintings are either masterpieces or meaningless repetitions of stale tricks.* (See the Redcoat-Coonskin discussion noted above.)

e. *Modern art is very high class.* "Modern art in America represents a revolution of taste—and serves to identify the caste conducting that revolution."

f. *Art is communication, but what it communicates is mostly shoptalk.* "The liberation from 'literary subject matter' boasted of by modern painting and sculpture has been accomplished by their transformation into literature. With images of genre and fable eliminated, the painting as a whole has become a *word.*... The function of art is to serve as a stimulus to further creation."

Rosenberg's magic circle derives much of its energy from the decaying orthodoxies, popular and esoteric, that it contains. Like Malraux, he has a talent for getting drama out of any piece of cultural debris. He and Malraux are both literary men who developed against a background of leftist political engagement. Both of them retain a nostalgia for sweeping moral visions of culture. Dialectical methods are habitual to them; both tend to polarize art history into a struggle between the good guys (humanist and revolutionary) and the bad guys (conservative and institutionalized). They both seem to think metaphorically, and to "read" art as an expression of something else that validates it, something more real than it is, social development or culture. The result is a fantastic sentimentalization of art.

When Rosenberg transports the concept of revolution into art, he has to rearrange the traditional furniture. The innovating work takes the exalted place of the old-fashioned masterpiece, and the realm of the new rises to support it. As the one crucial phase of artistic activity, revolution has the particular effect of making trivial almost everything produced. Moreover, let's face it, what's around now doesn't aim at social apocalypse. To make revolution a requirement of meaningfulness obviates the possibility of finding out what art is doing now.

Another possible flaw in Rosenberg's magic circle is that it has no paintings in it. Not because paintings have been forgotten, but because hardly any time is allowed in which the art object can truly be said to exist. There is only the moment while it flashes from the entrails of the artist into history. As the Green Giant says in the ads, "as soon as it's ripe, we freeze it."

For the artist, the painting exists as an interval in his creative life. This is the time during which the painting is in the process of being articulated and remains unknown as a product. It must remain totally unknown—the artist must not have any mental image of how he wants the thing to look. That is peeking, an evasion of uncertainty, and very immoral. Even worse, it bars him from art, for his work becomes craft and technique, which are funda-

mentally uncreative. "There is nothing in art that cannot be reduced to inconsequence if understood in how-to-do it terms.... What defines art as craft is placing the emphasis on the object and its qualities, to the exclusion of the personality of the artist, his unique consciousness, his dilemmas." In other words, it would probably be better for the painter to work blind-folded, since the picture can only distract him from his engagement with the inner life.

Involvement with the painting-as-art-object is a danger for the artist; for the spectator it is fatal. Attention given to what Rosenberg calls its "esthetic qualities"—its line, color, texture—identifies it as art and detaches it from the life of action, thus robbing it of the possibility of meaning anything important. "It is in their disquieting phase—when their strangeness causes them to see outside of art—that innovating paintings work to expand our consciousness and sensibility." Only while it remains NEW can a work serve its most vital function. Because art history kills the living work, isolating it from human circumstances and turning it into ideology, some artists try to escape the art-historical fate by constructing work that will disintegrate rapidly. An artist does this out of tenderness, being unwilling to allow his loved one to fall into the hands of taxidermists. According to "The Esthetics of Impermanence," the work with a designedly short life is "an antidote to the painting as an object that obstructs the psychic transaction between the artist and the spectator."

For art to fulfill Rosenberg's requirements, we must conceive of a work so baffling that it evades all categories of past experience and an artist so marginally attached to reality that he forgets (transcends) the fact that he is making something. Art that is so essentially transformation that it disappears in the thing created can hardly be at all. Rosenberg is like a lover whose belief in love is absolute, but for whom the act of love is so radically pure that it is hardly attainable; he is condemned to a sex life that is either degraded or institutionalized, whoring or marital relations. Art is real. It creates the identity of the artist and sets the forms of historical consciousness, but its meaning lies in the quality it has as experience; as an object it is empty, and nothing important can be said about it. This is very sad for an art critic, and Rosenberg bears up admirably in the pathos and absurdity of his situation.

We must set aside Rosenberg the critic before his real virtue appears: he is an A-1 art consumer. His relationship to art is beautiful in its voracity, its energy and its breadth. At the same time it is distressing in its indiscriminateness and its self-absorption. But Rosenberg's writing about art is a model of the way works of art can be ingested by the perceiver, how they can engender other visions, black suns radiating image and thought.

Rosenberg brings to art a whole range of passionate concerns. He is deeply interested in avoiding the paralysis of an automatized existence and the chaos of a mindless one. He plunges into art with a fierce appetite for clues to the way out of these difficulties. In practice and, more feebly and uncertainly in theory, he corrects the error of isolating art from the hungers and uncertainties of ordinary life. We are grateful. Outside of a few novels and our own private and often abortive experiences we seldom see anyone trying to make vital use of art the way people try to make use of literature.

But as a critic, Rosenberg is a menace. Once he has elucidated art's meaning, the public has had its esthetic experience; it has leapt through the work and transcended it. Even if his readers get bored with the contents-according-to-Rosenberg (the entrails of the artist used to divine the nature of the historical present), there is always the sensation of having escaped the dumb and ambiguous demands of the work itself. In fighting against the isolation of art from life, Rosenberg has "liberated" art from the particular objects in which it exists and dissolved them into his won world.

Often, he appears to dump all the distinctions of art history and criticism—all artistic conventions, stylistic distinctions, formal descriptions—into a trash basket. Claiming a naked encounter with art, he then sneaks the old terms onto the table again in the course of his own discussions. He is, finally, too sensible to abide by his own thrilling rejections. Thus, while the very concept of style is so depersonalized as to be anathema to him and to require the invention of a wild new term, "unStyle," Rosenberg is capable of writing quite a sensible piece on art movements which disengages itself from the individualist bias against the idea of style as a collective achievement. The bizarre premises and interpretations that form his magic circle are continually denied, re-interpreted and ignored under the stimulus of other ideas and events.

To acknowledge that Rosenberg's perceptiveness can triumph over his theoretical structure and reach a serious level doesn't mean that he comes out even. His inflationary style leaves his readers mired in habitual raptures, crucified in attitudes of cultural Yea-saying. And the work of criticism remains to be done. In relation to the terrifying fluidity of art today, Rosenberg turns out to be elsewhere. His refusal to distinguish between theoretical and rhetorical effectiveness is not petty self-indulgence. It is a denial of the function of intelligence and a refusal to be fully present as a member of the audience of art.

Arts Magazine, May 1966

A Note on Opticality

I see no alternative to placing formal analysis at the heart of art criticism, nor, it seems to me, should any alternative be sought. Yet keeping a cool Dick Tracy eye on formal developments in the overcharted jungles of contemporary art, so full of occasions for exaltation and distrust, is not the easiest thing in the world. A primary task is the formulation of a usable formal vocabulary, so that we can at least find out if we agree about what is happening out there. But a formal vocabulary, like any other sector of language, depends on the existence and co-operation of a community of speakers. Also, a formal vocabulary arises out of the exigencies of experience and undergoes a period of experimental usage before it achieves definition and official status. One of the more promising terms to appear during the past few years is "opticality."

The term "opticality" arose in response to Op art and was first used to call attention to the retinal flicker that results from the juxtaposition of highly saturated hues of equal value. It was rapidly extended to identify the response to other optical phenomena—the shifts of configuration often visible in Goodyear, Vasarely and others, and the shifts in the visual plane, on which the configuration occurs. It has also been applied to situations where the figure-ground relationship is ambiguous or variable, as in such Hard Edge painters as Kelly or Smith. Michael Fried, using the term in relation to Louis, Noland, Stella and Olitski, has extended it even further.

Deriving the concept of optical space from Pollock, Fried says, "... a picture field so homogenous, overall and devoid both of recognizable objects and of abstract shapes ... I want to call optical.... The materiality of Pollock's pigment is rendered sheerly visual, and the result is a new kind of space ... [space] in which conditions of seeing prevail rather than one in which objects exist, flat shapes are juxtaposed or physical events transpire." Although I am unable to agree with many of Fried's observations, he has, I

believe, performed a very valuable service in relating opticality to a particular kind of space and in identifying that space as the one which is most relevant to contemporary formal developments. However, Fried's discussion of optical space is (I think unfortunately) intertwined with the concept of tactility. He says, "Tactility remains an unavoidable … *metaphor* for characterizing the illusive opticality of space …," but subsequently he speaks of Newman's "tactile space" as well as of his "optical space." Without going into the complex problem of the various kinds of visual information subsumed under tactility, I would like to try to characterize optical space more fully.

The term is initially distasteful, I think, because it's absurd. Pictorial space was always addressed to eyesight alone, objects have never existed in it, nor have physical events transpired there. Until now. In fact, the new optical space is one in which objects do exist beyond the surface (Johns, Morris) and in which events do transpire (as in the moving light patterns of the GRAV artists). But still, I think, Fried is right and a new pictorial space does exist, one which has some right to be called optical space.

Traditional deep space can be easily related to and distinguished from the shallow space of the Cubists: Cézanne played the crucial mediating role that led our vision from one to the other. What we needed next was something to illustrate the development from Mondrian's surface, the mathematical plane of pure two-dimensionality, roughly coextensive with the canvas surface, to the new optical space that seems to move forward from that surface. I suggest that Op art has played this heuristic role for us, although optical space, as an artistic phenomenon, is considerably older than Op. (The Op phenomenon of shimmer, which seems to locate right in front of your eyeballs, turns out not to be a necessary characteristic of optical space.)

Clement Greenberg, in a 1959 essay on collage, noted: "The actual surface becomes both ground and background, and it turns out—suddenly and paradoxically—that the only place left for a three-dimensional illusion is in front of, *upon* the surface." A year earlier he had remarked of Newman, Rothko and Still that they create a "counterillusion which consists in the projection of an indeterminate surface of warm and luminous color in front of the actual painted surface. Pollock … worked to the same effect …" Irving Sandler's catalogue essay on Concrete Expressionism remarked on "the implied motion forward of bulky planes … 'inverse illusionism'" in the work of Held and Knox Martin.

These observations suggest that a rather wide range of contemporary styles and techniques make use of a common formal ground—they occupy a particular kind of space. Our new pictorial space is felt as being physically

grounded on the surface, but this surface is perceived as having density. It seems to move forward, toward the spectator, over a spatial range so small that specific relations of depth are indeterminate.

The arena of optical space is often physically contained by a projection of two or three inches. This is the picture space that we find in Arp's cut-out or layered pictures, or in the space between the front and back planes of Yvaral, Soto, and in other Op structures. Goodyear's layers of grids have a greater physical extension, but they are, I think, about the same visual depth. Optical space is an immaterial slab, at most no thicker than the usual Cubist space, but oriented outward instead of behind the surface. As Fried suggests, its salient characteristics are the absence of a single dominant pictorial focus and the weightlessness of the paint.

In optical space the homogeneity or continuity of the visual field is preserved by the number of occasions for visual focus. There may be lots of these, as in the '47 to '50 Pollocks or the Vasarely checkerboards, or there may be few, as in Frankenthaler or Newman, but there is always an attempt to disperse interest relatively evenly over the entire visual surface. This does not necessarily limit the articulation of optical space to all-over or color-field painting, nor does the total surface need to stay flat. Noland's show at Emmerich in March, for example, included several diamond-shaped canvases that had a definite torque. Bridget Riley, some of the *moiré* people and some Vasarelys give us a visual surface that contains passages of twist, bulge, bubble or sag. What optical space does require, however, is a surface that is either so agitated or so featureless that your eye keeps moving over it. Optical art does not encourage the single contemplative viewpoint that has been normal for so long in most Western and Far Eastern art.

The depth of field in optical art is ordinarily determined by color. This is where contemporary painting is most deeply indebted to Matisse, and, since the amount of color so strongly modifies its effect, where considerations of picture size become crucial. Shifts of linear direction, as in Poons or Riley, can also articulate spatial relations, but figural indications of volume or mass are absent.

Indeed, the major problem of the spatial field of optical art seems to be that it cannot comfortably support strong expressions of mass or volume. Even paint can get too heavy for it—the shift from heavy impasto oil to acrylic is often not mere fashion, but an attempt to meet this limitation. The loss of mass, of course, threatens a severe impoverishment of artistic resources. This presents a formal problem much more severe, I believe, than Fried's "integration of figural and optical effects." The difficulty with figuration in optical space is not that contour introduces disruptive tactile elements. Rather, the problem is that as soon as a figure in optical space

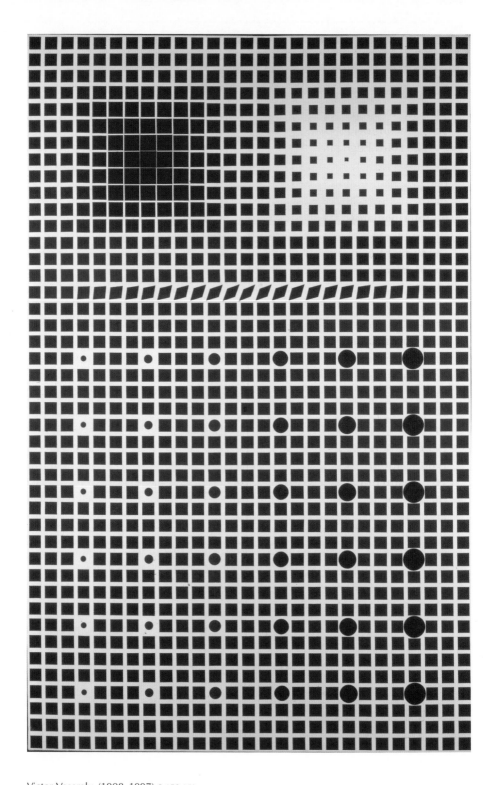

Victor Vasarely, (1908–1997) © ARS, NY
Supernovae, 1959–61. Oil on canvas, 241.9 x 152.4 cm.
Tate Gallery, London, Great Britain
© 2011 Artists Rights Society (ARS), New York / ADAGP, Paris, Photo Credit: Tate, London / Art Resource, NY

takes on any appreciable degree of density it begins to feel subject to the universal pull of gravity. Then, if the physical surface of the canvas is suppressed (by colorlessness, or assimilation to the wall), the figure is likely to seem uncomfortably suspended and unsupported.

The Hard Edge painters got around this by insisting on the solidity and evenness of the surface and by making their internal edges crisp and firm enough to mimic and play against the framing edge, thus reinforcing the picture's physical basis. The stained edge, on the other hand, gives the image an intermediate border that binds the fuller saturation of the figure to the unsaturated ground. The pervasiveness of the canvas's texture throughout the surface further sustains the spatial integrity of the picture. Both of these solutions are tricky—that is, they require extremely delicate adjustments of color and form, and they tend to work best with rather static and banal shapes. When mass gets so problematic, textures and movements that can create buoyancy become correspondingly important. Radial motifs are common, and one thinks of Olitski's airy, rather flatulent sprayed surfaces or Lichtenstein's Ben Day dots.

In fact, the formal problem of the incompatibility of visual mass and optical space seems to me to be crucial in accounting for the so-called emptiness and reductiveness of contemporary painting. It is this formal problem that perhaps best explains how we have arrived at "minimal art" (which seems to me a misnomer) and at what Mr. Kozloff calls "an ethic of renunciation." Artists are not notably renunciatory—they don't willingly give up anything they want. And many of them are so unwilling to yield mass to the requirements of optical space that they turn to shaped canvas and sculpture instead. But these have their formal problems too....

Arts Magazine, May 1966

McLuhan's Message: Participate, Enjoy!

Invitation to an orgy—Can we refuse to sing along with kitsch?

How can you tell the difference between a message and a loud noise? If the sound disappears, it's a loud noise. If it's repeated, it's a message. Marshall McLuhan is a loud, cheerful noise with aspirations. He has been claiming to have a message since 1951, when he published *The Mechanical Bride* and set up shop as a theorist of culture. McLuhanish overtones are presently reverberating from Madison Avenue through the Village, having found responsive frequencies at both ends. Yet even the people who find McLuhan's ideas useful withhold full assent. Even his fondest critics call him silly. Message or noise?

"Here is the image of the golden age as one of complete metamorphoses or translations of nature into human art, that stands ready of access to our electric age." McLuhan promises salvation through art, and his idea of art is a peculiarly modern one. It would be familiar to John Cage and unrecognizable to John Canaday. Rejecting the whole apparatus of middle-brow culture, McLuhan links avant-garde theories to the mass audience. Yet he addresses himself to the citizen-consumer, surrounded by benign structures of specialized power—commerce, government, art, education—the consumer who feels ignorant, impinged upon and helpless. McLuhan tells him why he feels that way and why he shouldn't worry about it.

Our environment, he explains, merely consists of the various expressions of technology. Our experience is confused because our technology is transitional. Since the Renaissance we have been enmeshed in the consequences of a print-based culture. Nationalism, the Industrial Revolution and the

fragmented, standardized life of Western man all derive from a print tech-
nology that is presently being replaced. Traditional ways of thinking and
feeling are obsolete in the modern world, and a new system, based on elec-
tronics, is being prepared. With television replacing the book as the central
medium of culture, the vivid, friendly, noisy life of the senses brings the
audience closer to full humanity than the solitary reader ever got. Moreover,
we are already responding to the new world, in ways we never suspected. As
sensuous illiterates yield to the new media they too will find an increasing
measure of participation, individuality and togetherness. (An excellent
account of McLuhan's ideas is available in Harold Rosenberg's sympathetic
review of *Understanding Media* in *The New Yorker* of February 17, 1965.)

It's a one-world and hallelujah story if ever there was one. It's cosmic
and up-beat and simple—McLuhan's categories of media and information
offer the most ambitious dualism since spirit and matter. But McLuhan
doesn't make it on his talents as a snappy salesman for tomorrow's world,
nor can he command reasoned assent, since he doesn't understand argu-
ment. He makes it because, oddly enough, his vision of our existence seems
plausible, and less oddly, because so much of his chat about particular
things (dark glasses, Nixon, poker) *feels* right, true. We know he is talking
about real things, and we are all too ready to grant that if we feel the same
way about real things we are onto something good. The rate of technolog-
ical change *has* made expatriates out of all but the youngest of us. We were
raised on a work ethic that has become irrelevant, for in order to feed us,
society increasingly does not require our work, but our consent. We are used
to being offered an ethic of love and excitement, though it tastes like Won-
der bread in our mouths. Staunchly addressing himself to the problem of
taste, McLuhan calls attention to the benefits of flavor additives.

Ultimately, he is persuasive because we are willing to believe that the
exercise of taste is participation in culture and the most significant aspect
of our lives. The fact that he is pulling a monumental fast one in turning
the human situation into an aesthetic one slides by unnoticed.

Not that McLuhan claims to be talking about art. He says he is talking
about media and technology. In fact, he applies himself to the whole
domain of artifacts, and he has chapters on clothing and weapons and cars
and clocks, as well as on radio, television, newspapers and comic books.
However, his interest in all these things if fundamentally aesthetic, for he is
concerned with "media" as sensuous and formal objects that express and
act upon perception, feeling and thought. McLuhan is not interested in
practical techniques or in theoretical systems. He is not profoundly inter-
ested in ideas, and consequently he finds religion, law, politics and science
trivial. For him, creation and invention don't come about as a result of peo-

ple being up against something. The significant creations, the ones that really change people, are the result of quasiorganic proliferations of the self ("All technologies are extensions of our physical and nervous systems to increase power and speed"). Social changes are merely accommodations to technological change ("an increase in power ... or speed ... causes a change in organization"), although what is speeded up or magnified is itself neutral ("The alteration of social groupings, and the formation of new communities occur with the increased speed of information movement").

According to McLuhan, man's extension of himself in technologies is the fundamental impetus of history. His theory of culture is thus built on the marriage of self-expression and technological inertia, which makes development sustain itself. In this radically de-moralized world, goals are as irrelevant as motives; willy-nilly, existence is a matter of style. Our lives are existential repetitions of a style derived from the dominant forms of information movement. It is a deracinated world in which processes formerly enmeshed with daily existence are isolated. Work is equated with craft, knowledge with information, perception with power. It is, above all, a world based on art processes, for McLuhan's media are not significant as work producers but as audience creators. Our participation in the new world is based on the premise of rich artistic involvement. How does he propose to achieve it?

For McLuhan, the effectiveness of the medium is built in. All media and all technologies affect their users, ither by impact (hot media) or by involvement (cool media). Television is supposed to be very cool, and here problems arise. It is undeniable that in the last fifteen years the style of show biz has increasingly dominated the social scene. Political images, corporate images, public images of all sorts have become the objects of loving attention as advertising expanded into public relations. This development is the result of taking the various cosmetic techniques that were formerly applied to products and programs and using them on the producers. The advertiser's claim to attention, that he served the public interest by providing product information, has followed a parallel path, and facilitated the elision of advertising into news. Television shifted attention to the artistic dimension even further. When news became visible, the report turned into a presentation. The fact that the audience is getting theatrically organized materials is increasingly inescapable. When the radio announcer says, "And now, the news from Viet Nam!" and we hear the sounds of recorded gunfire, thuds and assorted battle noises, not only is it impossible to doubt that the news is being managed, but Viet Nam becomes a fictional country. Everything is souped-up, organized for effect, and awareness of the clumsy artistic surface has the effect of setting reality at an all-but-irretrievable dis-

tance. McLuhan attributes this deadening of affect to the numbness induced by the radical experience of an innovating technology. Could it not, with equal plausibility, be interpreted as evidence of artistic failure?

Meanwhile, on the other side of cultural valley, artists are working, naturally enough, to annihilate aesthetic distance and to incorporate the impact of reality. Painting, sculpture and theater melt into each other as the boundaries between the arts sag under the pressure of thrusts toward the stronger effects. Hoping to keep his work from disappearing into the pigeonhole of conventional art the artist reaches for materials that will be palpably and authentically real. The audience is urged, moreover, to concentrate on those materials, on the physical body or surface of what is presented. Subject matter is visibly, irrelevant, and the search for content, Miss Sontag tells us, is an evasion of the work itself. You don't get meaning by interpreting content (already an abstraction from the work itself), but by yielding to its presentational immediacy.

From both sides of the wide-screen culture the emphasis is on sensuous urgency, which is touted as guaranteeing context with reality. McLuhan claims that perceptual experience in the electric age is necessarily integral and depth oriented, and the artists say that new materials create new effects. In both cases, sensuous experience is exalted and presentational immediacy is offered as a source of involvement.

It is very peculiar and interesting that McLuhan and radical artists agree. Like the artists, McLuhan thinks in diffuse and idiosyncratic terms—he shares their prophetic aims, which make precise and formalized concepts useless to all of them. Their common bias toward a jumpy high-keyed surface indicates a common feeling for style, a strictly contemporary sensibility. What McLuhan seems to be looking for in modern artistic experience is just that overwhelming inundation of the senses that the most *raffiné* artistic element in the city is trying to give us. Artaud's total theater is a much greater amplification of sensuous experience than any television program could be. Yet the idea of the loaded, discontinuous sensuous surface has, in fact, been artistically explored enough to give us a reasonably clear idea of its limitations. Emphasis on a highly differentiated presentational surface tends to degenerate easily into fussiness and fragmentation; vividness and tension are not textural properties.

The whole *mishigas* about presentational immediacy seems misguided, a false identification of sense experience and artistic experience. It is a psychological commonplace that perceptual experience is culturally conditioned and that non-cognitive factors qualify sensuous experience. More stimulus doesn't mean more impact *or* more involvement—not by a long shot. Four hundred Beatles would be less lovable than four Beatles in

any medium. The requirement for co-ordination of increased stimuli lays a greater burden on the artist and on the audience, for unpatterned stimulus is distressing at all levels of intensity. You can drive cats crazy that way. People are together, and mild distress has its artistic uses, but even people object to noise.

If one is going to talk about the perceptual surface as a screen of bits carrying information, the problem of noise should not be ignored. Noise is a central concept in information theory and McLuhan's silence on the subject is curious. The attractiveness of information theory as a metaphor for artistic experience is its dynamism, its emphasis on message reception as a phase in a process. Noise, as a by product of the system, is an internal threat to the efficiency of the system. As soon as something—an organism or a machine—can respond differentially to stimuli, noise (unpatterned perceptual stimulus) can become a problem. Noise is distinguishable only within the context of a functioning system that can define information and measure effective reception. Thus, the sound of an unknown language is not noise, because there is no language system functioning. But dead language is noise. In reading somebody like Shakespeare, whose language is no longer wholly alive, we have to learn to deal with noise. Sensitivity to artistic noise is a correlative of sensitivity to artistic meaning.

McLuhan has a rhetorical alternative for the problem of meaning. For him, meaning is an old-fashioned concept, suitable to an age when information was moved from one place to another by ox-cart. In an electric age, he says, we are more interested in effect, which examines "the total configuration of changes produced in a situation by the introduction of a new element." But noise can be defined as that part of the perceptive situation that resists integration into "total configuration." Thus "total configuration" either includes the problem of noise and is simply a new way of saying "meaning," or else it ignores noise and denies that incomplete or erroneous configurations can be made. The medium is the message only for organisms so coarsely organized that noise does not exist for them.

It is not his failure to deal with the problem of noise that ultimately dooms McLuhan's attempt to deal with art in terms of media that carry messages. Nor is it his inadequate grasp of form nor his mistaken claim that the content of mass media is irrelevant to its effect. (The treatment of moral implication in mass art is generally evasive, bland and perfunctory, but every hack knows you can't leave it out.) McLuhan can't deal with art because his cultural theory eliminates the extra-aesthetic world.

If we conceive of ourselves as the consumers of information, our experiences of life and of art are identical in form. But such a conception requires an enormous, fundamental abstraction from the existential situa-

tion. It requires that we ignore our capacity for action and deny its relevance to the human condition. If you can't make sense out of art, if it bores you and leaves you with a sense of not being with it, you don't commit suicide; you go away. If you can't make sense out of life, if it bores you and leaves you with a sense of not being with it, you will probably build some sort of theory. The theory may justify the maintenance of an "absurd" existence or the act of suicide, but either way *action is the category of human response.*

It is really crazy that we have forgotten this. In order for life to be bearable the sequence of daily experience must yield a sense of action, participation in real movement. Or else it is repetition and hell. Repetition that cannot be resisted or modified *is* hell, because it refuses the possibility of action. The efficiency of modern culture in turning us into a captive audience, bombarded with messages, information, repeated messages that don't give us a sense of possible action, is experienced as oppression and noise. It is exactly what yields frustration, alienation and yearning for an absent reality. Instantaneous implosive experience is the paradigm of the daily trauma of media bombardment, which makes us the victims of culture. To find a message in the cultural noise is the pious hope of all culture addicts. Otherwise why continue to expose oneself? The problem always is, given experience, what to do with it. Under pressure, we want to know which way to jump. How to turn one's life into form, a set of completed movements, "real" work instead of making a living, wisdom instead of information, existence instead of survival.

The elimination of significant action from contemporary productions of art is accompanied by sounds of pain and distress. The implausibility of being able to do anything significant, the sense of being trapped in inaction and impotence within a demonic world, is a characteristic contemporary experience. So is boredom. Boredom means that you are waiting for something and don't know what it is. It means the messages you are getting are irrelevant to your existence.

But artists, for all their noisy suffering, are at least prepared to recognize that a real problem exists. They are filled with a real, if puerile, nostalgia for reality. Camp, which points to art as a toy, is distinguished from art that is morally serious. It is a distinction that does not exist for McLuhan.

In Shakespeare's use of the metaphor of life as a theater men were actors, even if, implicitly, the plot was given. McLuhan takes us off the stage completely. He is so much a victim of the cultural boom that he eliminates the real world out of carelessness and frivolity. If you substitute experience for action the world disappears and art is a hallucinogen. A protest must be lodged in the name of art. For art is minimally a scavenger on the practical world, which it requires for its nourishment. It digests the undigestible and

assimilates dearth and excess, so that men can go to it and return to themselves restored.

The artist's moral experience is his raw material. His subject is not public things and private feelings, but the experience provided by his culture. As with the rest of us, the acts and furniture of his life have been soaked in culture, impregnated with meaning, have attitudes latched onto them.

His artistic material derives from the social world and is normally returned to it. Moreover, what the artist does with his cultural material usually modifies our relation to its original. What has Warhol done to Campbell's soup? Reproducing and enlarging the advertising image, leaving off the copy, shifting its context from commerce to art, he affects our experience of the original image. He cools it, as all Pop art cools the effect of the media it uses as material. And in the bombardment of a consumer culture—we are enjoined to consume goods, policy, etc.—the imperatives of advertising and propaganda must be modified or the response will be an alienating, self-protective withdrawal. We have to be able to tolerate the rain of media messages—Get, Buy, Give—and hold them in solution at a bearable distance.

Similarly, Happenings re-create with remarkable fidelity the experience of being a besieged audience, tormented with appearances that hold an indeterminable relation to reality. We are made to receive messages like mad, but the messages give us contradictory orders; they tease us and attack us and turn us off. Happenings, with their conjunction of different sources of information, their rejection of the audience, the interspersion of violently sexual and scatological materials, are an admirable mimesis of life seen as formless subjectivity and aborted involvement.

And yet hardly anyone thinks this is good enough. Cooling it, distancing it, turning the passing scene into spectacle and entertainment, doesn't satisfy the desire for involvement. The desire for involvement reflects a moral demand, since the need for action remains as the problem of what to do with energy and stimuli. Moral demands on art can't be eliminated, though it is absurd to say that when those demands are frustrated art does not exist. By moral demands I don't mean the thirst to approve or condemn, but the need to locate oneself in relation to possible actions. The ordinary idea of content is moral orientation, something that tells you what to do, like assertions of the desirability of love, the superiority of passion over reason, that sort of thing. People respond to the absence of moral orientation with complaints about the emptiness of artistic forms.

The difficulty of finding usable conceptions of form and content is evidence of the awkwardness and unsuitability of the traditional aesthetic vocabulary. Maybe McLuhan's apotheosis of media as audience-creators

will lead to a serious examination of the variables that do operate in relation to art. At least he does present a cultural theory that assigns art a reasonably active and pervasive role. His recognition of artistic elements and techniques is (to be polite) inadequate and spotty, but at least he acknowledges the aesthetic as an extended cultural domain, and doesn't identify it with a handful of genres and traditions. Also, his idea of media research as enquiry to be directed *against* the effectiveness of art is an improvement over art appreciation. The criticism of art should aim at an understanding of the subject, not the refinement of aesthetic pleasure. Aesthetic pleasure is nice, but it doesn't have much to do with art.

Arts Magazine, June 1966

The Sculpture of George Sugarman

What has insides and outsides and comes in 17 colors?
Answer: George Sugarman's new work

The cultural avant-garde is ill equipped to deal with George Sugarman. He is not a tease, his work is not hermetic. It is not boring, and it doesn't make allusions to literature or art history. It is too abrasive and active to inspire introspection or reverie, and it demands participation. An ideological approach to Sugarman's work is patently absurd; it would be like trying to evaluate the private life of a charging rhinoceros.

Moreover, work like Sugarman's, which deliberately violates the traditional subordination of the parts to the whole, runs up against a theoretical weakness in art criticism. The analytic techniques developed for traditional art are built on an ideal of total harmony and unity. Most formal criticism is geared to accept "variety" only for the sake of added "interest." Yet there are temperaments who find this idea of art intolerably bland. They want something that offers continual variety and involvement. For them, emphasis on the isolated totality of the work of art merely reinforces the spectator's disengagement. Thus Sugarman believes that if a piece of sculpture feels like a *thing,* even a beautiful thing, it's a failure. He wants a more energetic relationship between the work and the space it creates, for the sake of vivid response. Consequently, he believes that the relationship between one part of the work and another should not seem overtly inevitable and logical, but open and full of possibilities. The demand for a final unity is not denied, but such unity is put under pressure. Each part must repay out attention in itself, while the tension between consecutive parts must be compelling enough to lead the audience through the entire work.

Criticism generally has failed to grasp the artistic significance of tension. Yet work that is constructed discursively rather than analytically often depends aesthetically on tension and psychologically on stress. The indeterminateness of the sequence, both formally and emotionally, must be sustained. You don't know what's going to happen, or when it will end. Tension is partly a consequence of open-ended form, partly a response to the unfamiliar. For such work, absence of surprise is the kiss of death—yet the work must feel complete.

This conception of art is a strenuous one, attractive but extremely hazardous to weak talents. It requires great formal inventiveness of the artist. Sugarman welcomes the challenge. "I like hard art. If it's easy, it's easy to forget," he says. He admits that he can take as long as a year to decide whether or not a completed piece is successful; the audience can take it or leave it. But if Sugarman meets the stringent requirements of his vision, as I believe, he has not yet received his due. What stands between him and his audience?

Certainly the art of the past five years has made us increasingly sensitive to the variety of possible artistic ideas. Yet, since the decline of Abstract Expressionism there seems to be an increased resistance to emotional demands. We welcome elegance and formal innovation—and are so afraid of neglecting the possibilities of the latter that every gimmick arouses aesthetic speculation. If Sugarman's contribution were confined to his artistic discoveries (the exploitation of painted sculpture and the idea of relating a discontinuous sculptural complex to the floor), he could be more easily assimilated. But Sugarman is not only an inventor; he's an artist. And what seems difficult or even undigestible about Sugarman's work is that it strikes us as being simultaneously bizarre (formally inventive) and robust. It is the robustness, I believe, that is the more problematic for us.

Sugarman's sculpture carries a sense of physical, bodily vigor, a bulging aggressiveness that moves along the athletic line of sculptural history through Rodin, Michelangelo and the more immodestly dynamic Greeks. It implies a belief in physical energy, health and human efficacy that is very uncontemporary in feeling. We are more likely to deal with physical robustness in a spirit of parody or disbelief. This is still a time for the anti-hero; Batman is a big joke. Oldenburg suggests that matter no longer offers nourishment or resistance, and Agostini's latest work is a mockery of material fullness. In general, our idea of the body tends to be non-muscular. We see ourselves as sensibilities, flesh and nerves, pulp and wire. And although Sugarman is not interested thematically in the figure, his vivid sense of energy is primarily expressed as mass in action.

To understand what Sugarman has done, therefore, we must begin with mass—physical stuff. Do not mistake this for material. You would do better to think of Breughel's physicality than of the Venetians'. There have been artists for whom love of the artistic material—wood, marble, paint—was an impetus, but Sugarman is not one of them. In fact, when he first started painting his sculpture he was delighted to find himself foiling those who had earlier chosen to admire the wood grain instead of the work itself. Now his sculptural ideas are so thoroughly coloristic that during the construction of a piece, painting and building go on simultaneously. If he has trouble with a color, he is likely to conclude that something is wrong with the form.

Although Sugarman won his first major award in 1961 (second prize at the Carnegie International) with a piece in unpainted wood, he had already begun to use color, and his second show with Radich in the same year consisted entirely of polychrome sculpture. Sugarman uses color to augment the distinct separate character of each form, articulating the mass by disassociating its parts. He prefers strong, even harsh colors. At first he seemed distrustful of modulated or soft tones, fearing that they might dissolve the form, but increased control of color has brought a wider palette. Fierce or smooth pastels may now be combined with fully saturated hues.

At the base of *C Change* (1965), notice the rapid progression of small shapes which rise in a sequence of orange, cerise, white and pale tan. This is plastically a relatively quiet passage in which a series of shapes of similar size and form are loosely piled up on each other at slightly different angles. Those particular colors were absolutely necessary, Sugarman says, because without them the small forms weren't *there*. The bright garish hues, combined for strength and clamor, slow down the rate at which this section is seen, and work against our collapsing it into a visual unit. The white and tan, along with the light gray base, keep the bottom half of the nine-foot piece from getting compressed under the weight of the larger forms and generally deeper hues of the top half. Furthermore, the color increases the compactness of the form by minimizing the effects of light and shade. Through all its functions, color increases the materiality of the form, spelling out the independent density and presence of each shape.

The fact that Sugarman works with mass in the absolutely traditional manner of sculptors ought not to obscure the fact that he uses it a new way. In all his more recent work the energy of the mass is quite independent of its weight. It is not at all unusual to find that the largest elements in this sculpture are the lightest, the most open, the most inclusive of air. This separation of weight from mass is fundamental to his structure, and it is also the key to the disjunctiveness that has been widely acknowledged as the basis of Sugarman's personal style.

The obvious reason for considering disjunction characteristic of Sugarman is his unprecedented use of contrast—closed forms versus open ones, bulging shapes against piles of sticks or blocks, soft melting edges opposed to crispness. But simple contrast was obvious only in the earlier work. Moreover, additive agglomerations of contrasting forms couldn't possibly yield tension and coherence that mark Sugarman at his best. In 1961 he was still building his pieces as sequences of interdependent horizontals and verticals, with upright members bearing the weight. Shortly afterward, with color and a wider vocabulary of forms, the work had gathered so much energy that it was swept off the vertical. It became increasingly active, discontinuous and open. Now Sugarman is always crowding disaster. Everything could fall apart. Why doesn't it?

Every piece of sculpture has to meet the requirements of architecture: it must bear its own weight while preserving its form. This is no great problem for sculpture that is either monolithic or physically light and airy. In extended massive but continuous structures—sculpture, bodies or buildings—weight is classically carried by solid vertical elements, legs or columns. Columns could be extended and sheathed to form a wall. Modern architecture, however, can distribute weight using other principles based on tensile capacities of particular forms. The structural possibilities revealed by concrete shells or by Buckminster Fuller's geodesic design have outmoded the idea that stability demands an essentially static balance based on a single center of gravity. These new techniques for the stable dispersion of weight, especially along a set of diagonals, might be expected to interest sculptors. Few have responded. Even among those who work in welded metal tend to stick with post-and-lintel construction or with an immobile fulcrum around which movement revolves. Despite his old-fashioned materials, Sugarman proceeds much more radically. With the exception of the floor pieces to be discussed later, he works on the new basis of thrust and counterthrust. The energy required to support weight is given by the direction and openness of his forms, which permit them to span space without gross additions of bulk. Density and the play of directional forces are actually what hold the pieces together. These factors also account for the way Sugarman has managed to preserve the sculptural vitality of mass without referring to the movement of the human figure.

Of course, the physical coherence of Sugarman's sculpture does not guarantee its artistic coherence. However, an explanation of his mechanics does help to account for his dynamism and for the problems he continues to face. In terms of two-dimensional composition even his best pieces are rarely entirely successful. Their structure is more explicit and intelligible from some angles than from others. Since all the forms play a variety of

roles, you have to move around the work in order to see everything. At an unfortunate angle it can look alarmingly clumsy or overbalanced. It also photographs badly, especially in black and white.

The range of visual experience that one of Sugarman's pieces can provide is fantastic. If you move to the right or the left, the whole profile changes, the center of gravity shifts, the forms change their functions. A different view gives new information in no way deducible from the old. With a shift in the spectator's position, the massive inclined plane of the *Black X* becomes part of the crisp linear X of the title. The poised triangle in *C Change* that points threateningly down from one angle becomes, from another, an exultant opening V. The continual transformations and oppositions of both form and feeling are what make Sugarman difficult. Looking at his work is a tense, taxing, ultimately exhilarating experience. The excitement of Sugarman is not associative; it is built in.

One's immediate reaction to his sculpture is that he's kidding, he's crazy. It is true that he has done some goofy things. The blue blob in the piece formally called *Ramdam* drew a half-horrified, half-incredulous comment from critic Lucy Lippard: "One wonders how Sugarman came to conceive of that form ..." His barefaced originality is most easily seen as oddness. The work, its combinations of shapes and colors, often the forms themselves, seem peculiar, batty.

One of Sugarman's oddest pieces is undoubtedly *Inscape*. When it was first exhibited on the floor of the Jewish Museum in 1964, it seemed to make no sense at all. Like a child's game whose rules nobody knew, it combined elements of landscape and artifact in a lovable but baffling way. Sugarman's new piece, *Two in One*, develops straight out of *Inscape*. Much more highly organized than its ancestor, *Two in One* is simpler as a totality although its components are more complex. As usual, Sugarman has clarified his ideas by expansion rather than by reduction. Just as adding color increased the power and articulation of his forms, here the increase in scale has explicated the movement.

Basically the piece is a double development springing from a single form, the gray seed or mysterious quasi-tunnel at the beginning of the piece. Each of the two developments from the gray form is a journey with its own rhythm, its own characteristic forms and events, its own color. Then, at the end, the twin voyages are one—they were really married all the time.

This is a piece full of portents, crisis and wit. When the sense of a statement appears through rapid changes in tone from one element to the next, is this not the precise analogue, the essence of wit? As for crisis, when a rhythm is established and builds momentum only to find itself suddenly blocked, what else would you call it? Doesn't the squat green wall, for exam-

ple, play that role? Its thickness and the amount of space it encloses break the rapid stop-and-go rhythm of the progression. That wall is an enemy, but it makes sense. It tends to close the spiral unfurling of the vermilion form and to make a stop. Then when you start moving again with the two yellow pieces, you pick up speed on the basis of their close color, the correspondence of their profiles at the point of juncture, and the fact that the interior forms are now parallel to the movement, not perpendicular to it.

Cooler, simpler, more pure and elevated, the right-hand course of *Two in One* nevertheless contains a corresponding interruption. It comes at the prow of the great black form, which, juxtaposed to the low violet zigzag, presses against—nothing. The absence of massive resistance and interaction produces a suspension of activity, like a rest in music, that echoes the stopping action of the green wall. In effect, passage from the black to the yellow green is as swift as the movement from the dark green to the orange. This repetition of rhythm, occurring independently of the forms in which the rhythm is expressed, is also stated by the orange 8's and the yellow-green set of triangles that close the piece. Each of these forms acts primarily as the climax and coda of its own line of development. Functionally and in the shared rhythm of their openness and closure, they parallel each other.

Usually it is the gesture of a form that activates space and establishes sculptural rhythm. Here the open space separating and linking the forms is integral to the sculptural unit, which consists of a form and an interval. It is the form-interval pattern, and not the repetitions of form (which are subtle and limited), that primarily links the two major sequences. They are united by a common rhythm, a single pattern of growth.

It is ludicrous to turn from such analysis to the ponderous, vivid work itself. *Two in One* doesn't *look* so complicated. The invention and playfulness of *Inscape* are still here, but they have been transformed by art and intelligence into a work that is both humanly and artistically important.

If Sugarman sometimes gets messy, his work nevertheless makes a lot of other sculpture look dead. Its richness is radical testimony to the disadvantage of a high degree of simple organization. Not that Sugarman's work is disorganized—but his weaknesses are primarily failures to make his complex organization unmistakably intelligible. The trouble is that he tries for so much, and so much comes through, that it is easy to forgive him nothing. Yet it would take a very solemn and innocent mind to disapprove of exuberant risks, his stringent demands on the spectator.

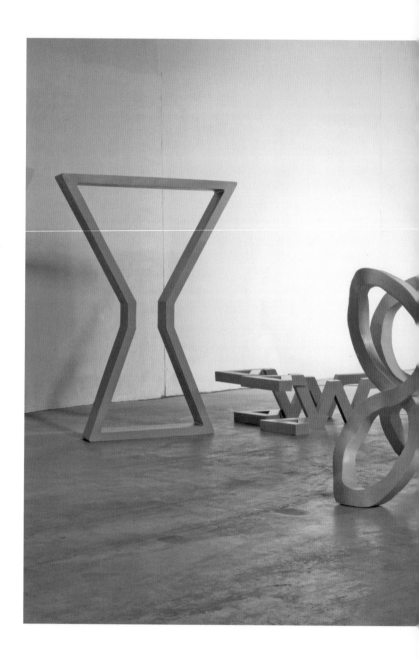

George Sugarman. *Two in One,* 1966. Polychromed wood installation of nineteen elements, 247.6 cm x 726.4 cm x 340.4 cm (97 1/2 in. x 286 in. x 134 in.) (2003.154.1/19-19/19)
Blanton Museum of Art, The University of Texas at Austin, Gift of the George Sugarman Foundation, Inc., 2003, Photo credit: Rick Hall

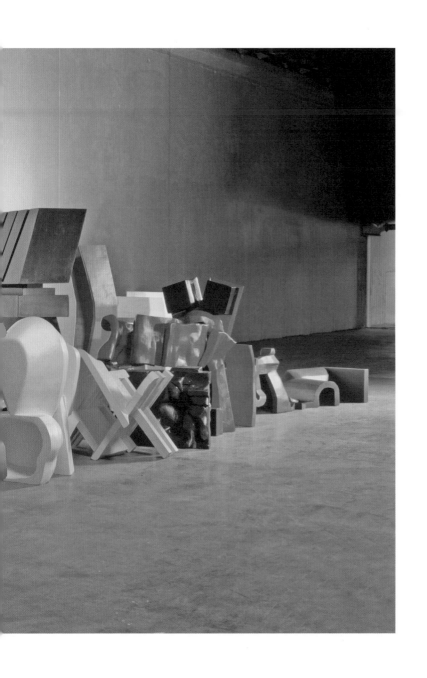

Art News, February 1967

Art in a Hairshirt

The dialogue today is taking place between a public of eager chatterboxes and artists who grow increasingly dumb.

Cultural piety, particularly when it is expressed in an old fashioned way, makes artists very nervous. Ideas and phrases that seem perfectly pleasant and ordinary to other people, like "Art is a force for social good" or "The artist fills traditional forms with new content" can drive artists out of their minds. There is a whole system of ideas, discarded by artists but retained by most of society, that now stands as an immense, invisible, dead-end obstacle course between us and them. Unsolved ideological problems are always very touchy, as anyone knows who has ever tried to have a heart-to-heart talk with a Negro about soul. When non-artists talk about art, artists are uncomfortable, and for good reasons.

A long time ago, in the process of a little innocent social climbing, artists got onto an ideological pedestal which elevated them about 130 feet above the man in the street. Art became very high class. In the normal course of intellectual history that pedestal sank, leaving the artists in an uncomfortable position of unsupported exaltation. For the most part, artists prefer to be where the action is, and from time to time they have kicked at the foundations of their prestige. "I'm anti-art!" they howl, "Get me off of here!" But since the tower, called the Palace of Art, was built by philosophers, it was made entirely of air and is nearly indestructible.

Until quite recently, the unresolved esthetic gap between artists and the rest of America was not particularly noticeable. People who had money and were interested in art bought paintings, and the artists grumbled and argued with each other, trying to figure out what was going on in Europe, and what they were doing as artists. The Abstract-Expressionists in partic-

ular found traditional esthetics, even modern imports like Surrealist theory, almost completely unusable. They were very disturbed by their inability to account for what they were doing, and everyone was relieved when Action Painting was explained to them. Unfortunately, the theory supplied for Abstract-Expressionism turned out to be special and inflexible. The next artistic generation relegated crisis esthetics to the pilings of the Palace of Art, leaving artists still stranded on the heights.

Then, suddenly, American artists found themselves part of the big picture. The klieg lights were on them and charisma was dripping off their leather jackets. They were asked to speak clearly into the microphone and to remember that all America was listening. Just about then they started to clam up. As long as American culture was neither a hot item on the international scene nor big news at home, the esthetic gap could be obscured in the usual way, by the flow of art. But when twentieth-century artists are thrust into a public position, they face the brutal difference between the public's expectations of art and their own. The esthetic gap becomes an open wound. Like the Dadaists, and through no fault of their own, American artists find themselves being sold as representatives of a culture in which they no longer believe.

Modern art started with a deep distrust of culture. Of all people, the modern artist is least inclined to take a rosy view of culture-in-general or to reinforce a normal cultural piety. It was cultural piety that outraged the moral sensibilities of the Dadaists and made them jump up and down screaming "Merde, merde, merde!" Asked to perform as culture spokesmen, American artists are considerably cooler. For one thing, they didn't choose a public role as the Dadaists did. Their problems are clearer. The spotlights are brighter and the hour is later. Many of them just try to get off the hook without saying anything that will force them to renounce production or take the vows of poverty. They are perfectly aware of the fact that the audience created by the communications industry is interested in news, not art. What they make is chiefly marketable as cannon fodder for the big guns of media. To get protective about their work—"I didn't raise my boy to be a soldier"—would be professional suicide. What is bought and sold is still called culture.

The one new factor in twentieth-century art, the factor that exacerbates all other sources of difficulty and gives it its peculiar tone, is the death of the audience and the birth of the public. In a society that repudiates the idea of a cultural elite (however much it may be tolerated in practice) the artist faces a nasty dilemma: either he works for everybody or he works for himself and his buddies. Once upon a time there was court art and popular art; once there was high art and not-so-high art, depending on what you

painted; once there was fine art and applied art. Now, God help us, there is serious art (for professionals) and commercial art, for everyone else.

For economic and social reasons, this dilemma has reached its height in America, but its principle can be traced back to the Dadaists. It was they who polarized the situation into moral confrontation where a group of artists—US—address themselves directly to an uncomprehending bunch of squares called THEM, bringing the news that art is dead. This implied that insofar as art is alive at all it is a direct, spontaneous, personal encounter that converts THEM into one of US. (If it seems too silly to think of somebody being dragged across the artistic gap by sheer physical force, you haven't been to any Happenings lately.)

It is because we are still facing the same unsolved esthetic problems of getting art, artists and audiences into some sort of tolerable relationship that our contemporary art is so embarrassingly like European art of 40 years ago. The rapid proliferation of styles, their game or puzzle quality, the artist's willingness to play the role of entertainer—this whole constellation has appeared before. Many observers have recognized the phenomenon, but in unnecessarily limited form—they see American art as a rerun of modern European styles. It is more than that, but unfortunately the difficult and pressing questions of what art is about has been answered by making art history the subject of art—an idiotic idea that preserves the autonomy of art at the cost of leaving every other problems unsolved and unsolvable.

Form or style simply cannot function as the subject of a painting, just as nobody can talk in Technicolor. "Colorful" language is a metaphor, and art can be the subject of art only in the same metaphoric way. Visual experience is traditionally the artist's starting point. An artist can take an image as the "inspiration" or occasion of a painting, as Gorky took an old photo of his mother or Picasso used Delacroix's *Women of Algiers*. But the subject of Gorky's painting is a woman with a boy, not the photographic image, and the subject of the Picasso series is three women (or four or five), not the Delacroix or art history.

So much seems obvious, but even this simple an assertion can't be made without one's realizing that "content" has something to do with subject matter, and that you can't disentangle one puzzling element in the artistic situation without having another pop out like a Kleenex. Subject matter, content (meaning?), effect (emotional? artistic?) and value (human? formal?)—all these terms are folded into each other in terribly confusing ways.

The general public is profoundly uninterested in esthetics. So are most artists. Everyone proceeds on the basis of feelings too vague to be tested, almost too vague for language. The feeling of the artist for art is hope, the feeling of the audience is based on nostalgia. On the other hand, our sense

of what art *should* do is emotionally quite precise. Great art is something that makes you glad to be alive and proud of being human. It leaves you feeling sold on the human condition. And the American public rightly suspects that modern artists aren't even trying to make anybody feel like that. In fact, the dominant characteristic of recent American art seems to be a retreat from salesmanship of any kind. No messages. No exaltation of anything in particular.

Whether we think of Op, Pop or Primary Structures, "advanced" American artists have been producing work that is curiously neutral to a moral effect. This "neutrality" reflects the artists' refusal to engage us in judgments of social value: a refusal to assume the posture of celebration or denigration, sometimes interpreted as irony. With or without subject matter, with or without severe limitations of artistic means, with or without using conventional materials, artists have stopped sending messages. What the viewer feels as emotional deprivation is art's withdrawal from occasions for love or hate. Even the work that most clearly invites involvement produces experiences that are anti-cathartic, morally ambivalent. Trivial and ambiguous subject matter eliminates from consideration the transcendent forms of fear and desire—horror and hope. Only in their most immediate physical aspects, as revulsion (usually in relation to food) or as eroticism, do fear and desire enter the pre-social world of contemporary art.

With an increasingly clear recognition of its direction, art does not issue invitations to join in approval or disapproval. This art absolutely evades polemics—you can't be for or against Campbell's soups. It seems possible to say that the whole range of contemporary art aims at being, in a moral sense, value-free. Thus it lacks one kind of human significance.

In the encounter between art and the mass audience it is precisely human significance that is at issue. Those who clamor for it are seldom aware of how narrow a range of feelings and ideas they consider appropriate to art. Because the term is so vague, the rigidity of their idea of what can be humanly significant escapes their notice. Nor do they recognize the extent to which they impose this decorum on the art of the past. In fact, artistic yearning becomes a kind of spiritual itch that good art scratches.

Serious artists are likely to see art that scratches the public where it itches as commercial art, regardless of its style or genre. Many jazz musicians consider Rock 'n Roll degrading and will play it only under economic pressure. Yet until recently, few serious artists abandoned the demand for art with feeling. It was abandoned, I think, as a part of the attempt to protect serious art from the encroachment of the market.

What makes serious art serious?

It is not the proficiency of the artist. There are commercial artists who can solve artistic problems with enormous elegance and inventiveness. A clumsy life drawing does not become commercial art because it is clumsy.

Is it the absence of a market? Many artists would say so. Yet when a successful serious artist can sell his future production—not a rare phenomenon—the buyer feels he is contracting for a known quantity, exactly as the advertising agency buys the skill of a layout man. Whether or not the artist feels certain of his artistic aims and capacities, he may find that he has a market for a characteristic product, a personal style. Is he then a commercial artist or not?

At this point the artist can give evidence of integrity only by withdrawing as far as possible from a personal style. Only by denying that his feeling are relevant to the work at all can he protect his claim to be making something objective, to being personally not for sale. The retreat from commercial art and its implications of moral impurity is transformed into a goal: art without feeling. But can the artist's claim to seriousness rest on his refusal to put his feelings on the market?

Face to face with the public expectation of meaning and feeling, artists can do three things. They can attempt to meet the demand; they can reject it but engage with it, revealing it as false or impossible, or they can ignore it and retreat into professionalism. While most artists working with Pop and Happenings take the second course, the Primary Structure sculptors and some of the shaped canvas people embrace technical professionalisms. In fact, they formulate their position in an unprecedentedly radical way. These artists reject any social interpretation of their activity. No self-expression, no guideposts for our time, no Malrauxian triumph of the creative spirit. Also, no reason, no composition, no feeling. The artist comes on as the dedicated craftsman: "I don't mean nothin', I just work here." What he makes, characteristically, is the art-object.

The art-object is unmistakably non-referential, so abstract that it is more reasonable to ask "What is it?" than "What's it like?" The answers are at once exact and maddeningly unenlightening: a box, a set of boxes, a cross-section of a triangle—in every case, a regular geometrical shape or sequence of shapes, a set of unstressed architectural relationships. It is formally intelligible at a glance—except for the unanswerable questions of existence: why *here, now, this size, this color, this* shape? Since the work has all the deliberate clarity of a demonstration, it seems natural to look for a problem. But the art-object is not talkative. In the no-man's-land between attraction and repulsion, boredom is not an unacceptable response. We can agree that here involvement is irrelevant and interpretation is absurd. Take it or leave it. The art-object just IS.

Is this a valid esthetic? Does it make sense in relation to the art? Does it make sense in relation to the perceiver?

The theory of the neutralized object does seem to fit the work. Most of it is not interesting. It usually sits in a very self-contained way, and, like a hum or an electronic sound, does not call forth any impulse to dialogue. It suppresses human reference. Sleek and unmodulated surfaces rebuff tactile responses. Pieces that float or are suspended from walls or ceilings often function as directional notations rather than bodies. Shells or grids hold disembodied volumes. Closed, static and regular forms are assembled "non-relationally"—that is, they are distributed with a sort of regular dispersal that neither asserts nor denies tension between the parts. Yet while this work precludes assimilation to personal situations, it encourages associations to science and intelligence. It looks mathematical, pure and, on a large scale, faintly oppressive. It does not and cannot remain completely neutral.

There is no object so relentlessly, transcendentally esthetic that it can escape cultural absorption. Artists who are deliberately trying to make work that loosens or evades the observer's associational hold on art find their intentions blocked by the habits of art lovers. Sometimes the artists accuse the critics of subversion.

It is true that criticism surrounds the work with interpretations that link it back to the public world. The artist may carefully leave meaning and feeling out; the critics will relentlessly put them back in. Indeed, the critic often sees his job as lying precisely there, in bridging the gap between the work and the life of its beholders. It is not an implausible view of his role. No matter how innocuous and silent the work might be, the conscientious critic rejects his impulse to take the Fifth. Bent on responding, he finds something to respond to. So the purified art-object, organized to sit as quietly as possible inside itself, is interpreted as if it were an emblem loaded with campaign buttons, directives, meanings: Withdrawal! Cleanliness! Mystery! Anti-art!

Criticism is inevitably a remoralization of the object. In this it absolutely reflects anybody's experience of art. No matter how it is "neutralized," the observer interested in knowledge will turn art into a metaphysical riddle, seekers after wisdom will find sermons, culture-mongers will find history and, for those of a literal turn of mind, meaningless sculpture becomes decoration and architectural detail. Removed from determinate function, standing ambiguously between toy and tool, the sterilized art-object is a pseudo-object. Like the pseudo-event, it becomes an occasion for the rehearsal of habitual responses.

The un-art object is a myth. Art cannot escape the category of art by calling itself nothing with a capital N; it can only be meaningless the way a

Rorschach blot is, by courting ambiguity. Art is a mixed bag, full of dead gods, old pots, and devalued coins, stuff that has fallen in by disuse. But the art-object is carefully aimed to hit the exact center. An artist does not make magic cages for invisible animals or non-cages for nothing. He makes art for us. Can we not set aside the celebration of fake mysteries and admit that, despite ourselves, by refusing worldly allegiances we have returned to Beauty? That fatal, sexless queen?

This beauty isn't the usual sort of love goddess, but more the spiritual type. Isn't it the Puritan beauty that identifies herself with moral purity? In the usual Puritan fashion, this purity is based on the refusal of intimacy, a denial of social involvement. It is the beauty of the sealed box, of the intact virgin. It ought not to be so unrecognizable—withdrawal and passivity in face of society is the hippy scene, the IN attitude. But in fact we have not seen this face of Beauty in a thousand years. For the visible isolation of inviolable privacy we must go back to the late Roman emperors. Eyeless as Little Orphan Annie, they are the next-to-the-last avatar of our blind inwardness.

The reemergence of beauty in contemporary art was completely unexpected. It was even more surprising that beauty appeared in just that work which was called faceless, anonymous and neutral. The epithets were descriptively accurate. They were precise, too, in reproducing the tone of disenchantment and deprivation with which the style was first greeted.

Now, with time and professional success, the same work generates enthusiasm. Its beauty is acknowledged and its austerity seems to take on dignity and charm. Yet the importance this work can have depends on its resistance to our avid affections. It aims at rejecting familiar emotional responses, and it claims to operate esthetically at a new distance. Hair shirts cannot become chic without losing a certain amount of hairiness. Can the sculptors of primary structure remain indigestible long enough to establish their esthetic? Tune in next season and find out.

Art News, December 1968

Léger Now

*Two exhibitions, of oils at Perls and drawings and watercolors at Saidenberg,
suggest that of all the big Paris stars, he is the most relevant today.*

Who are our contemporaries? The question is fundamentally a political
one. Our social environment includes bodies in all stages of historical devel-
opment: fetuses, disintegrating debris, inert material—and our
contemporaries, those who stand in more or less the same relationship to
the world that we do. To name one's contemporaries is to decide what issues
and involvements seem to us immediate and urgent. Our contemporaries
are those who address themselves to whatever we experience as our present
condition.

I wish to claim Léger as a contemporary, and I don't think that discus-
sions of art history, Cubism, influences, etc. can offer anything in
substantiation of that claim. Practically speaking, both the future and the
past are constructed out of the present moment. The first question is
"Where are we?" All the rest is literature.

For me, Léger was a piece of art history for a very long time. Being a
respectful sort by nature, I was dutifully and distastefully looking at *Big Julie*
one afternoon at the Museum of Modern Art when it suddenly struck me
that the butterfly alone weighs a good five pounds. This amused me; I
smiled; Big Julie remained glum. I saw the goddess as a dumb broad, and
Léger became my contemporary. Or, more precisely, I became his. Because
Léger, with his disinterest in expression and fluidity, his hardheaded con-
tempt for charm and fingertip sensuality, had been way ahead of me.

There are other people I know who switched on to Léger in the same
abrupt way after a long period of accepting him as part of museum furnish-
ings. We were all misled, I think, by the very grounds on which his

modernity had been offered, by his preoccupation with the machine. Yet it is in those pictures where Léger is most blatantly involved with the romance of the machine that he now looks most dated (which is not to say that those paintings are artistically his least successful). What is contemporary in Léger is his psychological detachment—the "inexpressiveness"—and his complementary engagement with the physical. We can recognize both of these attitudes as our own. What is less familiar to us is Léger's progressive detachment from technology, and here, I believe, he precedes us, because a lot of artists are still hung up on technology as a way of being modern. But what is involved in being modern? Objectively speaking, there is no reason why an automated factory cannot be built to produce plastic horse-collars—which is to say that the most advanced methods and materials can be used to turn out a product that is itself anachronistic. Indeed, such lapses in contemporary relevance are all too common, both inside and outside the modern art world.

However, the relevance of physicality to contemporary art is a proposition that needs careful explaining if it is not to remain uselessly vague. In the context of Léger's work it has nothing to do with materials or the ultimately physical nature of the art object. It has nothing to do with the machines, but it does have something—not much—to do with subject matter. Subject matter is at best a crude indication of an artist's interests, and in Léger's case it would be easy to conclude too much from his iconographic palette of women, workers, plants and domestic objects. Despite his old-left politics, I don't think Léger painted the things he did because he wanted to "say" anything about them, but because he liked them. Their value was simply that he found them real, authentic, and for him that was the same thing as being heroic. Strictly speaking, his clouds and tin cans, hand-painted ties and the Mona Lisa were all real, all equally noble and equally ignoble. This is a violently democratic idea, but certainly not a common or popular one. Léger himself insisted that he approached *all* his subjects as objects. When someone pointed out that the smiling circus artists in the *Big Parade* were violating his "no expression" canon, he protested. "For performers," he said, "a smile is not an expression, it's part of the job."

Léger saw the painter's job, his *métier*, in secular but traditional terms. The artist makes pictures of life, and life is whatever is truly modern and real. But "modern" and "real" are not categories but qualifiers. Léger's words don't tell us much. To find out what he meant we must go to the work. He was always a figurative artist, even when the "figures" are completely abstract. His forms are always articulated in relation to a ground. In the late work they are even more regularly referential than they were during the early periods.

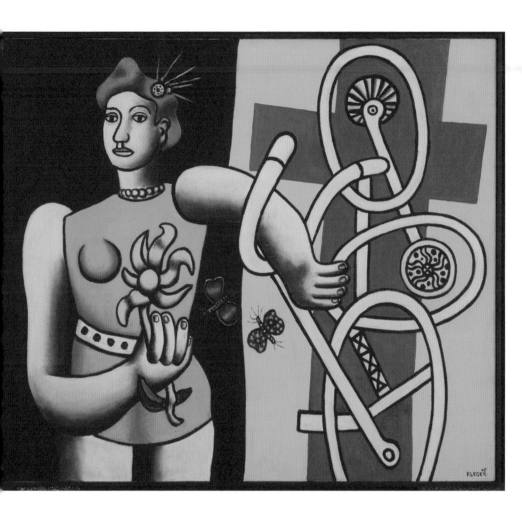

Fernand Léger, (1881–1955) © ARS, NY
Big Julie. 1945. Oil on canvas, 44 x 50 1/8 in. (111.8 x 127.3 cm).
Acquired through the Lillie P. Bliss Bequest. The Museum of Modern Art, New York, NY, U.S.A.
Photo credit: Digital Image © The Museum of Modern Art/Licensed by SCALA / Art Resource, NY

Yet it is a peculiar relationship to subject matter that ends up treating all subjects impartially, and a peculiar sort of reality that sounds a single emotional note regardless of what is painted. Mondrian, with his various rhythms, is less monotonous in feeling than Léger. In their own way, Léger's productions are as abstract and formalized as soap opera. He himself seemed unaware of his abstractness. His expectations of his "new realism" were touchingly naïve. When the *Construction Workers* was finished Léger had it mounted on the wall of the canteen in the Renault factory and sat anonymously at a table waiting for the workers' response. When the men laughed and said that nobody could work with hands like that he was disappointed. So much for the myth of Léger, robust son of a robust people.

Yet we stubbornly feel that somehow the myth is true. Compared to Picasso, Braque, and Matisse, Léger is not an also-ran, but somehow more radically "modern" than they, and uniquely close to "reality." The grounds for this feeling must lie in the work, more particularly in its use of form. Form is the technology of the artist, and the artist can no more deal directly with life, by passing artistic problems, than a financier can bypass commodities and deal purely with money.

For Léger, the ineradicable core of reality and objecthood was, quite simply, massiveness. Spiritual presence or emotional impact is interpreted, with startling directness, as physical density and volume. Thus the leaves that look like hamburgers, the plasticene clouds, the smoke rings as palpable as balloons. "Life is hard and heavy," said Léger.

Which is how he painted it. For him, reality was not an objective, quasi-scientific phenomenon, but the pressure of experience. All sensations have the impact of weight. But once we have seen the force, the obviousness and the downright banality of his central metaphor, the work of criticism remains to be done. Because, after all, how did he manage it? A direct visceral appeal somehow transforms having a body into something the spectator *shares* with the image, so that seeing the picture creates a situation that entails and bestows solidity, an immediate experience of endurance and energy.

Moreover, oddly central to the physicality of this art is its humorousness. There is definitely something comical in Léger, something dopey, a highly physical, utterly non-verbal *wit*, totally unlike the boulevardier humor of Klee or Grosz, with its overtones of the gallows. It is closer to the sexual humor of Miro or Oldenburg, but deeper, at once more physical and more abstract than that. You can see the same sort of thing in the choreography of Yvonne Rainer. As if there were something comical about having a body altogether. Or as if some sort of exuberance pops up when physical energy is freed from psychological conditions. Léger's forms strike us as holding

up under pressure—is it the hidden assurance of the indestructibility of the body that delights us?

Having come to no conclusions about that, I want to let it lie there, and return to the surer ground of Léger's pictorial form. There are artistic difficulties implicit in Léger's insistence on the presence of volume since it does not allow the same sort of pictorial construction that elsewhere grew out of Cubism. Pictorial volume directly threatens the integrity of the picture plane, and in general modern art has tended to preserve the plane above all. The business of making pictures is interpreted as a matter of energizing the surface without breaking it or getting visibly fussy, and plasticity has been reassigned to sculpture and architecture. Artistic energy itself is seen as leaning on the intuition of movement rather than the mass. Moreover, in modern art, movement is understood to be a linear force, not an expansive one. Movement in our time is directional thrust, expressed either as painterly gesture or as the axis of primary or sequential forms in sculpture. The artistic experience of mass has all but disappeared. In exchange we are offered gigantic size, an eviscerated monumentality that corresponds to the contemporary idea of power.

In classical Western painting, the problem of distributing mass throughout the picture became the problem of balance, and the "logical" distribution of weight required every pictorial element to be supported by another, so that everything balanced out and rested ultimately on the ground plane. The force of gravity was always visible, and the architecture of pictorial forms was seen as a strict analogue of the architecture of real weight and mass. Modern art has dispensed with all that, throwing the idea of pictorial structure up for grabs. We no longer know what it is, except that it seems to have something to do with the picture plane.

Léger, however, was French enough to assume that the classical principles of pictorial structure were eternal. Consequently he proceeded to solve a very modern problem—reconciling the distribution of visual mass with the design requirements of the picture plane—in a thoroughly straightforward and satisfactory way. Indications of mass and plane are interlaced and amalgamated, always in a strict parallel to the picture plane, in such a way as to give every pictorial development (across the surface or into space) its counter-indication. Tying everything together is an outline that alternates between being the edge of a flat shape and the contour of a form, with a few side excursions into pure arabesque or pattern.

If we compare the study and the final version of the 1930 *Composition with a Top* we have a remarkably clear demonstration of the sources of Léger's artistic power, because the two are so very close and the final version is so very much the better picture. Our first impression is that the final ver-

sion is more spacious and less crowded than the study. In fact there is a small difference in the proportions of the two formats. The large canvas is slightly narrower, but has a pervasive sense of increased breadth and looseness. All of Léger's modifications here serve to counteract the vertical gravitational pull of the study without lightening the massiveness of the component forms. In both versions the heaviest element is the tall black silhouette just left of center. The major changes are those which modify the weight of this form. Taking out the line in the white below it strengthened the hook-shape so that it came forwards to cradle and contain the black, and stepping the bottom left contour of the black form sets the top into a clearly foremost and dominant position.

Most of Léger's usual construction devices are clearly visible here: the alternation of straight line and curve, the reversals of position among overlapping forms, a single color appearing now in front, now behind. The palette is very limited, keyed to the intensity of black and white. Léger avoids vibrancy—complementaries are rarely juxtaposed—and if the colors were not constantly shifting position, moving ahead and behind, they would be monotonous. See how much the mobility of the big yellow shape at the right is increased by the little white footprint that has been slipped behind its right edge. Freed from an unbroken supporting plane, the yellow begins to ripple like its white counterpart on the left.

All this back-and-forth business is going on at right angles to the surface—a third dimensional dynamic that does not disturb the lateral stability of the image. That is still locked to the format and the picture plane by the repetition of horizontals and verticals parallel to the edges of the canvas. Léger seems to spend half his time building protective frames around his forms (the head encircled by an arm is a very characteristic gesture) and half the time slamming a new color or shape in front of them. The middle of the picture plane acts as a center of energy, countervailing the force of gravity and drawing the major shapes around it while secondary and small-scale forms tend to break away. When the complex forces at work are insufficiently articulated and separated the scheme doesn't come off. A nasty clot of suspended fragments, like a bunch of octopuses locked in a death-struggle, seems to be floating by.

Around 1940 Léger began to experiment with new ways of opening up pictorial space. *The Construction Workers* and some of the late still-lifes use a centrifugal composition, with the forms dispersing outward from a central vertical axis. Even earlier Léger had at times dropped local color and tried to set up a fugue-like situation in which the line establishes one series of forms, color areas another. He kept trying to make this idea work until the end of his life. But Léger neither was nor wanted to be a facile artist, and a

control of color came especially hard to him. He couldn't put down a veil of anything—his palest yellow lies on the surface like a rug. Even if the brilliance of the white were not annihilated by the thick black lines of drawing, it could not support the density of his colors. Since the color and line don't reinforce each other, and since neither creates a satisfactory plastic situation in itself, these paintings end up by being structureless. Everything goes flat and dull—the wandering streams of black muddy the color without interrupting it.

On the other hand, when Léger dispensed with the white ground, his color became capable of playing a more powerful role than it ever had before. *The Young Indian* of 1944 is a beautifully realized painting, taut, brilliant, expansive and full of Léger's mysterious teasing humor. Here the articulation of space and form owes nothing to Cubism and almost everything to color. Everything is weighty, yet wholly sustained—you could float a battleship on that orange. How firmly but lightly the red Indian is poised within it! Notice the play between the real bird and the painted bird on the drum. Despite the modeling on the painted bird it stays flat within its plane, while the real bird is solid and free, held up by the strong colors that surround it. The antigravity factors in this painting are completely effective—all the most active forms point straight up while those directed downward decline slowly and obliquely. Here, too, Léger seems in unusually full control of his decorative elements. There is not the sudden shift in scale for details that for me often mars the earlier work.

Nowhere does Léger express any intention of making structural or formal innovations in art. His idea of the painter's *métier* was, as I said, traditional, and his excursions into film, mural painting and sculpture were not formally radical either. Léger is modern innocently and nonanalytically, by temperament, like Andy Warhol. And, like Warhol, the esthetic conventions he placidly accepts are as integral to his modern style as the violations of convention he instinctively introduces.

In stressing Léger's artistic emphasis on weight and physicality we face the challenge of justifying these things as values. The physical has never been considered an independent source of value—though indeed it has some history as a diabolic force, antithetical to spirit. There is no question of turning Léger into an advocate of physical fitness or some neo-Greek ideal of physical harmony. He has nothing to do with muscle-building. The importance of physicality in contemporary art lies in its implied insistence on the primacy of direct experience. Physicality emphasizes experience, not information, as the basis of human response. Information is symbolic, precise and decipherable. Experience is direct, physical and existential. For all of us, identity must begin in the body and be nourished by the senses if it

is to sustain the onslaught of modern technology. Moreover, our bodies have a unique and crucial relationship to history. In our bodies it is always her and now. Yet our bodies learn, they incorporate the past and carry it into the present in the form of scars and developed sensitivities.

Being clever seems to have left us so disoriented and confused that it might be sobering to connect with being just bodies for a while. This is what Léger gives us: the feeling of a purely physical existence. And it is a "feeling" more than a vision, because these paintings insist on plasticity: sensations of mass, fullness and tautness. Léger's bodies are specifically limited and located. At his best we experience firmness without rigidity, the kind of sexless, direct energy that elsewhere in our society is celebrated as a spiritual ideal. The flower children should recognize Léger's lurid blossoms, crazy but challengingly real. In gesture, Léger's plants are more violent than his people, but for Léger everything is a body and bodies aren't deathly, they don't commit suicide or murder. Art that stresses the physical aspect of existence presently seems hygienic to us, and the more visceral our response, the more likely we are to call art good. Which is why Léger is so satisfying now.

At his worst, Léger is simply awful. For Instance, the 1929 *Composition* manages to be thin without being buoyant and fussy without refinement. Always, because of the density of his forms, Léger runs the risk of clumsiness. He is always threatened by bloat and the muscle-bound cloddishness of a hung-over Mr. Clean. It's easy to fault Léger when he's bad, but it's a lot harder to account for his quality when he's good. What can you say of those ladies drinking tea, female deities as beautiful as cows? Léger's sensuality is so profound that Michelangelo seems petty: "He couldn't paint an arm without thinking about muscles!" So violent a celebrant of life that when he was asked for his ideas of how to decorate the city of Paris for a fête he wanted to paint the avenues different colors, all the façades on one boulevard yellow, on another blue, "…and Notre Dame in tricolor." Such a scheme, he explained in perfect seriousness, would help to guide tourists around the streets, and it could look great at night if you had helicopters overhead shooting down beams of light.

It would have been nice to see André Malraux's reaction to that!

Unpublished, 1968

Why I Think
Art Doesn't Concern Individuals
Or The Difference Between an Audience
and a Bunch of Individuals

We distinguish between a public and a private self. That is, everyone yields others the right to make some demands and refuses them the right to make others. I can ask you: Do you find this picture erotic? and feel I have a right to an answer. I think if I were to ask the virgins in the class, or those who have had a homosexual experience, to raise their hands I would not be entitled to an answer. Yet of course, the two questions are not unrelated, and having asked one it would not be illogical to ask the next. But it would be very rude. Out of politeness I assume that everyone in the classroom is an adult and has had a similar range of sexual experience. I am quite aware of the absurdity of this assumption.

Nevertheless, the convention of public discourse requires the assumption of common experience. It is taken for granted that if necessary you can and will fake membership in the group that is inferentially established.

In fact, every conversation establishes *some* implicit definition of what the speakers will find acceptable as the "self" relevant to the occasion. Who we are for each other, now, here—politeness requires the parties to recognize and sustain that social level, and rudeness is violating it. Thus, it is rude to treat your lover like a stranger in private.

The point I want to make about art is that every picture establishes itself at a specific social distance and makes sense at *that* distance. In fact, understanding or "appreciating" art precisely means being able to pick up on the work the way you pick up the other end of a conversation. It means to infer what the topic is and what kind of response or interest is appropriate. For instance, it is naïve to wonder what a symbolic or allegorical nude does for

a living—it is not appropriate to consider that in relation to Botticelli's *Birth of Venus*, say. Yet it is NOT naïve to consider in relation to a Courbet nude or Manet's *Olympia*. The dialogue initiated in each case is different, and the responsive viewer correspondingly brings another aspect of HIS self to the situation. That sort of adjustment is, in fact, exactly what the sophisticated viewer understands, just as the person who is socially sophisticated can pick up on the sort of manners a new group of people will find acceptable.

To specify, the difference between an audience and a group of individuals is this: To say that someone is an individual is to consider him apart from any particular social group. An individual, by definition, is a private person, one who has the right to refuse the claims of any group to his absolute membership. But in relation to art we are audiences—a relationship that is directly analogous to a social relationship. The work might address itself to very intimate feelings or very abstract ideas—but it always tries to bind the viewer to some distinct relationship. That is, after all, a condition of communication. (Being part of a system.)

By "distinct" I mean "specific". Though, it is very hard to specify the character of a relationship in words or to define the "rules" of decorum.

Art News, April 1968

Morris Louis:
Thinking the Unwordable

A series of late paintings by this leader of the Washington D.C. school of color painters are "utterly clear, lovely and mindless as a birdsong."

It is not necessary to work up an art-historical froth in order to enjoy the seven late (1961–62) Morris Louis paintings on view this month at the Emmerich Gallery. Louis was never a difficult artist. His paintings are not problematic. They're voluptuous and restrained and for making you happy. It helps if you are a little simple-minded. Art for tomorrow's tired business man. It says nothing. For these paintings, talk is irrelevant. Then why write about them? Because the critics have laid down a lot of conversations on Louis. I take no issue with his art, and I agree with the other critics in finding Louis valuable. But he is usually discussed in terms of the newness of his concepts and the radical innovations of his style. One of these ideas seems to me mistaken; others seem true but misleading. Fundamentally, I think Louis has been wronged by his critics. They hold arc-lamps and eclipse his light. It is not easy to do justice to Louis' gifts without overstating the case. He is an artist who projects a nameless something very purely and powerfully and directly. Something utterly common, nearly vulgar and rarefied—like Marilyn Monroe. He offers us beauty, which is no small thing but at the same time he remains somehow trivial, beside the point, even lost. These feelings hold true particularly for the horizontal stripe series completed in the year immediately preceding his death. They are the most beautiful and the easiest, most banal Louises I have ever seen.

Of course, a denial that these paintings are theoretically interesting will be read as a put-down. Ever since the days of Abstract-Expressionism, the

claim to artistic values has been accompanied by a cliff-hanging esthetic. Recent art theories suggest that good art is always an artistic adventure into the unknown. Nowadays art is art history or it is nothing. The critic plays lyricist to the painter's tune, and his esthetic theories are the words without which no songwriter can possibly survive. Yet, if Louis' late paintings can be said to raise any issue at all, it is the necessity of esthetics that they put into question. They seem to me as utterly clear, lovely and mindless as bird-song—and as difficult to evaluate. They are marvelous as far as they go, which is both all the way and not very far.

In earlier paintings Louis was more radical and more off-putting. In the two series known as *Veils* and *Unfurleds*, the vastness and vacuousness of the canvases can be dis-concerting. The more-than-Oriental splendor of his color, particularly in the *Florals* and some of the *Veils*, is sometimes so lush as to be embarrassing. None of these disturbing qualities is present here. In purging his work of its radicalism Louis reaches us with unequaled ease and unabated force.

If the focus of Louis' efforts and the major source of his artistic value lie in his formal inventiveness, it is certainly peculiar that at the end of his life he could, *without failing artistically,* simply discard many of his own innovations. But that is exactly what he did. He did it by a further simplification of his artistic problem, a simplification, moreover, that was complete before he brought paint and canvas together.

With two decisions Louis reduced the stress on color that conditioned his earlier work. The main decision was to preserve and even intensify the narrow format of the vertical stripe paintings that immediately preceded, but to turn the canvas sideways, so that its tenseness is radically reduced.

Morris Louis, *Partition*, 1962, Acrylic on canvas, 2597 x 445 mm © Tate, London 2010

These paintings are very wide—some are 10 feet from side to side—but most of them are extremely short, the tallest being only 32 inches from top to bottom. The amount of gravitational force exerted on a surface averaging around 20 inches in height is simply not very great. It's not hard to keep this little canvas buoyant

The second decision was to allow the unpainted canvas to surround the sequence of stripes on all four sides. For the first time his canvas has the over-all design of a printed page. Sometimes there is an additional zone of open canvas in the middle that seems to divide the page into two paragraphs.

Disengaged from the edge, Louis's bands are released from the gravitational field of the format. The directional thrust that dominated the vertical stripe series is eliminated. Holding on to nothing but each other, the stripes are no longer energized as a linear movement. Since they always appear in series and are never isolated on the surface, they evade being perceived as things with independent weight and individual contours. Softened at their boundaries and equalized in width, the bands create only the mildest sense of rhythmic interval. With the strongest possibilities of weight and movement closed off, the stripes can show life only within the range provided by the resonance or vibrancy of color. In terms of form they are almost completely inert. Neither completely free-floating nor locked into position, they sit on the surface with a kind of relaxed, genteel poise. All activity is given by color moving back and forth from the surface.

It is all very simple. The initial controls reduce Louis' problem to that of keeping the total amount of color vibration and density roughly equal to that of the white canvas. Overmastering the white, too much dazzle would

tend to make the stripes flip off the surface and frizzle electrically in front of it, in the fashion of Noland's recent stripes. Too little vibration, permitting the dominance of the canvas, would melt the sequence of stripes into a solid rectangular shape, thus establishing the old figure-ground relationship so distasteful to contemporary sensibility.

These outcomes set the limits of the problem. The discriminations that remain, all relating to color, are twofold: the balance between the color-filled area and that of the unpainted canvas, and the character of the sequence created by the blocks of colored bands. The relationship established between these two areas of decision is what gives each painting its individual quota of energy. Although the possibility of visual density is excluded by the style itself, Morris seems to me richest when, within these limits, he most energetically resists the tendency of his colors to chime and float. Thus *Number 45* seems to me a better painting than *Number 16*, with its over-easy mirroring of yellow and its wide top margin.

Given the problem of achieving pictorial definition while eliminating mass, it is interesting and, I think, characteristic of Louis that his solutions remain closer to figuration than to opticality. His preference for orchestrated, bright and shadowy color and his taste for a special slow, inhaling kind of movement are visible here as they are through most of his career. (One truncated fan-shape, differently defined, occurs in both the *Veils* and the *Unfurleds*.) The traditional elements of form and illumination are not so much eliminated or overleapt as they are carefully neutralized.

Unassertive as the height of his canvas is, Louis usually limits it still further by confining his color sequence into four, five and six bands each, interposing a zone of open canvas as a lift or rest. This zone is under no tension; there is no counterpoint or opposition established between the top and bottom units. Both celebrate a single color sequence opened by a short interval of silence. The most energetic contrasts are usually in the lower part, to keep the whole self-sustaining and to reduce pressure on the lower border. This decision was made posthumously; Louis marked off the shape of the stretched canvas without indicating top or bottom. There is independent evidence of his intention to exhibit these canvases horizontally. (A particularly nice examination of Louis' concerns can be made by comparing *Number 12* and *16*, which use the same colors in different positions.)

In only one picture, the largest and most magnificent of the show, does Louis hazard an unbroken sequence of eleven stripes. Against the risk of accumulating weight he gives us his least somber and most active color. The beginnings of articulated rhythm are to be found here, too, in two beats of cold red.

The heart of Louis' achievement is still color, although the drama of the *Unfurleds* and the hectic quality of the *Florals* are here equally remote. This color is definite without being chemical or startling or even particularly idiosyncratic. There is no sense of a programmatically limited palette, no feeling of a restricted range of clarity or hue. An unabashed acceptance of harmonic color—intermediate and transitional hues—is combined with sudden, "modern" juxtapositions of high intensity. As you watch, the bands seem to coalesce and then to separate again. Sometimes a near repetition will thrust the intermediate band forward into a stellar role, as the blues dramatize and flatter the red in *4–27*. Throughout the whole series color breathes with utter freedom. There is no sense of light calibrated independently of hue, no feeling that sheerness has been achieved by distorting the normal body of color or by giving the canvas a vampirish tendency to drain off its life. Now somber, now vivid, the color looks so *natural*, and works with so unforced and clear effectiveness that you have to force yourself to remember that paints don't inevitably do these things. They don't identify and position each other, not just by themselves.

It is primarily in relation to the color that the format makes sense. It is what gives the color both the monumentality of extension and the easy immediacy of people-sized paintings. (You can't call it intimacy, the scale is too broad. Besides, Louis' effects are not only sub-verbal, they are below the level of personality.) The format acts like an organ pedal for the stripes, sustaining and amplifying them. Since nothing whatever *happens* horizontally, there is no feeling of landscape or narrative. It is the vertical direction that is both active and most physically accessible, and we are naturally led to look, vertically, at a relatively small section of the total surface. The extraordinary length of the stripes is something to be felt rather than looked at; it slows down our perception of the color and gives a sense of a continual prodigal *presence*, generously beyond our need. Ultimately, the charge released by one of these paintings is that of a sustained chord, structured to focus a keynote.

For what feels so traditional about these paintings is not simply the clear, unforced resonance of a comfortable amount of color. Everything else, the supplementary stripes, the framing expanse of white canvas, the format, simply enriches and reinforces a special note, often a clear yellow. If colors were people these would be portraits. Not passport photos for identification purposes, not "A Day in the Life of," but classic, fully articulated portraits, in which social class, character and mood are all distinctly noted.

The response these canvases evoke is also traditional. By reducing his scale and increasing the density and intensity of his color, Louis encourages us to assume the familiar attitude of esthetic contemplation. We are relieved

of the necessity of peering at the physical surface to find out where the color went. Nor are we driven to seek a metaphysical basis for a picture whose size and indeterminacy challenge our ability to grasp it visually. Here amplitude and order finally match Louis' sensuousness. But the pictures are wholly relational.

They rely on balance rather than symmetry, and we no longer feel the pressure on a single factor typical of avant-garde art. We sense intuitively and correctly that the fullness of Louis' achievement is as much the result of dealing with conventional pictorial forces as it is the consequence of isolation and exploitation of a single formal means. Form has been carefully channeled to provide a serene experience of radiant color.

Not only are these pictures less radical than many of Louis' earlier paintings, they are less daring than even earlier work by Still, Newman and Rothko. Should the horizontal stripes therefore be considered lesser artistic accomplishments? Are they to be *forgiven* Louis, as a relaxation of his will to test or expand the possibilities of modernist style? Surely, to complain that these paintings are not *strenuously* beautiful seems graceless and childish, they so clearly disdain athleticism. And their beauty is obvious. It can be conceded by many who would refuse them the tribute of being interesting or the respect of calling them important. In this welter of evaluations how can we identify "quality"?

If I understand him correctly, Michael Fried claims that art is identical with "quality" which is identical with being modern, which is identical with being pregnant with futurity. (I make no attempts to reach Fried's stylistic pitch which repudiates the traditional resources of rhetoric to depend, amazingly and literally, on typography itself.) Moreover, modernist art is supposed to be independent of traditional pictorial structure. This proposition, at least, is limited enough to be questionable.

Like other modernists, including Stella, Louis makes his picture out of framing elements, internalized repetitions of the format. Stella's "deductions" are usually repetitions of the contour of the format set forth in regularly diminishing scale. In Louis' stripe paintings the major formal units are rectangular aggregates of stripes that repeat the format's shape and orientation. (*Not*, as Fried would have it, the "physical support itself." For all his insistence on the literal, Fried invariably forgets that three-dimensional things have as many shapes as they have aspects.)

Now, the use of framing elements to establish pictorial structure is not an unheard-of device. Early altarpieces, for example, used framing elements so, disguising them lightly with furniture or architecture to integrate them with the story. Since framing elements repeat the format's characteristics of line or shape within the surface, they inevitably support a sense of corre-

spondence or logical coherence between format and the image. When indications of traditional pictorial space and form are suppressed, so that the picture is treated as a spatially uniform, marked surface, this sense of coherence is sharply augmented.

It seems to me that this compositional principle has been the major constant of pictorial form in American painting after Pollock, beginning with Rauschenberg's lay-out type of arrangement and remaining crucial throughout the best of Op and Pop. Fried's modernist painters and their Abstract-Expressionist connection, Helen Frankenthaler, constitute a group chiefly because they focus on the problem of maintaining the openness and density of a surface so rarefied, so identified with the picture plane, that it can no longer support any energized form at all. The stylistic resources of modernist painting, based on framing elements and a delicate awareness of the space-and-body-defining properties of color, seem to be extremely limited. At its worst, when the color doesn't work, we get childish, coloring-book executions of mechanical design. At its best we get amazingly lovely, amazingly *simple* paintings like the Morris Louis canvases at Emmerich's. But the distance between the best and the worst has grown stiflingly narrow. If you don't like stripes you're dead.

Objectively speaking, modernist painting looks more like a cul-de-sac than a through street to the future. Yet, whether or not it does turn out to be a byway, it is indubitably Morris Louis' territory. It may be No Man's Land, but it's where Louis is home. He is uncanny in his ability to reach us, no hands. We are moved without being touched; sent, but not grabbed. These weightless, motionless paintings disarm and unman us without degrading us to fantasy or elevating us to spirituality. They are startlingly like acute experiences of nature, but a prelapsarian nature, having no relevance whatever to the modern human condition.

Louis' vision is odd and un-Blakean, bleached of death and prophecy. His artistic emphasis on stasis annihilates time, refusing us the active participation in process that we call joy. Are these paintings important? I have no idea.

Art News, November 1968

One Cheer for Expressionism

The hot passions of German Expressionism are seen as junctions of art, not Angst, in a show of works mostly new to the U.S.; at Spencer Samuels.

The exhibition of German Expressionism at Spencer Samuels contains what is probably the only painting extant whose subject is a cat in season. It's a good painting, too. There are also a lot of other Kirchners, some solid Noldes, including a couple of beautiful watercolors, a fine Schmidt-Rotluff, Pechsteins, Jawlenskys and Feiningers, plus a scattering of work by peripheral Expressionists like Hofer, Klee, Beckmann and others. Even though the exhibition is not set out in an art-historical, family-tree fashion, the implication of such a show is that the work in it constitutes some sort of a genetic unit. In the case of the German Expressionists, this claim is always troublesome. The extent to which the Blue Rider group can be considered Expressionist has often been questioned—it comes down to individual paintings. In this show I would tend to except most of the Jawlenskys, the Klee, the Beckmann—quite a few of them.

This sounds like a picky and academic matter—what difference does the pigeonhole make? Isn't it the artistic level of the work that counts? The point is that in Expressionist paintings traditional sins like garish color, crude drawing and skewed composition are quite acceptable. Beckmann's *Garden in Bayern,* for instance, which is a reasonably good painting in normal terms, is awfully boring Expressionism. It makes an exhibition such as this one more than usually problematic for a critic.

On the other hand, German Expressionist painting is marvelous for people who don't like art. It has the raw appeal of old-time Country-Western music before Country Western got drawn into the higher synthesis of integrated rock. As art it is very White, brutally sentimental, hysterical. Even at

its weakest, Expressionism has an emotional power that the viewer can reject, but not ignore. Often overlaid by fake primitivism, at its best something primitive does seep through the pretense that art is direct, emotional utterance.

It isn't. Of course. A scream is not a primitive form of language and a physical gesture is not a primitive form of line. As far as I'm concerned, Expressionist esthetics—theories about a special relationship between the artist, his materials and his audience—are pure Hollywood, the stuff of which coffee-table art books are made. The painter as yo-yo artist, sending SELF out to the end of the line and then retrieving it, miraculously loaded with transcendence, by a tricky flick of the wrist. The audience, sullen, yearning: "Sock it to me." The artist, eyes glazed with looking into the void, leaps, flinging his all—*will he make it?* If *he* makes it, we've made it. Orgasms all around. Happy, happy.

Almost everything that has been written about any Expressionist art uncritically accepts it as an illustration of Expressionist esthetics. It is the unchallenged consensus of opinion that these paintings express the personal feelings of the artist and that they reflect his emotional relationship to the world. As the story goes, Expressionist painting is pure content—formal devices as well as subject matter are read as the "natural" results of direct emotional impulse. The question of individual quality is seldom raised in relation to Expressionist art, since it does not seem to offer itself as an achievement, but as a message. When someone says, "I love you," it's rude to criticize his diction. Consequently, Expressionist techniques—the heavy disjunctive line; fully saturated, complementary color; deliberately clumsy draftsmanship; willfully incoherent spatial relationships—are not treated as the components of a style, but as the quasi-involuntary traces of emotion.

As pure argument, this formulation is silly. There is no objective reason at all to suppose that a zig-zag line must be drawn with more feeling than a curve, or that a full heart will reach for a lemon yellow faster than it will for yellow ocher. If Expressionist esthetics really depended on the existence of such "natural" laws of expression, Rauschenberg's mocking duplication of Abstract-Expressionist spontaneity would have scotched it. The strength of the theory comes from the art. If you think about the theory without looking at the paintings, it sounds idiotic. But set the theory against the paintings in a mental slide-lecture, and reason is stilled. (Somebody should do a study of slide-projected art history as the perfect form of brainwashing. If you can keep your head while all about you are participating in the ritual of the darkened room, receiving the meaning of art, you'll never make an art historian.)

Given the paintings, all swaying and steamy, the feelings are real. To suppose that the hot wind arising from them is the very breath of artistic creation seems unavoidable. Then, because the violence of these feelings makes them unrecognizable as your own, you embrace the inexhaustible honeypot aspect of Expressionist theory: the artist puts his feelings in, you take them out. At least the felt energy of Expressionist art seems somehow accounted for.

But in fact it's just as easy to derive Expressionist content from Expressionist form as it is to go in the opposite direction.

The most pervasive formal characteristic of German Expressionism—one which disappeared, incidentally, during the unfolding of American Abstract-Expressionism—is the repudiation of a consistent treatment of space and form. This is rather tricky, since an inconsistent handling of space is something you find in almost all bad painting, whether it's Expressionist or not. But Expressionist painting is lumpy when it's good, too. You get nodes of three-dimensional form appearing in a sea of gesture or atmosphere in Marc, in Kirchner, in Pechstein, in Kokoschka. Essential to the development of this formal characteristic is the fact that German Expressionism is figurative. A palpable body appears, not on the Renaissance stage or in a Baroque dance of mutually supportive forms, but set within a suggestive atmosphere that does not support visible weight. The result is a psychologically distressing vertigo easily and intuitively interpreted as a disproportion between a self and an environment. Even unpeopled landscapes suggest a world in which man cannot be secure or dominant. Compare the distinctly Expressionist pathos of the brooding Pechstein bather to the ordinary treatment of figure-in-landscape in Chinese art. There the disproportion is reversed, tiny pilgrims in the mountains are dwarfed by nature, but still assimilated to it formally. We are given one world. Pechstein's lady in her daring bathing suit is in a world that neither supports nor resists her weight—and one that gives her nothing to sit on. Kirchner's Mardersteig brothers have only the most precarious toe-hold on their mountain. It is largely the scale and continuity of gesture carrying figures and peaks in a single swoop that keep the brothers from falling right out of the painting. The same detachment of figure from ground, the same proliferation of inconsistent clues about the spatial relations of forms or masses, can be found in some abstract paintings—early Kandinsky or some of Gorky. A composite form of space-handling is not only characteristic of the German Expressionists, but of other artists who have been called "temperamentally Expressionist" as well.

I am thinking particularly of Tintoretto and his nervous white calligraphy—a line as disengaged as any of Kokoschka's. More specifically, of

Tintoretto's habit of shooting back into deep space on one side of the canvas, with a sudden, violent shift of focus that is very like the explicit local telescoping you find in some of Kirchner's street scenes or in Munch. Think of *The Cry*, where it serves to explode the screaming figure out of a distant vortex. In fact, Expressionism generally seems to deal with distance and closeness rather than with anything as systematic as a consistent spatial framework. The emotional tension generated by the style seems to me fundamentally to be aroused and sustained by strong linear rhythms and plastic instability. A stress on paint texture and the suppression of figurative detail help to keep you moving and guard against focusing on areas of special psychological interest, like faces. The hands in a Kokoschka portrait, for instance, are usually actively gesturing, easily as "expressive" as the heads.

In Jawlensky's faces and still-lifes and in Nolde's heads and figures, absence of detail and the unusually, even oppressively, close focus are formally the main source of what is usually interpreted as emotional intensity and intimacy. The fact that this is an interpretation is usually obscured, because the habit of psychologizing perceived spatial relationships is so universal and deeply-rooted. The Esalen school's programmatic experiments with various qualities of body contact represent the only psychological institutionalization of this insight that I can think of, but painters and filmmakers have always used it, either deliberately or intuitively. By rejecting familiar schemes of pictorial space or combining different ones, the Expressionists encourage us to drop the whole notion of space as objective. Discarding objective space, we are led by inference to the suggestion of a subjective world and a subjective vision.

At the same time, the "personal" focus is reinforced by a multi-directional but regularized agitation of all pictorial forms. A continuity of figure and ground is established that diffuses movement throughout the picture while disengaging it from muscular or mechanical energy. This we read as *beseelte Natur,* "nature with a soul."

As for color, it never played the formal role in Germany that it did in France. Germany simply does not seem to support the same freedom for the detachment of formal values that France does. Only when tonal contrast is minimized can color emerge as an independent element, and this the Expressionists were never willing to do. No color symbolism has the absolute impact of light against darkness. The flourishing production of German graphic art during this period—especially in the most contrasty of mediums, woodcut—is evidence of Expressionism's attachment to the intensity of black and white.

The reason for Expressionist insistence on emotional immediacy as an artistic aim is not to be sought in personality or in esthetics. People tend to

look to art for the satisfaction of desires that are aroused but frustrated by the society around them. To this extent the theory of Expressionism that sees it as the artistic reflection of social instability may have some truth to it. But not *any* sort of social instability will do: it must be experienced as alienation, impotence and ideological uncertainty before the need for emotional contact is so pressing that it pervades that established rituals of art. At the same time the conventional forms of artistic production must be both strong and flexible—shaky?—enough to absorb and integrate large doses of emotional immediacy. The fact that both German Expressionism and German Dada disappeared into political activism suggests, among other things, that neither style provided a conception of art broad enough to hold the complex aspirations of its artists.

In suggesting that a composite form of space-handling is central to Expressionist style, I am taking issue with the awesomely distinguished gathering of art historians and literary critics that convened in Florence in 1964 to study various artistic manifestations of Expressionism. At the final meeting, the International Congress on Expressionism "… congratulated itself … on not having produced a 'definition' of Expressionism, i.e., a dead and formal letter, but on having agreed upon the acknowledgment of the fact that the Expressionist trend has renewed itself and created a novel fascination for practically all the arts of the present, so that, rather than to speak of the heritage one could speak of the permanence of Expressionism as an artistic, human, and even moral factor."

Only in the arts can you find people congratulating themselves on their failures. It is comforting to know that the charms of anarchy will never be forgotten as long as art is alive. The substitution of a half-baked esthetic for a unified conception of a specific Expressionist style, however, insists upon some of the peculiar virtues of Expressionism. Expressionism is affirmed as an instance of the recurrent artistic revolt against the institutionalization of art. The protest is not necessarily directed against public institutionalization alone. Expressionism takes issue with the inevitable formalization of art itself. It objects to the way art that grows out of high and firmly held convictions turns into *mere* art, something addressed only to the eye and independent of commitment. Yet, like all artistic repudiations of form, Expressionism is not simply a cluster of revolutionary, anti-art intentions, but is itself a style. To the extent that it is an artistic expression it succeeds in establishing its own vocabulary of form. If Funk Art proves capable of development it will do the same thing. The importance of the Expressionist insistence on the relevance of heart and spleen to art is not that they said it, but that they developed an art to do it. It is the foolishness of the critics and

historians that locates this insistence in the personalities of the artists instead of finding it in the structure of the work.

We see the instability of Expressionist painting, we see images falling out of the frame or jammed into a format that feels uncomfortably restricting and we react like tailors forgiving reformers for wearing ill-fitting clothes. "Their hearts are pure," we say, "they are not interested in composition, not interested in form." But these failures, slippages, incoherences are exactly what Expressionist work is about, they are what carries its message of the incommensurability of means and ends.

It is not hard to make comfortable, well-tailored, "serious" pictures, and God knows that it is easy to make strident, oversimplified, "emotional" ones, too. To accept Expressionism, these cosmetic heads, Harpo Marx in Byzantium, to accept all this melodrama of not wholly voluntary grotesqueness and primitivism as the expression of feeling, dismisses this work as art. Regarding the style as intention, and failing to discriminate its strengths and weaknesses, we refuse to acknowledge it as a volatile but unmistakable artistic accomplishment.

A Spring-Loaded Mind

by Max Kozloff

Amy Goldin insisted that art must convey import to viewers, whatever their states of readiness, even though the presence of meaning is certainly intangible, and she was no populist. She wrote clearly, too, despite the fact that she was a professional art critic. I think that the work she did in the 1960s through the 1970s drew its strength from its no nonsense attitude towards the clichés of its field, while she nevertheless contributed to its discourse and debate. Here was a writer who never dreamed of exerting "leadership", for all that her insights often have a feisty tone. It sprang out from her eagerness to explore neglected territories of artistic production whose relevance to certain tendencies in the contemporary scene she was the first writer to discuss. She opened an intellectual door to Islamic arts, public and "outsider" arts, and world decorative traditions, in the process affirming their dignity, which has grown. From our perspective, it would be fair to call her a premature multi-culturalist (a phrase she may have objected to.) Where the criticism of the period tended to be hierarchical and focused on personalities, hers was expansive, often concerned with craft output by practitioners unknown. She looked beyond technical issues to ethical principles, employing rigorous analysis all the way.

Just the same, what stands out at first reading is her talent for snappy, spring-loaded epigrams, which currently we would call "sound bites" (with emphasis on the second word.) About Harold Rosenberg's insistence that the true artist exalts his living but perishable inner life, to which the art object itself is subordinate, she recalls the ad in which the Green Giant says (of vegetables) "as soon as it's ripe, we freeze it." When extreme artistic austerity is acculturated and finds a market, she considers that "Hair shirts cannot become chic without losing a certain amount of hairiness."

These remarks may sound flippant but they are also the genuine expressions of a skeptic who knowingly comments upon fanciful activities, and

who wants, within reason, to give them their due. "Reason" is derived from a reckoning with our values, hopes, and actions, as conditioned by culture in a changing historical framework. In other words, a critic has to be curious about her society, and those of others where interesting art is produced, in order to make sense of the interaction between art and its viewers. She was aware that the deliberately unrewarding stances of some avant-garde artists might be pretentious, but admits that they can also be seductive. There runs through so many of her pages a fascinating dialogue about the ways we resist or yield consent to the willfulness of unfamiliar artistic programs. In addition to describing a visual transaction with the work, criticism needed to locate its social psychology. That is why she objected to Marshall McLuhan's technological determinism, which would account for the sway of consumerism in media, but was helpless to explain the perception of content in art. For all that you could aestheticize technique, you cannot reduce aesthetics to form.

When young critics entered their scene in the 1960s, they had to figure out where they stood in relation to some large questions. How should they react to previous traditions in American art criticism? What kind of language and method should they use? And what was artistic content, anyhow; how could words get at it? Amy Goldin was among the few of those critics who pursued a career without following or elevating a belief system. She worked mostly for *Arts* and *Art in America,* hospitable magazines that lacked a party line. In a journal of literary ideas, *New American Review,* Goldin contributed "Deep Art and Shallow Art," which should be considered a foundation piece offering her scheme for iconoclastic perspectives.

For example, "deep" (modern) art was traditionally perceived as an intellectual challenge, with which we have to struggle. Only by engagement with the struggle may we be rewarded by the rich and complex meaning the work has in store for us. Criticism analyzed such meaning by recourse to the idea that content could be ascribed to the achievement of difficult or radical **form.** "Shallow" art, on the contrary, had been defined as oversimplified, debased, formulaic, decorative—in a word, easy, and not worth serious analysis.

Goldin argues that these distinctions have only an invidious utilitarian value, and no psychological base, given the experience of people in cultures that are inherently dynamic. Who would disagree with her that the distinction between art and utility is not always fixed: "Our museums" she writes, "are full of things that became art after respectable careers as pots, illustrations or ornaments. 'Art' is not a physical category like 'plant life', it is a social construct … a part of the human work … artistic meaning is integrative and synthetic, a gathering together of ideas, sensations and attitudes

learned in non-artistic experiences." She even goes so far as to say that the less you're burdened by art historical shibboleths, the less you will be distracted by "irrelevant expectations." As for such contemporary phenomena as minimal art, "none of this stuff means anything."

If you think such a remark brands her as an aesthetic conservative, phobic about innovations, you would be mistaken. In *The New American Review* essay, she takes stock of the anti-heroic consciousness of '60s art and respects it, without being deferential. Artists did not so much reject contemporary subject matter as they withheld comment upon it. For viewers who needed to approve of "deep" art either because of the critique it offered or the pleasures it afforded, this impassivity was a slap in the face. Goldin thought such a belligerence was probably evidence of a cultural malaise. A mass industrial society is inhumane, for its emblems and processes discourage psychological involvement. Artists re-cycled such discouragement in galleries; they rather conspicuously repressed any potential for feeling. What she notices about this state of affairs is nevertheless very interesting.

The artistic refusal to suggest moral orientation sounds bad but it also corrects what was fallacious in the hierarchy of deep-shallow theory. If so-called deep art could be purposely shallow, than so-called shallow arts—often called applied arts—could be inadvertently significant. In the first case, the repudiation of a hand-made look reinforces the impersonality of focus; in the other case, impersonal processing broadens visual attention. However, traditional work in decorative ensembles is not self-effacing because the concept of an artistic self is not an issue.

This distinction leads us, via her brainy essay "The Aesthetic Ghetto: Some Thoughts about Public Art," to her important pieces: "Matisse and Decoration," and "Patterns, Grids and Painting." They stand out as position papers on a marginalized esthetic that is atmospheric rather than climactic, a visuality that may well have an emotional range yet lacks any regard for "ideas." What excites her about decorative patterns and grids might be misconstrued as negative discovery. "The subject matter of decoration is usually recognizable as an intellectual and visual cliché." "The decorative field has no intrinsic shape or position of its own. It is seen as directionless and centrifugal, its presence marked by specific density, texture and coloration." And yet, as she describes the particularities of these attributes in Matisse's work, she reviews how the artist manipulates something vital: the levers of visual pleasure. Much as Matisse was respected, that word "pleasure" was not a favorable epithet in 1970s criticism.

But here it justifies works that are celebratory and content-less, often realized in architectural scale. "Like a mosque" says Goldin, "Vence is primarily a decorative ensemble." The clergy who commissioned Matisse's

pagan display that masqueraded as Christian iconography was more responsive to the instinctual gratification of art than were Manhattan art critics. With ambitious or ritual decoration, those critics would have to switch their habit of concentrating on iconic nodes to scanning for a visual rule that is definitely un-centered and often flouted. Oddly enough, though related shifts of pattern in the same work leave "your mind alone," they also tease us with the hidden intelligence of their systems.

The fertility of camouflage in decorative arts motivated Goldin's close readings, based on first hand contact when she traveled to Afghanistan and Iran. Afterward, she bravely solicited criticism of her writing from the foremost expert on Islamic arts, Oleg Grabar, and won his approval. When a Western sensibility engages with Eastern visual culture, there were opportunities for error that she wanted to reduce. Following Amy Goldin's venture in such terrains, one is struck by her scrupulous—as well as dogged— mode of address, impelled by a connoisseur's eye for decorative rhythms. They envelop the viewer with pure sensation, even as they are directed away from narrative involvement. Clearly, as she often insisted, a detached view of such material was an appropriate one. She brought a comparably distanced oversight to bear on Conceptual Art or women's traditional arts, illuminating what was of value in them, without advocacy. Just the same, her critical body of work is passionate in its logic, which was largely ignored in its time, but is instructive and is not to be trifled with in ours. With this gathering of her essays, their author is finally afforded the place in history that she hugely deserves.

New American Review #4, 1969

Deep Art and Shallow Art

War is simpler than revolution. It is very tempting to believe that war is efficient, and that it really does offer final solutions. But does it? Suppose we decide to wipe out that insidious system whereby the green world diverts the power of the sun from human to vegetable purposes. Down with photosynthesis! In such a war, defoliation, chemical weaponry, fire, and sword will avail us nothing. As the last leaf withers, we may still wonder if we have eliminated the system of photosynthesis, or only leaves. All the men and material in the world can obliterate only bodies. Systems are hardier, including those systems of feeling, thought, and value that we call culture.

Whatever man makes of the world—mythology, art, science—any system of meaning he creates *is* culture. We traditionally approach meaning in terms of form and content, ignoring its systematic character. We treat cultural situations, from modern dance to urban renewal, as if they were physical situations that contained nonmaterial meanings—as if the leaves contained photosynthesis. This is a frame of mind that encourages schematic violence as a technique for engendering new cultural values. As long as we reach for meaning as if it came in form-and-content bits, the way letters come in envelopes, we preserve our stupidity and guarantee the inefficacy of culture. Culture is the human form of existence. An unusable culture condemns us to enduring life rather than living it, and we in America are the world's pioneers in the experience of humanly unusable culture.

The last world war stimulated technological and political developments that accelerated the tempo of cultural change. During the same period, new approaches to the problem of meaning arose in connection with developments in analytic philosophy, in Chomsky's linguistics, and in Levi-Strauss's cultural anthropology. The concept of meaning became more available to investigation, but for the most part, those gains have remained within the

special disciplines. The theories that have appeared to account for new situations owe almost nothing to recent work in philosophy or science.

At first glance this seems surprising. Most people assume that new ideas travel in a single direction, like water. We suppose that the fountainhead of thought is high culture, and that it flows downwards, picking up reality as it goes. Popular culture supposedly represents what is left of high culture after it has been brought down to earth, popularized, and debased. High culture is the good stuff, the crystal stream of theoretical knowledge and truth, while low culture is full of colorful oversimplifications. Middlebrow culture is supposed to be in the middle, closer to pure, clear thought in essence, but less precise and more concrete in expression. I doubt if this was ever wholly true; it is certainly not true today. Middlebrow theorizing is unlikely to borrow much from specialized investigations aside from rhetorical details. Their popularity depends on the delight of finding that what everybody knows can be used to explain what they don't know.

In a very dynamic society, however, what everybody knows is not uncommonly wrong. By the time everybody has learned something, new questions and new answers have superseded. Theoreticians are probably formulating the most pressing questions in other terms or in relation to other matters. By updating and extending popular assumptions, middlebrow culture often reinforces old-fashioned and false ideas. We cannot simply assume that theoretical elaboration represents intellectual growth or refinement. It may be flatly reactionary, inhibiting the spread of genuinely new ideas and making their acceptance more difficult.

At the same time that the form-and-content organization of meaning has been under scrutiny in literary criticism, philosophy, and the social sciences, popular theories have multiplied, based on the very assumptions that are so painfully being questioned elsewhere. Popular or middlebrow theories win power, like politicians, by being fundamentally banal, and they gain plausibility by being vague. McLuhan is a notable case in point. Although he uses the rhetoric of information theory, in which meaning *is* system-bound, he does not take into account the problem of noise—that is, the possibility of meaninglessness. So he is free to identify media with messages, and the forms of communication become "contents." McLuhan's is not the only recent cultural theory that struggles with the old form-and-content problem and ends by embracing it. Negritude or Negro culture is characterized by "soul," a formless content, and theories of modern art try to account for the significance of abstract form.

The difficulties of the form-and-content structure are notorious. They were obvious thirty years ago, when people hunted false dichotomies all over the place, the way we go after flying saucers today. Why does it persist?

Form-and-content is a beguiling explanatory device because it allows us to interpret appearances any way we like, attributing importance to them or withdrawing it as we please. We can assure ourselves of the permanence of something desired, like love or creativity, by saying that the form has changed but the content remains the same. Conversely, we can claim that something unwanted, such as anti-Semitism, is changing despite appearances, and that new attitudes are concealed by the persistence of rigid forms. The important thing to notice is that "content" in these theories cannot be inferred from material evidence and must always be intuited. Form-and-content acknowledges a theoretical complexity but allows us to act simplistically. If we divide a complex situation into an important aspect and a trivial one, we can neglect its complexity with perfect righteousness. And either form or content can be considered beside the point, according to taste.

Form-and-content is so shoddy a framework for thought that it is most often found in off-the-cuff, informal theorizing. In the arts, however, the form-and-content scheme is entrenched. Art theory has steadily stumped along on these twin pillars, holding beauty in the appropriate place, between them. Style is considered to be roughly equivalent to form, and subject matter to be the ultimate source of content. The meaning of a landscape, for example, might be summed up as "the artist's interpretation of nature." This is not a very satisfactory explanation, but the problem of accounting for pictorial meaning did not become acute until the advent of art without subject matter. In the past the confusions of traditional aesthetics were eased by the satisfactoriness of art. Today art itself looks meaningless. My fundamental argument is that what is difficult and problematic about modern art has little to do with style. It depends on the complex nature of artistic meaning itself.

|

Explanations of modern art usually proceed historically. Beginning with the Impressionists, art history is read as a series of revolutions, a quasi-Hegelian sequence of styles and theories that followed each other so rapidly that meaning got lost in the shuffle. There is a suggestion that each "historical factor" walks onstage, plays its part, and disappears into the wings. We get a narrative in which the decline of the French Academy is linked to social change, the Dada movement to moral protest, and the appearance of Cubism to abstraction. The present state of art is explained away as the outcome of social and cultural forces. Indeed, it no longer exists as an opaque

situation at all. It is hardly more than the accumulation of cultural debris left behind by the march of time.

Because many people continue to find contemporary art opaque, I propose to deal only with the present. Neither historical explanations nor persistent exposure to art is likely to reduce the frustration aroused by finding modern art meaningless. Some of that meaninglessness is built in. Unfamiliar kinds of meaning go unrecognized. However, regardless of the reasons for the experience of meaninglessness, the attendant cultural malaise is not trivial. Primitive societies define the human condition by locating themselves within and over against nature; more dynamic societies define themselves historically. To be old-fashioned is to be lost, a stranger in one's own time. Bombarded by the culture explosion, it is easy to be seized by a metaphysical nostalgia for feeling at home in one's own culture. Such nostalgia leaves one especially vulnerable to traditionalist theories that rationalize and harden alienation.

Beginning with the artistic situation at present, I shall begin, too, with a description of what I take to be common assumptions about that situation. Although popular culture has grown more respectable, most people still believe that art can be divided into its nearer and farther reaches; into deep art and shallow art, or high art and low. This division does not simply correspond to good art and bad, but represents different levels of artistic aspiration. We acknowledge that commercial posters or carpets can be judged artistically, as good or bad examples of their kind. It is in high art, "serious" painting and sculpture, that we expect meaning.

Low art, we feel, tends to be easy to take, decorative, and at times old-fashioned or conservative. We don't expect low art to mean much; it's shallow. High art, on the other hand, is supposed to mean a great deal. That's how it got so high, by having all those layers of meaning piled up on each other. It may be difficult to untangle the layers of meaning, but we imagine that its ultimate decipherability can be intuitively felt. The presence of meaning seems almost tangible, even though we can't say what it is.

The difficulty of modern art, whatever experimental complexities of form the artist has chosen to get involved in, is stubbornly approached as a problem in locating meaning. We "intuitively" set up a list that looks like this:

Deep Art	Shallow Art
meaningful	decorative
hard	easy
abstract	representational
radical	conservative

Having assumed that high art is meaningful, we expect certain personal and social consequences to follow. We expect to have to struggle to grasp that meaning. We expect to find ideas in art, we expect the art to have cultural importance, we expect high prices, critical attention—the whole bit falls into line. And in fact, the social trappings and the theoretical claims of high art have remained stable and recognizable. It seems as if the only thing that's changed is the art. Or, if the art is still high art and the artists are playing their "traditional" roles as cultural innovators, the elite audience has somehow become stuck, somewhere around Picasso's *Guernica*.

The trouble is that high art, nowadays, is not deep at all. It's shallow. To equip yourself with aqualungs and flippers to penetrate its depths of meaning becomes ludicrous. Yet people will not tell you that meaning has been displaced.

Why not? Because nobody is quite sure what's happened to it. Moreover, now that it seems to be gone, nobody remembers what it looked like. Cultural conservatives say it looked like subject matter and was consequently incompatible with abstract art. People who are culturally with-it say that meaning looked like artistic quality and it's still there, only you have to be terribly sensitive to recognize it because styles have changed so. The question of meaning in art has become a matter of faith, a dogma separating the believers from the unbelievers. The hostiles say that contemporary art is meaningless and empty; the defenders claim that art is still meaningful, and that nothing has changed but style.

WHAT IS MEANING? For most people, most of the time, meaning is something moral. It has to do with behavior. In daily life, meaning in the lexical, definitional sense of the term rarely becomes an issue. When it does, the "problem" of meaning can usually be cleared up quickly, and the issue is felt to be trivial. But when the verbal meaning is clear and we ask someone, "What do you mean by that?" we are asking him to clarify his intentions or his attitude, so that we can know if he is well- or ill-disposed toward something. If we ask of a theatrical performance or a piece of writing, "What does it really *mean*?"—we initially try to find whether the author wants us to respect the thesis or situation presented and find it worthy of serious attention, or whether we are supposed to laugh and repudiate or deplore it. It is the author's attitude toward his subject matter that we are trying to locate, so that we have a norm with which we can agree or disagree.

Whatever it may have experienced or felt, an audience deprived of moral orientation feels deprived of meaning. Uncertain of its own role in the artistic situation, the audience is likely to deny that it has felt anything, for lack of a position from which shades of feeling can be identified. Regardless of

the grounds offered for admiration or disapproval, people want to know what moral attitudes are aesthetically appropriate. An audience torn between approval and disapproval is an unhappy audience.

Abstract Expressionism was given an aura of approval when it was baptized "Action Painting." "Action," with its connotations of personal heroism and social significance, is clearly a Good Thing, so Abstract Expressionism became the latest member of a series of icons celebrating the identity of the Good, the True, and the Beautiful. Abstract art was saved for moral idealism. Almost as soon as the style was thoroughly accepted by the artistic establishment, however, it was abandoned by a new artistic generation.

The artists of Pop, Op, and Happenings, and the sculptors grouped around Minimal art *all* made gestures and verbal statements repudiating the idea of cultural heroism. Whatever their work looked like, the artists talked as if they had something against art. Anti-art statements from artists and writers, however, only make sense as a notice to the audience that the artists are shifting their artistic intentions. What intention could be expressed in such a range of styles?

The one element common to all recent art is the insistence that the audience's approval is irrelevant to the meaning of the work. This art wishes to disengage itself from appeals to strong, morally unconflicted emotion. It makes no appeal to feelings of human tenderness and admiration. Our habitual attempt to interpret art as a pleasant form of moral propaganda while enjoying and approving of our own feelings is deliberately flouted or evaded.

Those artists appear most up-to-date who, with greater or lesser steadfastness, refuse to participate in things that encourage public love. Stylistic developments allied to Pop—Funk art and various forms of theater—actively reject it by incorporating repulsive and scatological materials. Abstract sculpture and modernist painting withdraw from being lovable by insisting on an impersonal *look*, which is reinforced by a critical theory that makes it appropriate to react to those works as morally indeterminate objects.

Although Pop is presently not a widely used style, I wish to discuss it briefly because it uses subject matter, and uses it in a manner that neutralizes and complicates our emotional reactions to it. As soon as the element of emotional uncommittedness or complexity is lost and affectionate nostalgia is allowed to dominate, Pop shades off into Camp. Pop is most ambitious when it manages to preserve its bite. How does it do this?

By treating advertising, pornography, and news photos as artistic subject matter, Pop began as an in-joke at the expense of art's pretensions to spir-

itual elevation. Largely as a result of the genius of Claes Oldenburg and the intelligence of Rosenquist and Lichtenstein, Pop has been able to extend its range of reference while maintaining a precarious suspension of moral commitment. Reproducing the materials of the commercial world, it presents the businessman's Garden of Eden, the Good Life as deep feeling, fun, and gracious living without either affirming or denying the value of these things. Unharmonized color, weightlessness, and relatively broad scale help to keep the viewer at a public, nonintimate aesthetic distance. The style functions to separate the picture's meaning from that of its subject matter, the way quotation marks do in isolating the tone of jargon or colloquial expressions from the tone of the surrounding sentence. "Task Force Oregon announced that it had killed … 3300 enemy soldiers and 'detained' five thousand people." The inner quotation marks report a specific situation and call attention to the reporter's withdrawal from full acceptance of the official point of view—"They said it, I didn't"—while refraining from taking any direct issue with it. It's a neat trick, but difficult. Pop can sustain its ironical good humor and its consequent emotional complexity only by being extremely careful about keeping its subjects of reference highly charged while emphasizing its own formal cool. When this tension is lost, it can easily fall into Campy chic (Lichtenstein is particularly liable to this) or dramatic gesture (Oldenburg's midnight "burial" in Central park).

Contemporary abstract art is so thorough about repudiating human involvement that it looks like the result of industrial processes even when it's handmade. Canvases seem stained rather than painted, sculptural forms are bland and regular, and variations of surface and form are everywhere limited or suppressed.

Work in monumental size avoids "aggressiveness" or strong movement, suggesting the simultaneous assertion of the presence of power and the fact of its being sealed off, so that the viewer is left unthreatened. Other sculptural styles present the audience with unfocused sequences of industrially defined spaces or forms as "environments" "fields," or "progressions" which make a point of leaving the spectator disengaged from anything but a vaguely architectural situation. This work presents itself as pure artifact, unusable and inhuman, a sort of simplified maze in which you cannot lose yourself or a circular supply room with an entrance but no exit.

None of this stuff means anything. The artist's message to the viewer is: "I have no intention of charming you or frightening you. I don't intend to do anything to you. I just make things. What you see is what you see." Feelings of density, awareness of stasis or unfocused movement, the experience of unwilled, inorganic, but rational repetition—these are complexes of sensation that are not easily available to ordinary consciousness. Nor are they

feelings that are likely to strike us as being noteworthy or interesting, lacking as they do any special moral orientation. That is, they seem neither particularly desirable nor undesirable. Yet it cannot be denied that these feelings, now made available for the first time in art, seem to be particularly insistent in a mass industrial society. Our art forces us to acknowledge them and refuses to judge them. It also refuses us the commonplace humanistic reassurances, leaving us uncertain whether their absence is to be taken as warning, prophecy, or mere observation. Our art only says, "Notice it. Maybe it means something."

The artistic problem involved in making the repudiation of meaning and emotion explicit in Minimal art lies in the quasi-involuntary beauty of simple orderliness and smooth industrial finishes. In terms of artistic form, this work, which effaces itself as anything beyond a physical presence, cannot easily avoid being assimilated to architectural or interior decoration. The artists' denial of any extra-aesthetic intention does not succeed in creating a moral Switzerland for them to work in. They are still pitifully vulnerable to being loved *anyway*, and being accepted as purveyors of depth and beauty.

It is interesting to observe how difficult it is to formalize and develop a style that will evade implications of moral commitment. It seems as if the audience is determined to find art uplifting, no matter how strenuously artists try to discourage them. Be that as it may, the point remains that the evasion from passionate approval is sought, and that this evasion constitutes the deliberate "meaninglessness" of modern art.

II

I have insisted on the primacy of treating artistic meaning as a moral concept although the idea that the plastic arts carry moral connotations was generally banished from criticism a long time ago. It was revived only for special styles; the social protest art of the thirties and for the Existentialist message of Abstract Expressionism. In general, art criticism has tended to proceed as if the content or meaning of modern art was intellectual rather than moral.

I assure you that this idea is ludicrous. Intelligence is common, among artists as elsewhere, but original ideas of any sort are very rare indeed. There are few artists with original ideas, and those they have are likely to be bad. In this they resemble chemists, engineers, teachers, doctors and lawyers.

I suggest that ideas in art are, like beauty, to be found chiefly in the eye of the beholder. No matter how thoroughly abstract a picture is, critics can always be found to tell you what it's about. Pictures that are smudged or

airy-looking are often supposed to be about moods, feelings related to nature, or images of one or another state of the inner man. (Since nobody knows what the inner man looks like, who can deny it?) Abstract paintings with fewer and more decisive marks have recently been interpreted as being "about" art. Sometimes it's art materials or elements—what critics call the pure *fact* of paint, or of color, or of space. But more often it's style. The implication is that art history or aesthetics is somehow the work's implicit subject matter, and that if you don't know anything about those subjects you can't expect to understand the work. Assertions that abstract art is about anything, and particularly about abstractions like time, science, or Cubism, are nonsense—desperate attempts to preserve the old form-and-content structure of artistic meaning. Artistic meaning cannot be created by fiat. Even if the artist says that he wants his work to be interpreted in some particular way, his expressed intentions do not constitute a rule that establishes meaning.

The Formalist thesis that artistic meaning corresponds, at any particular moment, to the essential formal conventions of a given style is simply obscurantism. Formal conventions may be the focus of interest for a hard-working art critic, but he has no reason to suppose that the entire world of art is a gigantic conspiracy to provide him with professional puzzles. The suggestion that extensive study of aesthetics and art history is necessary in order to understand contemporary art is utterly false. Our art is so far from being a privileged message, a game intelligible only to highly trained players, that it is truer to say that the less you know about art the better. Irrelevant expectations of meaning will not distract you from the essentially simple-minded, sensuous pleasure to be derived from it. It even seems as if a high degree of literary culture can be positively inhibiting. Certainly some very refined and artistically well-educated people—Bernard Berenson, for one—have found themselves unable to tolerate modern art at all.

Before the end of the nineteenth century, it was possible to understand art without particularly concerning yourself with artistic ideas. On the other hand, in order to grasp an artist's meaning you usually did have to know what vices and virtues were considered important. Consequently you needed a rather firm grasp of Christian and pagan myths and symbols, but you knew where to look for artistic meaning. The same habits don't work for modern art. Today the range of experience relevant to art has shifted, and it is narrower, not wider than it used to be.

But if art today is so simple, and requires neither enthusiasm nor high intelligence, what is it that *seems* so difficult? We have to change our habits, and look for artistic meaning in new places. "Meaning" is here a lamentably imprecise term, but it lies close to "moral," at the intersection of the per-

sonal and the social, and it unites elements of thought and feeling. We would expect art to have something to do with these matters. The discussion that follows is primitive, but in a field as intricate as art, a firm hold on the obvious may be worth as much as ingenuity.

We are commonly liable to feel that anything unfamiliar and large is intellectually challenging. The most complex structures and phenomena, as long as they are familiar, seem easy. Nobody thinks of his monetary or kinship system as presenting intellectual difficulty; they seem natural. In fact, they *are* natural, in the same way that art is. They isolate and structure the pervasive social values, and we can scarcely conceive of "money" or "relatives" or "art" apart from the structures with which we are familiar. Ideas about art, however simple, are characteristically hard to grasp, abrasive, and indigestible.

The shift in art away from the traditional moral location of meaning is a major idea, one of the sort I described as very rare. Although it is an old idea by now, it has become commonplace without being thoroughly grasped. Nor have the appropriate revisions of art criticism or aesthetic theory been made. Meanwhile, most (not all) of the developments in painting and sculpture of the last eighty years or so have been statements, variations, and investigations of nonmoral artistic ideas.

Most artistic ideas are not the sort of things we usually call ideas at all. They are fragments or clots of feeling-about-something, intrinsically complex, like ordinary experience. It is because new artistic ideas *are* in part new feelings that we don't know what to do with them. They can interrupt old patterns of feeling and demand a place for themselves while we are still uncertain about whether we want them. A novelty or a commercial gimmick is always welcome, because it brings an air of freshness without disturbing anything. We are offered something that we can react to in a familiar way, with only the slightest shift of nuances. But now feelings, like new ideas, can disrupt the psychic economy.

A "new" feeling, of course, is not a heretofore unexperienced emotion. It is a new complex, a new feeling-about-something. If we are suddenly presented with the fact that we are reacting to A in a way that we had always supposed was appropriate only to B, we seem to get something we can call either a new feeling or a new idea. Suppose you suddenly found yourself feeling about a boy in a way you had always supposed you cold feel only in relation to girls. You can see that a new feeling in this sense could require at least as much psychic reorganization as a new idea of what the relationship between the sexes should be. Because new artistic ideas are feelings-about-something, they can be presented either with or without

familiar subject matter. Pop art offers an example for the first; Cubism an example of the second.

Artistic ideas are the particles of artistic meaning, and it is as difficult to define them outside the context of art as it is to define a word outside the context of language. A sound becomes a word by entering the mainstream of language usage in a regular and structured way. Artistic ideas enter the public world in the same manner, by becoming discriminable regularities in the experience of art.

The most blatant characteristic of art is the one it shares with language: both are structures of meaning. At this point, however, we must stop talking about meaning as if moral meanings were the only sort there are. Moreover, meaning is not a physical characteristic, like weight; understanding meaning is something people *do*. Similarly, art objects are not a special class of things. Our museums are full of things that became art after respectable careers as pots or illustrations or ornaments. "Art" is not a physical category like "plant life"; it is a social construct, like marriage or the church. Art is a part of culture, a part of the human work, and artistic meaning is integrative and synthetic, a gathering together of ideas, sensations, and attitudes initially learned in nonartistic experiences.

Art is also cheap, exactly as life itself is cheap. Art always means something, but it needn't mean much. Creativity is absurdly overrated nowadays—it's what is created that counts. In folk art, for example, meaning is usually so banal that we hardly notice it. Advertising is the folk art of industrial societies, and it is usually pretty dull, too. Because so many kinds of artistic meaning are repetitive and trivial, the pleasure we get from art, as opposed to any knowledge or profit, becomes very important. And because modern communication techniques make the repetition of sounds, images, and ideas ubiquitous, we are frenziedly grateful for variation and novelty.

At the same time, artistic meanings are extremely varied; the feelings and ideas art carries range from the picayune to the exalted. Therefore it is possible to conceive of art as a melting pot of the sacred and the profane, an alembic for the clarification and redefinition of what men consider important. Both rejection and celebration are necessary to this process; Pop art can be read as raising the fallen world. That is, the squalid, fragmented world of contemporary disorder becomes a part of the iconic, highly ordered structure of fine art, thus creating the possibility of a jollier, more unified existence.

THE IMPORTANCE of art lies in its effect on extra-artistic meaning, for it inevitably *has* effects, quite independently of whether it is high art or low, good art or bad. A work of art that satisfies us binds us to the world and, by

doing so, reinforces some of the society's established values. A work of art that repels us exacerbates our sense of social and personal incoherence and facilitates the dissolution of social conventions into new attitudes and new ways of appraising experience.

I would like to suggest that artistic meaning can best be understood as arising from three interacting levels of experience, *none of which ever occurs in isolation.* At any point in time we are physical, social, and moral beings, and although most of our experience calls on us to make a highly discriminated response, art stops us. It characteristically blots out extra-artistic discriminations and unifies experience into a closed, focused system.

For instance, a sudden loud noise is primarily a physical experience; our response is to jump and look around to see if we are in physical danger. An ordinary question addressed to us ("What time is it, please?") requires a social response: an answer offered in an appropriate language and manner. A problem or a confrontation can call for an act or a moral decision. If the question addressed to us is an indecent proposal, we have to decide whether to accept it, ignore it, walk away, or maybe call a cop.

The important thing to notice is the way these classes of experience nest into each other. The social implies the physical, the moral implies the social. The formal level of experience—the range of choices and behavior appropriate to a class of experience—can shift swiftly and easily, even though the physical components remain stable.

A work of art always addresses us in terms of sensuous, physical experience. This is the primary level of artistic form, the formal level of art, and it corresponds to the physical level of experience. All art sustains formal analysis, although confused or undeveloped methods of analysis can make such procedures trivial. Abstract art tends to stress this level of response.

A work of art also engages us on the level of conventional social communication: the level of genre. A genre defines the social function of art, and generic distinctions allow us to discriminate advertising art, political cartoons, or religious art as providing special, highly specific kinds of meaning. Religious, literary, and other sorts of social symbolism are established on this level. Sometimes a stable iconography developed in one genre spreads to others.

Any response more lively than flat indifference engages us morally. If we find a work attractive, we want to keep on looking; if we are repelled, we want to escape or attack it. The fact that art can spark behavior, sometimes in very direct ways, is probably the reason most people get interested in it. We first learn to respect art on the basis of its brute power to move us, to make us cry with pity, burn with indignation, squirm with concupiscence. Pornography, propaganda, and advertising—art that sets out to affect

behavior without stopping at "Go" to pay its respects to aesthetic values—have repeatedly been disowned as not belonging to the category of art at all. This is silly. It is merely a sign of the authoritarian temperament that would like to bind all power to the service of a selected slate of attitudes. The fact that art stimulates such sanctions and judgments is merely further evidence of its ability to engage us on this level of behavior.

The moral level of response includes more innocuous reactions: seeing a still life can make us decide to buy it or resolve to go home and bake a cherry pie. Art can also affect us as demanding an urgent, overt response, yet it is a mistake, I believe, to equate this vividness with the apogee of artistic power. Ultimately more far-reaching is the tendency of works of art to bind and coagulate feelings, values, and meaning, the tendency to become iconic, stabilizing our sense of what is ideally true, good, and beautiful. Most people assume that all artists want to move them morally above all, for this is the way in which they most want to be moved: vividly, emotionally, and in familiar directions.

Modern art rarely aims at this response. It focuses on the first level of experience, emphasizing body feelings of openness or closure, and avoiding, as far as possible, suggestions that any state is ideal or deplorable. This is likely to strike most people as surprising, indeed, barely intelligible as an artistic intention. (I think that the artists themselves have found it difficult to keep from idealizing and embellishing their work, turning boxes into icons of the private, inner-directed man. The unprofessional public is not alone in its habit of interpreting works of high art as microcosmic or macrocosmic emblems.) Perhaps we should see the will to make art that inhibits easy moral responses and tries to engage directly with "reality" as itself embodying a moral intention. It looks like one to me, a proto-ethic of a highly rationalistic sort that places great importance on not lying or overstating anything. The emotional austerity of Pop and Minimal styles tends to create a low-pressure experience for the audience at the opposite pole from appetite-oriented advertising. The moral suggestion lies in the implication that dispassion is valuable.

Probably the most serious question posed by the withdrawal of our best artists from a willingness to mean anything in the usual sense of artistic meaning is the problem of accounting for the prestige of high art, the respect it receives and demands. It is reverence for art that seems to be called into question when we have serious art that insists on fooling around and making jokes, the way some Pop does, or when, like Minimal sculpture, it solemnly renounces the status of art in favor of object-hood. Perhaps the fine arts are still "high" because they still imply the artist's impersonal seriousness, his attention to the implications and moral consequences of

attending to artistic meaning. Of course, this sort of seriousness doesn't necessarily produce great art. It can encourage an owlish solemnity that is hilarious to an unsympathetic audience—Neo-Classicism provides many examples. Moreover, we should not forget that the connection between moral or religious intentions and art of high formal coherence may simply be a sometimes thing, a matter of historical fact.

What does it mean to say that a picture is intelligible, or that we understand a work of art? We have been so sentimentally eager to "appreciate" art that the question has barely been raised. We have tried to settle for love, without regard to the complex transactions of meaning that actually take place in all experiences of art. If critics were less eager to see themselves as defenders of the cultural faith, they might have something useful to tell us. In this age of mass communication we are an audience longer and more thoroughly than we are citizens. The arts are charged with social power, and the Victorian assumption that culture is intrinsically polite is a twentieth-century joke.

Eleanor Antin. *Amy Goldin,* 1971. From the Portraits of 8 New York Women series.
Installation with cot, mattress, pillow, linens, blanket, earrings, lantern.
Photo credit: Zindman/Fremont
Courtesy Ronald Feldman Fine Arts, New York

Art in America, January/February 1975

The Post Perceptual Portrait

In 1970, in rooms in the Chelsea Hotel, Antin exhibited "conceptual portraits" of eight different women one of whom was Amy Goldin, a friend of Antin's. Each portrait consisted of a selection of objects from which the viewer could infer central characteristics of each woman's personality and achievement. To decode each portrait the viewer had to glean psychological evidence from the juxtaposed elements. The women depicted cover a broad range of the cultural spectrum: Naomi Dash, Margaret Mead, Rochelle Owens, Yvonne Rainer, Carolee Schneeman, Lynn Traiger and Hannah Weiner. In this portrait, we have the rare instance of a critic's critique: a portrait of that critic.—R.K.

Ostensibly, 'Eight New York Women' was to be a Woman's Lib sort of thing. Antin wrote that she was determined to "present women without pathos or helplessness, for once." ... her subjects were women who (according to Antin) had built life-styles independent of men. It seemed to me though, that the dominant note of the exhibition was not women with work but women without men. Almost every "portrait" projected implications of renunciation, rejection or submerged yearning ... my own was a pale, narrow bed with a kerosene lamp above it (a nice touch; I've always felt inadequately illuminated) with a pair of tiny pearl button earrings on the coverlet (one earring would have been more realistic, I think; still, the pair carried through the general tight-assed quality)."

Art News, March 1970

Conceptual Art as Opera

by Amy Goldin and Robert Kushner

With taste, connoisseurship and art history discarded as irrelevant,
Conceptual Art may possibly make us get down to finding out something
about artistic meaning.

If a lion could speak we could not understand him.—Wittgenstein

Can the art publication replace the gallery? If you've seen one hole in the ground, have you seen them all? Is there a difference between conceptual art and the earthworks? If you know what a hole in the ground looks like, do you need to see it? If the art product is an act of imagination, whose act is it, the artist's or the viewer's?[i]

There are a lot of definitions of conceptual art. All of them stress the neglected but undeniable fact that perception is an intellectual act. Particularly in relation to perceiving art, the appropriate response is closer to the "I see" of discussion than to the "I look" of physical report. Past this touchstone, disagreements multiply. Important matters on which conceptual artists do not agree include the esthetic relevance of appearances, the centrality of language (as opposed to other sorts of notation) and the aim of conceptual art. These issues are presently being precipitated out of the increasingly frequent publication of conceptual works and credos.

To illustrate the range of disagreement: Sometimes intention defines the conceptual work. At the New York City Cultural Center exhibition, the space allotted to Robert Barry, Ian Wilson and Lawrence Weiner contains

statements asserting that the work *appears* in the catalogue only. Jack Burnham has claimed that the ideal medium for conceptual art is telepathy, and certainly whatever appears as conceptual art is overtly peripheral and dispensable.

For Joseph Kosuth, conceptual art is not to be defined by intention or by morphological characteristics (physical traits), and the use of invisible materials is not adequate differentiation for it. For him it is intellectual in function—either speculation about the nature of art or gnomic catalysts to such speculation (his reliance on A.J. Ayre's *Language, Truth and Logic* makes it hard to tell which). Others, like Douglas Huebler, apparently find non-visibility an adequate idea, at least for working purposes. His pieces usually consist of specified parameters of location and/or duration. These boundaries enclose the object of esthetic attention.

Practically and theoretically, boundaries are a major problem for conceptualism. Indeed, the isolation of art from presences or processes in the world that are not art is being faced as if it were a brand new worry. But to examine the nature of art in terms of physical materials versus intellectual concepts is fatal. Those categories repeat the old body/soul bag which leaves important aspects of artistic experience unacknowledged. If you disregard the social dimensions of meaning you are forced to puerilities like "man's spiritual needs." (This is the phrase Kosuth uses to end his first lesson in *Studio International*, October, 1969. I bet he wouldn't say that without quotation marks!) Moreover, the "problem" of materiality is a false one. We can take intellectual stimulus or satisfaction from physical objects or make physical responses to "intellectual objects." Like the relief we feel when we infer respect from somebody's form of address. If Kosuth is right and art-seeing is a special mental usage, it is a human habit and not the occupational disease of conceptual artists.

Artistic experiences cannot be understood by means of physics or speculative philosophy. They are a part of civilization, and esthetics, like art, is patently a part of the history of intellectual and political fashion. (Technology also ran.) Kosuth wants an alternative to formalist esthetics, but he is not prepared to drop the formalist notion that art should be "pure," wholly self-generating and self-referential.[ii] This refusal destroys the possibility of locating the public component of artistic response. Yet the enquiry is one that conceptual art is uniquely well-prepared to sustain.

Conceptual art talks differently from previous art. What has changed is not the message, but the entire grammar. Conceptual art tries to focus the viewer on an aspect of art that he is not used to noticing. He must reconcile a visual stimulus with unexpected but intrinsically connected associations and meanings. With conceptual art, no one is expected to contemplate the

object for a meaningful artistic experience—he will soon become bored. By the same token, no one is expected to spend a day meditating on the ideas. They are too simple. Rather it is a matter of finding *that* idea butted up against *this* visual situation. This meshing or confrontation provides the basic interest of conceptual art. It is the juxtaposition, not the object or the ideas in themselves, that is the conception of conceptual art.

Conceptual art raises its own peculiar problems. There doesn't seem to be anything strange about not wanting to look at something because it is too boring. We might decide to stop looking because the work is too trivial, but that's another story. The lesson that art can be visually innocuous is one that conceptual art learned from Uncle Minimal, but it does him one up by making the work simpleminded as well as boring to look at. Yet it is essential to conceptual work that it be visually unreminiscent of art. Obviously, if something is interesting to see, people are likely to look at it—there is no way of being caught in the kind of confrontation with which conceptual art engages us. If, for instance, the art-thing looks too much like a formal paint-ing or sculpture, the viewer will not proceed to the implied idea. He will stick with the formal art object. On the other hand, if the art-thing looks too baffling, repulsive or unfamiliar, the paths of inference will be blocked. And in order for the idea to be grasped, *it* must be relatively banal, too. Con-ceptual art has to work with pretty simple ideas and with a deliberately impoverished formal situation in order to keep you from getting hung up with it as an object. The blandness of its formal properties links conceptual art to Minimal. But unlike Minimal, conceptual art does not want to hold us to the work as a physical object with specific esthetic properties.

In 1910, at Der Sturm gallery, Picasso and Braque were exhibited as French Expressionists. This observation is not made to suggest how difficult it is to assess works of art when they are first made, but to warn us that we shouldn't force things to do what they don't want to do. As Cubists paint-ings the works stand on their own. Read as Expressionism, the same paintings become boring and banal. Such misreadings occur with a lot of the work presently being viewed as conceptual. No one would say that Kauffman's vacuum-formed plastics are conceptual—but Robert Morris' earth pieces are thought to be. Nevertheless, they and many other earth-works are simply not prepared to compete on a conceptual basis, and they shouldn't be asked to. As conceptual art they are banal because they offer none of the tension between presentation and import that is so crucial to conceptual work. Similarly, Oldenburg's talent for iconography may make him a precursor of conceptual art, but he makes things that are simply too interesting in themselves. You never get beyond the object itself.

The transmission of conceptual art depends on the habits of the society in which it operates. If the visual material is complex or subtle, the message will not get across. The stimulus is designed for maximum transparency. Would you believe a Zen koan proposed by Henry James? In conceptual art, words are meant to be read, not looked at. The artist is banking on the viewer's pickup of shared assumptions and his automatic responses to conventional clues. The graphic components of conceptual art are dealt out deadpan, like a poker hand. And we pick up a handful of Tarot cards. Thus Douglas Huebler's "42nd Parallel" piece marks the existence of 14 American towns that lie on or near the 42nd parallel, their "presence" being "validated" by a map and a series of registered letters. A map is a schematic, referential set; the letters turn abstract locations into authentic places with real postal clerks in them. Visual details are trivial, but the reverberations of presentational form are artistically relevant. Presentational forms: Kosuth's library table with appropriate materials on it, a gift (Kaltenbach), receipts (Kienholz), a set of instructions (Heizer), labels on a blank wall (Paris), assortments of unused consumer goods (Eleanor Antin). The presentational form in which the work confronts us creates expectations that are deliberately falsified, thwarted or set askew by other components of the work.

The importance of presentation form means that whether an artist chooses to execute a work of conceptual art or merely to publish a program for it becomes a decision calling for artistic tact and judgment. Which tactic will provide the most suitable vibrations, the appropriate contextual resonance? If he chooses print, *where* the work is published selects the audience and the setting. To read something in *Vogue* is to make it enter a set of interactions very different from those available in *Artforum*.

A particularly clear example of the way contexts affect the way we read can be seen in Kaltenbach's early series of messages (Tell a Lie, Art Works, etc.). These works were executed in two forms: as texts among advertisements in *Artforum* and as inscriptions in metal plaques intended for insertion in buildings or concrete walks. It is instructive to see the kind of difference that arises when words are made public in different ways. "Art Works,"pressed into a permanent material, becomes a label; in the magazine it reads as a statement. The grammar shifts, with "works" reading more easily as a noun in the first case and more easily as a verb in the second. But in neither case does the work lose its ambiguity or its character as conceptual art.[iii]

The significant thing about the use of language here is that it is perfectly normal and gains no special stress from being in an art situation. The idea of the work is not carried by the words, but by the words-in-the-situation.

The artistic message is not simply the verbal one, it is what we understand as a consequence of meeting implications *here*. The inter-action of symbols and social conventions makes for new meanings.

The use of language as socially embedded is peculiar to conceptual art. When words appeared in art before, they worked differently. Think of Duchamp's *Bride Stripped Bare*, with its punning subsets of associated pieces, like the *Malic Forms*. Think of Johns's flags and targets, which were icons, simultaneously symbols and the objects they represented. But in conceptual art, words are not motifs or emblems. Nor is the conceptual use of language independent of its setting—it does not become literature. Rauschenberg's portrait telegram, a lot of John Cage, the early work of La Monte Young—these are conceptual art, but the artists aren't *writers*. Their work is hard to reconcile with traditional art, not because it falls between the old media pigeonholes of poetry, paintings, theater or sculpture but because the artistic experience does not result from attending to the medium in the usual way.

What conceptual art is doing should now be clear. It sets us up for esthetic experiences. The stuff of conceptual work is confusing because it is produced and sold like works of art, but in fact art is not in them. Like books of song lyrics, they present necessary but partial conditions of artistic experience. Notations must be deciphered and consciously combined with other percepts before the art occasion can be created in and by the "viewer." The art-thing is only one component of the work. To experience the whole we must make the connection between the presentational situation and the idea available in it.

Both language and documentation, it seems to us, play a more traditional, mnemonic role in earth art. Here photographs, maps, materials and text are primarily referential. With no agenda of their own, they accumulate associations and data to yield a generalized image of an event or situation. Frequently the event could not have been grasped directly—it happened too fast or too slowly or too far away. Some artists who do earth art (Oppenheim, for one) consider their photographs poor proxies for direct experience possible only on the site. I doubt if more than a conventional preciousness is involved. Moreover, if photographs do not permit an adequate grasp of what the artist is doing, he probably ought not to show them.

Earthworks can be conceptual—Baldessari's ingenious California piece would be an example. But they seldom are, primarily because it is hard to disengage them from landscape considerations. If we agree that conceptual art works by forcing us to link a context with an idea we can see that normal artistic reinforcement makes such linkage automatic. Regular associations and familiar moods reduce intellectual tension. Most earthworks seem

designed to demonstrate a single idea—the notion of nature as the Great Eraser. They suggest an impersonal, serene contemplation of death—dissolution as seen by Spinoza, under the egis of eternity. Organic process as the healer and absorber of human action. Nature as a re-foliation program. Once familiar with this rather comforting version of persistence of natural processes, we can rehearse it on any piece of terrain. The work offers no resistance. Familiarity with the artist's program obviates the necessity for holding concept and execution together as one "thought" in an odd way that provides the esthetic shock of conceptual art.

Although the differences between earthworks and conceptual art are more interesting than their similarities, those differences have largely gone unexplored. Discussions of one or the other usually go into the same old business of anti-art. As if 60 years and Dada and Duchamp hadn't been enough. As if we still had to be convinced that works of art were not precious objects made out of art materials.

It's been a long time since materials were an artistic issue. Nowadays an artist normally assumes that he can make art out of anything. It's a commonplace that different materials offer different information and support or inhibit different experiences. As materials are a pseudo-problem, anti-art arguments against the art establishment's institutions and conventions are pseudo-criticism. Not that those arguments are irrelevant—they are just too far in the background to be specific to the artistic problems of a contemporary audience. Moreover, criticism that deals with art as polemics usually evades the tricky matter of locating the active elements in the artistic situation. When Hegel flies in the window, wide-screen panoramas of art history elbow out the single, all-too-evitable occasion of artistic encounter. There are, after all, many ways of not-making last season's art object. Why is the artist doing *this*? Why go on about non-art forms and materials?

For audiences, art materials are important because their presence traditionally marked the site of esthetic response. Art materials located the work for the spectator and pointed him in the right direction. They clued him into what the artist was doing. But the physical site of the work is not identical with the site of esthetic response. If an artist is involved with the setting, with ideas of remoteness, with the accretion of individually imperceptible changes or the cultural assumptions of the viewer, the viewer's presence on the work site offers no advantages at all. It may even be distracting if it constricts his focus of attention to the immediate physical situation. All that matters is that we be clued in *somehow*. Conceptual art has made it perfectly clear that esthetic response is not necessarily bound to any single location or point of time, and that it does not require a formal

art object at all. Who doubts the possibility of esthetic response to a sunrise, Times Square at night—or in daylight for that matter.

None of this should be surprising. Just as esthetic response is not dependent on art, art was rarely dependent on its materials. One may even suspect genuine oil paintings of NOT providing esthetic experiences. Art was always suspected of being false and delusive—even when people knew where to look for it. Whenever the problem involved in locating "art" was closely inspected, people decided that whatever was central to the business—its "essence"—was not in the material object, but lay elsewhere, behind or beyond it. There shouldn't be any theoretical difficulty. After all, the dematerialization of art merely illustrates what everyone supposed all along, that meaning and value escape from art like steam from a vaporizer. Hadn't we always supposed that art was a gaudy confidence game, not to be taken literally, and recommended for mature audiences? In literature, the paradox of true fictions is the beginning of understanding. In the plastic arts, however, and most particularly in post-representational work, a vulgar sort of esthetic materialism has put artistic issues beyond the reach of ordinary understanding. Actually, encountering unfamiliar art is more like meeting a new person than it is like facing a new *thing*. If we neglect the social basis of art, artistic meaning becomes inexplicable and magical. A capacity for artistic judgment becomes something bestowed on the fortunate at birth by good fairies.

The assumption that the study of art is the investigation of a special class of objects is made by art historians, not by philosophers. When criticism is dominated by the art historical point of view, artistic ideas turn into pigeonholes. Ideas become categories. Critics assumes the task of designing family trees for every new arrival on the scene. They ought to be busy seeing that new experiences are not distorted by discarded concerns and criteria. It's their business to keep art talk somewhere in the neighborhood of artistic reality. It is perhaps amusing to observe that art can survive a divorce from the gallery and market system. New forms of patronage and dealership can apparently arise that will find the transfer of information as rewarding as the transfer of property. But the critic's business is to locate art for its audience. In relation to earthworks and conceptual art, this is a more serious problem, since such art challenges the adequacy of the ordinary critical vocabulary. "Style" and "expression" have been central to criticism and art history since Cubism, but what good are they now? How can we account for communicativeness of work so ephemeral, unbounded or fragmentary? In fact, the explanatory value of formalism and Expressionism alike has been declining ever since Pop. While art has been repudiating physical description, increasingly engaging with factors outside its body—factors

like the physical setting and the cultural environment—critics have not followed. Retreating to a factitious and outmoded "objectivity" they insist that the basis of art must be physical while all aspects of meaning must be intellectual.

The nonsensical assumption that all modern art is peculiarly intellectual (as if earlier art were peculiarly dopey) has left us totally unprepared to assess the role of ideas in art. The commonplace of modern art's intellectuality entails no agreement as to what ideas are to be found in it or how they come to operate. Thus Kosuth can make the startling provincial claim that it was Duchamp who first raised the question of art's function—as if that hadn't been the crucial issue since Plato.

If we compare 20th-century art with that of the 19th-century, say Courbet or the Impressionists, the first thing we are likely to notice is how much modern art leaves out. Images of the world in the first place, and human emotions in the second. Compared to traditional art, contemporary work looks considerably less complex, much more stripped-down and blank. In fact, it IS simpler. There is no reason to equate all that apparent elimination with abstraction, as if everything that seems to be left out were still there in some awfully spiritual or intellectual way. The absence of bodies and feelings is not evidence of the presence of mind. It is just too good-natured to assume that art which does not move us forward viscerally is probably intellectual and possibly over our heads. Whatever is going on in conceptual art, I see no reason to suppose that it somehow contains more ideas or better ideas than earlier art. In fact, the most interesting thing about it is that, as the least visceral of all art, it forces us to recognize an old habitual mistake. Intelligence is not in objects but in ourselves, and the work provides the occasion that triggers its operation.

You can understand a glance or a hairstyle. That doesn't make them intellectual. One is a material object and the other isn't. Yet the glance is not less intelligible for being ephemeral. In both these examples, our understanding comes off something we've seen. Like the hairdo, earth art tends to work off historical and literary associations, while conceptual art, we believe, does something much odder and more complicated. Seeing art is a rational endeavor. Its meaningfulness, however, is not a simple consequence of the quality or even the presence of the ideas we get from it.

Probably the major contribution of conceptual art lies less in the value of individual works and more in its reintroduction of meaning as a clear constituent of artistic experience. It makes sense again to think about what art means instead of what it formally is. With taste, connoisseurship and art history discarded as irrelevant, we may possibly get down to finding out something about artistic meaning.

Think of the different ways in which ideas get into novels. Think of allegories, then of Kafka, who is full of ideas but deformed by allegorizing interpretations. Think of Mann's novels of ideas or of Svevo's stories of intellectual people. Of Borges' ironic use of ideas. We have hardly begun to pay attention to the way ideas get into art and how they are involved in artistic meaning.

i 1. Yes
 2. No
 3. Yes
 4. Sometimes
 5. Please repeat the question.

ii The iconoclasm of conceptual art comes from a distaste for restricted art, trivialized by its materiality and degraded by its relationship to private wealth. A claim to the unlimited autonomy of art, however, means that "function" is necessarily external to it.

iii The distinction between presentational form and structural form which conceptual art has made visible could well become important in a non-formalist esthetic.

Rugs

If you have more than 30 seconds for aesthetic contemplation, it's got to be rugs. Anything else is too uncomfortable.

Contemporary art makes no compromise with the contours of the human mind. It demands an infinitely expanded sensibility; no used brain cells need apply. The very fact of mind becomes ludicrous, anachronistic. Intelligence belongs in the left-baggage department. Truly modern art calls for the muscular tautness and nervous rigidity of an ice skater, and it's all rather hard on the middle aged. Spiritual athleticism goes with translucent, flat-bellied youth. It looks pretty funny on people who go to dentists and podiatrists.

Rugs are for people sunk in flesh. For those willing to go halfway, acknowledgers of inner fields and outer margins. For the embracing of regularities and being grateful for small freedoms. People a little slow on their feet, the doubtful, the neurotic, the corrupt, the fat. The secret vice of the fashionable, the indulgence of the poor, rugs are for thrift-shop Orientals, *ancien* middle-class. Those unenchanted with ambiguities, unmoved by promises. Nothing fancy can distract us. We crave complexity.

The secret of all rugs lies in the relationship of the field to the borders. It is a relationship capable of expressing infinite variety, the most refined calibrations of expansion and repression. The division of field and borders shunts every form toward the centrifugal or the centripetal. Every margin IS form, holds form, divides form. Thus no Oriental rug fails to acknowledge thesis and antithesis, the boundaries between selves, the inevitable gap between the social and natural world.

In this they are exactly opposed the simple-minded idealism of Minimal art and post painterly abstraction, the one-worlders who never felt the ter-

mite's secret rape. Stella and late Noland are totally framing elements. Olitski all field. Louis is sometimes one, sometimes the other, never both. Their singleness is the modern version of purity. Rugs reject all that. They deny the very possibility of revolution—art history is just one thing after another. Accept with whole-hearted cynicism cultural sinks and the cold intricacies of government. Rug people know that the race is not to the swift but to the cheaters.

The traditional cheat of the *aprash* is just the beginning. The *aprash* is a horizontal blotch of a slightly wrong color. A visual hiccup, a belch. A fake shift of the dye that mimics sunlight, running-out-of-the-proper-color and plain absent-mindedness. The glorification of poverty and contingency. It reminds us: all rugs celebrate (unequally) the Law and the violation of law.

I have a coarse Caucasian kelim, unbelievably gay, clearly made by some irresponsible Nomad family on relief. It's a tent door and made in two halves, one side a good 8 inches longer than the other. You can see where each idiot child took up the work in turn, drunk on camel urine, playing hopscotch with the wools. The Jukes and Kallikaks of the tribe no doubt snickering at the design. An ascent of huge vaginal diamonds, obscenely split up the middle, rimmed with a million fingers turning one way and another the whole crazy trip.

I have another kelim, a Persian, a Sehna, but you never saw a Sehna like this one. Sehnas work off small-scale motifs, normally a refined, staccato sort of thing that easily gets fussy. This Sehna is monumental, unusually complicated. It's new and I don't know it well yet, but the pattern keeps coagulating and dissolving, pouring itself into different shapes and sizes, Impossible to follow the repeats because of the multiplicity of eddies. Ravishingly pale color rose and green, cultivated and fatigued, with Spanish inflections by way of France. The whole thing set onto a stark midnight blue that goes black in the tawny borders. An incomprehensible rug, aristocratically out of its skull. What years, what blindness arrogantly demanded of its weavers, slowly ripened fruit of sin. Exact, with the paranoid watchfulness of hawks. A madness of absolute legality, perfect in each detail when, with painstaking effort, you battle the flow and penetrate its symmetries.

There have always been these two kinds of rugs: high-class and low-class. Aristocratic rugs made in and for the courts, and the nomad rugs made by the tent-dwellers. Then as now nomads cluster around the source of their mobility, shack up beside their stinking beloveds. A raging commercialism makes the difference come to nothing in the end—a matter of neatness and knots to the inch. The aesthetic is the same, quality is democratically dis-

Senneh kilim made in Iran. 1910. 130 x 208 cm (4' 3" x 6' 10").
Stock D1250. Image © Bukhara Rug Company

tributed. There is some specialization in motifs, but artistically speaking, the difference is negligible, a matter of taste. An easy insouciance is appropriate in face of those alien social distinctions.

The redundancy of rugs. Beginning, of course with symmetry. Theoretically, nothing happens once, but all things follow law and reappear in their season. A production of will and insistence, with more rules folded in than you could shake a head at, laws secret as the permutations of genetics. The tint you find *here* you will find *there*, there are a lot fewer than you might suppose before you start counting. The motifs, too, are standardized and limited, in the rugs and among them: tarantulas, flowers, combs, dragons, urns, over and over again. A repertoire of ideas, not of shapes. Ideas eroded and blunted by millennia of repetition, and most of them pretty slender to start with. To find the public idea in the particular shape is the scholar's delight but aesthetically trivial. You don't need it. Illiteracy is, after all, no barrier. The intelligence here is habitual and non-verbal, the acute formal intelligence of the jazz musician who has heard all the changes. Rugs are music, with the color for the timbre and pitch, intervals for breath, and scale for volume. The whole thing is the rhythm. Who needs lyrics?

Rugs are not what you think they are. They are what they think *they* are, and they insist on identity with mechanical tyranny. But artistic principle is never allowed to obliterate personal autonomy. There is always the breakaway, the assertion of merely human authority. In rug literature this is referred to as piety, the ritual incorporation of the deliberate mistake, a humble renunciation of the hubris of perfection. What a joke! Could there be anything more ironic than a *selected* failure? Frankly speaking, isn't it infinitely more likely that the violation of the pattern is the flaunted signature of the maker? The emblem/initial of the performer whose virtuosity outshines the designer's legitimate theater? A sneer, after all, at ART? Ah, the low pleasures of decoration!

A Visitor from Brooklyn

by Oleg Grabar

The pleasure of a teacher's professional life is the appearance every year or every semester of new faces of students or visitors. There is usually eagerness in these faces, especially when, as has been the case of my teaching of Islamic art, one's field of study is not a traditional one required of all students, but an exotic elective chosen mostly by those who wanted to learn something new and different. It is only rarely that eagerness is tied to originality and uniqueness of purpose and approach. Such was the case in the Fall of 1973, when Amy Goldin appeared as a student in my seminar on Islamic painting and decorative arts. It is probable, although I do not recall the event, that she visited before the semester began to find out whether we were compatible with each other and whether it was worthwhile for her to use a grant she had received from some New York source to come to Cambridge every week to learn something which was not then available in New York. These were generous times for grants.

The straight and slightly snobbish young graduate students from various Harvard departments were suddenly joined by an exuberant middle aged New Yorker who was passionate about contemporary art. She had discovered formal affinities between some of its developments and the decoration of walls and objects which had appeared in the Islamic art of Iran some twelve hundred years ago. Since there was no historical or cultural connection between Islamic Iran and the contemporary world, the parallels had to be explained in formal terms, an approach that was quite new at the time (it is still rare today) and certainly one that was not practiced in the Harvard of those days. Since cultural reasons were unlikely to be found for the phenomenon, some other way of explanation had to be invented. Amy jumped at the problems involved, participated with gusto in class discussions, and prepared oral and written presentations which contained at times basic his-

torical errors but which did manage to present, however tentatively, a new approach to questions like the frames of image or the principles of composition which have become standard approaches now. All this was done with enthusiasm and, as I recall it, with a visceral joy that affected all of us and that still remains as one of the most memorable occasions of my teaching days.

Art in America, March/April 1974

In Praise of Innocence

The objects the Whitney has put on view are generally so downright enjoyable that any good-natured viewer is unlikely to ask for more; but I wish he would; for we have more to learn from folk art than this exhibition suggests.

The Whitney Museum's exhibition of American folk art, 1776–1876, is a very old-fashioned show. An amiable overview of vernacular arts and crafts, it is a cozy, big, extremely attractive and perhaps slightly pointless potpourri. It is not pointless for those who may be still struggling to understand modern revisions of the Western artistic tradition. Folk art highlights the arbitrariness of the accepted boundaries between fine art and applied art or craft; it reveals the esthetic triviality of correct academic rendering of anatomy, perspective and chiaroscuro; and it demonstrated the compatibility of art and humor. Those who find modern art perverse, senseless or crude can hardly find an easier means of sliding towards 20th-century artistic attitudes than by developing a taste for American folk art. The Whitney show reminds us how delightful, gay and even elegant such work can be. Nowhere is it easier to understand the merging of art and craft than by seeing that the sleek decoys of hunters, retired from their jobs, are admirable pieces of sculpture. Equally, a weathervane inside the house can be as esthetically satisfying as any mobile. The objects the Whitney has put on view are generally so downright enjoyable that any good-natured viewer is unlikely to ask for more. But I wish he would; for I am convinced that we have more to learn from folk art than this exhibition suggests.

The official view of the exhibition can be found in the handsomely produced book which serves as a catalogue for the show and which is an effort parallel to the show itself. Its publication was sponsored by the Whitney,

and it was written by the show's organizers, Jean Lipman and Alice Winchester. In the book they have chosen and illustrated 410 objects to represent the *Flowering of American Folk Art* (Viking; 288 pp., $19.95). Some three-quarters of these are included in the show. The book and the exhibition, then, stand as mutually corroborating evidence of a particular stance in relation to folk art.

The authors' avowed aim is to show that folk art is artistically equal to the professional product, which they usually call "academic art." Since various interested parties have been attacking academic art for around 100 years, however, the import of that opposition has become highly ambiguous. By now, professional art in general (rather than just the academic kind) and naïve art in general (rather than just folk art) are likely to embody our view of the significant alternatives.

But does this antithesis exist? The nature of the problem becomes clearer when we realize that the suggested tension between an art of the academy (or of the professionals) and one of the "folks" is in fact an invention, whether we talk of the 19th or the 20th century. Moreover, it seems to me unfair and misleading to talk about folk art and academic art as if the academy were the source of all regularity and as if folk art were intrinsically unbanal.

"Modern" art, in the manifestation of Impressionism, was rejected by the French Academy and developed outside it, supported by dealers and critics. Modern artists after Impressionism have adopted and integrated a whole range of alternatives to the traditions of the academy: so-called primitive art, popular prints, photography, African sculpture, children's art, as well as folk art. Whole groups, as well as single artists, have chosen specific non-academic sources. The importance of folk art for Kandinsky and other Russian avant-garde artists, like that of children's art for Klee, is by now standard art history. The occasional closeness of folk art to modern work no longer amazes us. To find Westermann or Saul Steinberg all over again, as the book is pleased to point out that we do in this show, can be depressing rather than exhilarating. We want folk art to be different.

It is time, I believe, to see if we can deal with folk art as a type of production with identifiable characteristics and with its own strengths and limitations. The organizers of the Whitney exhibition occasionally imply as much, but they do not go beyond the consideration of folk art as the expression of individuals. They present it simply as "the unpretentious art of 'the folks.'" Their claim is that the absence of formal training allows individual talent to shine through the clear glass of innocence—a proposition which seems considerably more naïve than this art. Besides being outmoded, this mythology of innocence is destructive. Whatever we can learn, we can't

study to be innocent, and surely the false naivete characteristic of so much present-day folksy ornamental painting, from Paris to Belgrade to Bahia, ought to be discouraged. Aside from innocence, little explanation of the special appeal—or the special characteristics—of folk art is offered by Lipman and Winchester. It is regrettable that neither the exhibition nor the book acknowledges the need for a more precise and coherent way of thinking about this work. Surely it is time to go further.

To call an artist nonacademic does not do very much to specify his relationship to traditions of production. The book notes that the work here called "folk art" has been variously labeled "naïve," "primitive" and "tribal." Then the question of category names is discarded as trivial. I don't agree. The label, I would claim, makes a difference in what you look for, and thus both in what you find and in the value you are prepared to put on what you find. Category names are shorthand for a whole series of complex decisions—judgments about artistic intentions and functions, which justify certain interpretations of the work and not others, so that the meaning of art is involved; the establishment of grounds for applying criteria, so that artistic value is involved. In short, many of the serious questions that can be asked about art are already implicit in the questions of stylistic category, because status is always implied.

On the other hand, the rejection of stylistic categories implies that all art is essentially one kind of thing, unlimited and unknowable except perhaps by intuition. This attitude denies the possibility of criticism and the relevance of tradition. From a theoretical point of view the Whitney exhibition is confused and confusing. The authors present their objects ingenuously as those "we like best," although they refer often, if vaguely, to color and design as significant criteria for folk art. They refuse to call folk art a style, although they treat it as such, and stress its special relation to artistic tradition.

When a range of production doesn't show the degree of regularity we are accustomed to in a style, but does show more-than-random consistency, what do we call it? A proto-style? A "taste"? What esthetic properties characterize the work that John Kouwenhoven (in *Made in America*) refers to as American vernacular, and can his term, now widely used, be applied to painting and sculpture? When we are faced with folk art, our ability to talk about art history only in terms of style seems a severe limitation. It is as if only highly conceptualized or institutionalized phenomena were real and as if unpigeonholed production had no significance at all. It is as if political historians could deal only with shifts of government, and not with social change. Yet it seems unlikely that folk art has left no trace on later developments in our arts and crafts. It is a fact that folk art began to be collected at

the same time that self-taught or naïve artists were sought out, during the 1930s, but the significance of that fact for a history of taste or art is completely obscured by the disinterest in separating folk art from naïve art.

Perhaps American folk art does constitute a body of work extended and coherent enough to be called a style. Can we say that the subject matter of our folk art may be wide-ranging, while its emotional range is usually limited? Does not its artistic vitality lie in the area of decoration? Such generalizations must be offered tentatively, as hypotheses against which the reader is invited to measure his own experience of the work. However, any invitation to thought is better than none, and if do-it-yourself art is worth making and exhibiting, it is also worth thinking about.

Some sections of the book seem to support my conviction that the primary appeal of folk art is that of decoration. When it argues that its strength lies in color and design, one is led to expect that a strong exhibition of folk art would make its decorative aspects manifest. That kind of show could make a lot of sense. Recent abstract art has sharpened our sensitivities to these matters. And the most recent downfall of Puritanism has sparked an interest in decoration—witness the recent enthusiasm for Art Nouveau and Art Deco—that has not so far been matched by any investigation of its principles and resources.

Yet, for the authors of this show, although they refer constantly to color and design, folk art ultimately is a manifestation of simple—very simple—humanity. Innocence, charm and documentary values all too often take first place. Concomitantly, whatever is mechanical, repetitious or complexly geometric seems to fall outside their interest. (It is perhaps significant that the exhibition does not include any of the Shakers' mystical drawings with their formal resemblance to Tantric diagrams.)

Repetition is an inescapable ingredient of pattern. Whether it's boring or not depends on the creation of relationships among repeated elements, not on the elements themselves. The symmetry of the appliqué quilt from Pennsylvania (page 72, bottom) is inescapable; but compare the design of the embroidered coverlet from New York (page 72, top). Less overtly axial, it reads radially as well as gridwise, mostly because it avoids alignment on diagonal axes. Its staccato motifs shift speed and direction with the masterful abandon of a twelve-year old on a ten-speed bike. Since folk art tends to lean heavily on symmetry as an organizing device, this kind of refinement of flat design becomes crucial. Here, artistic quality is in no way the fruit of innocence, but is the result of refined discrimination and active visual intelligence.

According to the book, marine and landscape painters, "unable to paint realistically … had to organize and stabilize their compositions from the

point of view of design." But design is not a device; it must always be created anew. It is not something that can glue an image together when volume and illusionistic space are ignored, as the authors seem to think. They accept the idea that design "explains how an artist unable to describe reality adequately can nevertheless be unhindered in his capacity for expression." This certainly is a peculiar conception of an artistic resource that is often associated with artificiality and the highly intellectual issues of formalism.

But even if we agree that "design" serves the purposes of expression, the idea that folk artists "luckily" hit on expressiveness while vainly striving for description is certainly wrong. The exhibition itself is evidence that folk art is neither so simple nor so homogeneous. Its artists display a wide range of capacities and aims. Folk portraits, for example, can be literal or ennobling, concerned with psychology or with emblems of class membership, treated as formal documents or intimate mementos. And folk artists are not always so very lacking in illusionistic skills. They can and often do make things look solid or distant. And while the organization of the exhibition into mediums and subject categories tends to obscure the fact, folk artists are often not interested in description at all, but are at pains to fulfill the requirements of a conventional pictorial or sculptural type: a grave-marker, a portrait, a pastoral vision or, in the case of needlework or penmanship samplers, the display of virtuosity.

Augmenting a certain confusion on matters of what design is, the authors introduce some startling explanations which bear on "abstraction." For example: "Although the folk artist might be able to produce a good likeness—or at least one that pleased his patrons—he usually found detailed anatomy and linear perspective beyond his technical abilities. As a result, his painting took on a decorative quality that today we call abstract." One hardly knows how to begin to challenge all this.

Just to start with, "abstract" does not necessarily imply flatness (see Gorky) and "flat" is not necessarily decorative (see Mondrian). Nor is two-dimensional design inconsistent with the presence of correct anatomy or Renaissance perspective. It is true that the problems of organizing a surface are independent of anatomy and perspective, and that composition usually entails considerations of volume and space. But in their two-dimensional aspect volume and space appear as shapes and intervals, so that the concerns specific to two-dimensional design are integral to Renaissance composition (which, of course, is the basis of academic composition). Although design was not isolated as a separate topic in academic training, it was not ignored, and our great academic draftsmen—Ingres, Degas, Matisse—have been artists with a powerful interest in decoration, artist who paid serious attention to keeping the picture surface alive.

If there are so many elements which are intermittently common to folk art and to professional or academic art, how can we account for the palpable differences between them?

It is interesting and somewhat peculiar that different sorts of artistic failure are as distinct as different sorts of artistic success. The answer, I believe, lies less in the art than in the process of becoming an artist, which subtly affects everything any artist makes. Bad student work doesn't look like folk art, even like weak folk art. Art students characteristically betray a confusion of artistic aims and standards: folk artists never do. Something slightly different marks amateur work. The sophistication of the accomplished student, who deliberately explores established styles, is quite different from that of the competent amateur. The amateur wanders through the art world like a tourist, picking up whatever attracts him while the student investigate zoning laws with an eye to taking up residence.

However, today, students and amateurs are both inevitably aware of alternative professional models. The knowledge comes with their interest in art and is sustained by it. They work or play in the implicit presence of a cosmopolitan art world. The folk artist, on the other hand, worked in a local situation for a local audience. Of course, local standards were ultimately based on urban or cosmopolitan production—where else would they come from? (I don't mean to imply that the relevant tradition is necessarily an academic or obvious one. I think the relationship of quilt patterns to Oriental carpet and fabric design, for example, is remote but significant.) But for the folk artist, the cosmopolis was far away. His artistic goals were clear because no extra-local standards were relevant to him. His security was like that of an only child in an adult community. The role assigned to him was indistinguishable from the one he defined for himself. Unlike the tribal artist, he didn't measure himself against predecessors whose accomplishments were familiar to everyone. There was no transcendentally right way to do the work he undertook nor, in the absence of competitors, was there any need to be innovative. The folk artist had to produce a standard article that looked vaguely "right" to his client and the people around him. Past that, he could do as he liked. His business was not to make Art but to please.

To consider folk art from the point of view of artistic success or failure, then, is to propose an outsider's judgment. What is banal for us may have looked impressively suave in a small rural community. In fact, for us, folk art seems inauthentic when it looks professional. Its own audience admired it for the conventions fulfilled, while we prize it for its violation of conventions.

The conditions under which folk art was produced discouraged but did not prohibit consistency, complexity or a high degree of formal integration.

They encouraged the artist to elaborate what he did best and most easily, since that was likely to be where his most vivid satisfaction lay. Composition, traditionally the most intellectual of artistic tasks, was usually handled as simply as possible—hence the frequency of symmetrical arrangements and centralized vanishing points. The folk artist's own predilection for solemnity and decorum largely determined his originality. The playful inventor who painted a still life of an egg salad was engaged in games other than those of the artist who "plays" by painting cans of tomato soup. Warhol was deliberately flouting artistic traditions that everyone around him took seriously: but folk artists, like their audience, saw their work as fundamentally private—and thus both unserious and free.

No modern audience needs to be convinced of the advantages of freedom and spontaneity. It is much harder for us to see the point of conventions and disciplines. Yet the folk artist's freedom was based on a highly structured situation. He or she worked to the requirements of established forms, specific customers, special occasions: and often under limitations having to do with scarce materials. These external strictures were severe enough to make internalized discipline unnecessary. Having proved himself or herself at the level of craft, the folk artist could let exuberance carry the work through to the end.

Contemporary artists' egos are at stake every inch of the way. They work (poor bastards) under the eye of their peers, who measure their accomplishment by the portentous scale of global art history. Who wouldn't wish for decoration to come back again?

Art in America, May/June 1974

The Esthetic Ghetto: Some Thoughts About Public Art

It seems to me that what is offered as public art today is, for the most part, large-scale decoration. I think it is even responded to and criticized as such, though nobody admits it *is* decoration, the category of decorative art being very ill-understood nowadays. So is the category of public art, which could not otherwise be mistaken for decoration. In the past, much of the best work produced seemed to fit the category of public art. Today there seems to be very little of it, though not for lack of people trying. My first aim in what follows must be to attempt a definition of public art, based on a sense of what it was in the past. The real problem is to explain why it is virtually an empty classification at present.

In my vocabulary, "decorative" is not a dirty word. I don't expect decorative art necessarily to be lacking in artistic quality or intellectual interest. Furthermore, the categories of decorative and public art seem to me to present a functional distinction rather than an intrinsic difference. Many of Tiepolo's ceilings, for example, were in a category of public art when they were painted. We can still recover their iconographic significance and read them as political doctrine. Yet today their politics has faded as completely as Mother Goose's. We see them as decorative art, no more serious or less delectable than the interiors created by Boucher. Designed to be strictly private, Boucher's rooms are now available to the wider public that Tiepolo envisioned from the first.

From these observations we can suggest two criteria for public art. First, it solicits a wide audience, usually on the basis of its size and physical setting. Second, it deals with subject matter of recognizable social import. (Recognizability means that style and subject matter can't be obscure or "personal.")

These conditions are necessary but still not sufficient. We need a further qualification that will allow us to account for the fact that Géricault's *Raft of the Medusa* feels like public art in a way that Gauguin's *Where Do We Come From? Where Are We? Where Are We Going?* doesn't. An element of urgency which I am unwilling to call a mood seems to be implicit in art traditionally called "public." *The Death of Marat* is every bit as public a work as Delacroix's *Liberty Leading the People*, though the two pictures awaken utterly different sorts of feeling. What they share, however, is the quality which I think belongs most specifically to public art. Each painting solicits the audience's moral response, inviting it to approve or deplore the scene presented. It's difficult to say exactly how artists do this. How can a sympathetic portrayal be given the overtones of heroism that elicit our admiration, or how can a pathetic subject be made to carry enough moral weight to convey a sense of indignation or injustice? Sometimes subject matter will do it: for example, the baby crying among the dead bodies in the well-known anti-Vietnam war poster. Sometimes a gesture or detail quoted from religious or classical art will add the necessary touch of nobility. Idealizing elements in themselves are not essential to public art. (Hogarth's production was almost totally devoted to public art and shows almost no idealizing elements.) Their chief purpose is to complicate sentiment, to distance and generalize the subject, so that response doesn't stop with emotional recognition. Public art addresses its audiences as participants in a public world. Sympathetic attention is not enough. We are encouraged to take sides.

We can't even talk about public art, however, without risking an implicit mistake—the idea that all art is either public or private, so that whatever is clearly not public must therefore be private, and vice versa. Not so; I am talking about art that bears a highly specific sort of relationship to its public. Many other kinds of relationships are, of course, possible as well. The "wide audience" that constitutes the first requirement for public art does not simply mean "a lot of people" or even "ordinary, nonartistic people." Only in very small societies with homogeneous populations can the audience for public art be literally everybody. In larger societies, whole groups of people can be disregarded without weakening the public character of the work. For instance, the "message" of Versailles was addressed to "everybody"— "everybody" being a newly concentrated aristocracy that could be counted on to receive elaborately coded messages. When Mme de Pompadour changed her iconography and had herself portrayed as the goddess of friendship instead of love, "everybody" understood it to mean that she was no longer sleeping with the king but remained allied to him on a spiritual

level. This art was conceived as public, though its audience certainly included a very small part of the population of France.

We must inquire into public art's relationship to its audience, because the investigative techniques available to contemporary critics—iconography, style, formal analysis—do not help us account for it. Public art is not identifiable on any of these grounds. In fact, given today's normal assumption about art, public art is impossible. All we can ever do is put private art in public places. For us art is something made by an artist, and we think that if he is a true artist, his work will bear the mark of his personality. We see art as ultimately bound up with the inner life of both the artist and the viewer. True art thus becomes basically personal and individual, and an authentic response to it becomes a personal and individual response. On such grounds the idea of public art as a specific genre, not merely a kind of subject matter, becomes an absurdity. In such terms, the transformation of something impersonal into subjective experience and personal realization is what art is all about.

True enough. However, the weakness of this position appears at the next step, when we take the cause of our vivid experience to be the vivid experience of the artist. It is not. The cause of our experience is the work of art, and while our relation to *it* may be a matter of chance, its relationship to the artist is a matter of claim, interpretation or mythology. If Ellison or Baldwin or Cleaver makes being black real to the white reader, it is not because they are black but because they are artists. We might want to say that their work is important for social or moral (extra-esthetic) reasons— that depends on what you believe the value of art to be. But what the reader experiences is not the writer's life but his work. It is impossible to think about art until the locus of art is clearly established. Today, most people are more aware of the charismatic force of personalities than of objects: our esthetic tradition has encouraged us to think of art as a vehicle shuttling feeling from individual to individual like a crosstown bus. Whenever art is emotionally vivid, it has for us the mark of an authentic personality. For us, the artist's style, his vision and his personality are inextricably bound together.

It is not necessary to think that way and, in fact, in relation to architecture or to what we awkwardly call primitive art we don't think that way. Even when we can attach a maker's name to a dance mask or a cathedral we don't attribute the total artistic conception to one creative mind. Here we know that culture—traditions of belief and behavior shared by a lot of people over a considerable period of time—is much more to the point. The work transcends individual capacity. No single person could create all the conditions that link the mask to its wearer or the dancer to the dance. Nor,

single-handed, could any one person assemble the range of materials, techniques and ideas that appear in even a smallish church. We recognize such works as the creation of a whole society. Products like these are not the result of a single creative act but parts of an extended process. They require at least as much shared intelligence, cooperative effort and just plain time as the development of the Jersey cow. Moreover, they culminate to as great an extent in a result that is clearly in the public realm, and they exist among other objective physical facts. All of them are artifacts—artificial and at the same time supremely natural—linked to human life in a hundred poetic and unpoetic ways.

The difference between public and private things, particularly in relation to art, is not well understood. The artist's solitude and aloofness from his audience are still felt as necessary ingredients of his heroism and creativity. We prefer not to examine the common terms the artist uses to make contact with us but to concentrate on his specialness. That refusal is a remnant of an old-timey Humanism which believes in an artistic star system and not in art. But this is a little like believing in Newton and not in the methods of science.

Artistic preferences are not merely personal; audiences find their artists as surely as their artists find them; and that finding is a matter of social selection based on shared ideas of what is important in the human world. "Revolutionary" artists are those who shift attention from one set of shared values to another. They reinvent only art; the values themselves are preexistent. The star system distracts us so that we forget that attitudes as well as subject matter (or the distrust of it) predate the artist. Before he can take us anywhere, we must meet on common ground. Common ground is not necessarily public territory or the field of artistic discovery. Andrew Wyeth, for example, is a profoundly conservative artist who attracted a wide audience long before he was given art-world sanction as a star. Wyeth, however, does not work in the genre of public art. His "content" is consistently individualistic, and the withdrawn, alienated, solitary figure is his major theme. Wyeth is the poor man's Eakins, and he gives us the pictorial equivalent of Gary Cooper, the lonely hero. Wyeth is a popular artist.

Popular art is a different bag from public art. Like public art, it is addressed to a broad, nonprofessional audience, which it reaches through well-established conventions of iconography and style. Yet it doesn't address its audience in terms of a public world but with reference to a private, domestic scene. Its basic themes are modesty and innocence, expressed as quiet, passive sentiment or sensuality. It may (but need not) carry a note of pathos. There are first-class artists whose popularity can, I think, be accounted for by their conformity with the petit-bourgeois vision: Vermeer,

Chardin, Renoir when he's not too exuberant. Corot sometimes and Dutch interiors generally are other examples of painting that reaches a wide public on essentially nonpublic grounds. Popular art addresses its audiences as neighbors. It aims at a population of low aspiration that wants primarily to be left alone. These are people who feel, rightly or wrongly, that they have paid their dues and earned a right to tranquility.

A lot of Photo-Realist painting qualifies as popular art. It projects a consumer's world, but it must do so "objectively"—nausea and desire are off limits. As popular artists, the super-realist sculptors Duane Hanson and John de Andrea are problematic. Their figures lose the painters' relationship to the photograph, which is an enormously domesticating device. It introduces the picture plane, framing and esthetic distance in a single swoop, transforming every subject into a private possession and a neutral document. In both painting and sculpture, the hallmark of Photo-Realism is its stress on a painstaking craftsman's skill that can be interpreted as either precision or love but that, either way, successfully sidesteps subjective vision.

At different moments we are members of different publics. The audience that pays to see *Love Story* also sits through the cartoon. Yet with the cartoon, the audience aimed at changes, for the cartoon is not popular art but something else—mass art. The clue to mass art is that it is supposed to be addressed partly to children. It proposes for itself, therefore, a broader, less rational audience with a shorter attention span. Here the demonic, so thoroughly excluded from popular art, comes into view. The grotesque, the fantastic and the elliptical are notoriously to be found in television commercials, though rarely on its main bill of fare. The situation is analogous to the phallic, comic entr'actes that provided "relief" in the intervals of classical tragedy and Elizabethan court masques. The point is not that the artistic form is broken, but that one decorum gives way, temporarily, to another.

The decorum of mass art is thoroughly irresponsible, fragmentary and nihilistic. It's a form-*breaker*, and has nothing like the wide sustained acceptability of popular art, being almost too "senseless" to bear. Mass art addresses its audience from a madhouse, as inmate to inmate. It is interesting to notice how insistently elements of mass art have appeared in high art of the 20th century: Dada, early Surrealism, some Pop art (especially Oldenburg); even Conceptual art sometimes breaks through its pedantic format to give us something as embarrassing as Vito Acconci. Mass art is largely a modern phenomenon; past art only hints at it. There are demonic elements in Bosch and some Goya, as well as Gothic and Romanesque architecture and Romanesque manuscript illustration. Non-Western art is

richer in this area, since codified demonologies are often integrated in pagan and Eastern religious art.

Neither popular art nor mass art claims to mirror reality or to tell the whole truth. Perhaps because of that, we tend to separate them from the mainstream of the fine arts, where nothing less "ultimate" is admitted. That mainstream tends to be defined by public art—by such things as religious art, ruler portraits, history painting and war memorials (an enormous category of objects going back to Sumerian reliefs). Public art was once the major category of artistic production. (Private art was domestic—the furniture, decorations and pots and pans of the home. The distinction between public art and "minor art" goes all the way back.) Public art in the past dominated Western esthetics, forming our ideas of what was essential and normal for high art. Yet today, public art is so discredited by its association with propaganda and advertising that artistically respectable examples of it are hard to find. In effect, we have almost no art that addresses us as citizens of the public world. Why?

I think the main reason there is so little genuine public art today is our disbelief in the reality of the public world itself. Nowadays almost anything big and/or public is suspect. Up till now size has always been a major clue to the publicness of art. Before the mass media, sheer bigness was a necessity if a lot of people were to see the same thing at the same time. Monumentality was simply an artistic adaptation of style to the requirements of large-scale presentation. A big scale meant—and still does, to some extent— expense, in terms of labor and materials. Thus the look of grandeur was the prerogative of rulers. But today, nobody who has ever taken a 747 can believe it. Nowadays the look of grandeur means that you will have to wait in line. That kind of scale still implies money, but no longer does it clearly suggest power and authority.

Moreover, the conditions of mass communication don't leave the audience's civility intact. To be aware of oneself as publicly addressed is today a cue for cynicism. The young especially expect the information given them to be primarily manipulative. It is extremely rare now for a public announcement to tell us anything at all. Public statements tell us what we are supposed to believe, and it is generally expected that the truth will lie elsewhere. Consider George Washington. Audiences expect to see their own social conventions mirrored in public art. That's how Horatio Greenough blew it when he put his *George Washington* in a classical toga. Americans expected the father of our country to keep his clothes on in public. Houdon's *Washington*, using the (then) artistically more radical convention of contemporary dress, looked considerably more normal and respectable to the American public. Nowadays neither figure would look authentic. We

expect the "real" man to be the one we are not allowed to see—the one his mistress knows, or his tax consultant. The man at his most private.

What public art we do have today takes modern forms. It doesn't have to be big and the public no longer needs to be assembled in one place. It's enough to know that others are sharing the same experience at roughly the same time. Thus newspaper cartoons are usually public art and so are movies: movies about policemen or The *Sorrow and the Pity*, originally made for television presentation. Whether sponsorship is commercial or governmental is now a matter of indifference as far as artistic significance is concerned. The scale and social range are more crucial than the source; context of presentation overrides differences of style. In the setting of Lincoln Center, Calder and Moore became interchangeable. Their differences became a mater of taste. In public parks and buildings, anything that clearly proclaims its Art-nature is identified with Management. For a politicized society, works of art become first of all class-bound objects, with the stigmata of officialdom. Only imagery as blatant as Oldenburg's giant toilet-ball floating in the Thames could–just possibly–escape the art-box and enter the public realm.

It seems natural that when public art is least available our yearning for it should be greatest. The intense, frustrated involvement in public life is acute among today's artists; professional success does not assuage the frustration. There is a sense of being penned into an esthetic ghetto, condemned to being invisible as men and women. We who are their audience share those feelings. We, too, are impatient for the work that can release us from privacy.

Art in America, September/October 1974

Qajar Painting at the
Iranian-American Cultural Center

There is a kind of artistic experience that acts like an epiphany. When you have seen, casually and intermittently, a lot of little things that were rather nice and vaguely like each other, you can come upon a related work so broad, rich and polyphonic that, with a single glance, you comprehend a *style.* Past experiences regroup, and from then on every example is electrified by the magnetic field created in that one, synthesizing vision. For me, the exhibition of Qajar painting in Teheran in June had that effect.

Anyone with even a desultory interest in Islamic art has seen examples of reproductions of mediocre Qajar-type paintings, for they decorate all sorts of Iranian objects, from mirrors and trays to pillboxes and playing cards. This decoration is more or less charming in a fancy way, hovering between the directness of folk art and the self-consciousness of Safavid decadence. Given that context, first class Qajar painting is an utterly unexpected knock-out. It demands recognition in terms of its own formal traditions.

Essentially a bastard style, Qajar painting was born of a liaison between Persian miniatures and Italian Renaissance. Many New Yorkers will remember last year's Asia House exhibition of "Shah Abbas and the Arts of Isfahan." Paintings in that show, which covered the period 1587–1722, already gave signs of European influence, but we know very little about the development of Persian art for the hundred years after 1680. Scholars speculate that there wasn't much, for Isfahan fell to Afghan invaders, and Iran's subsequent rulers were too militaristic in spirit and too orthodox in religion to support royal studios. But that can't be the whole story, for when Persian painting surfaces again at the end of the 18th century it shows too many novelties. More has been added than the magnificent collection of jewels

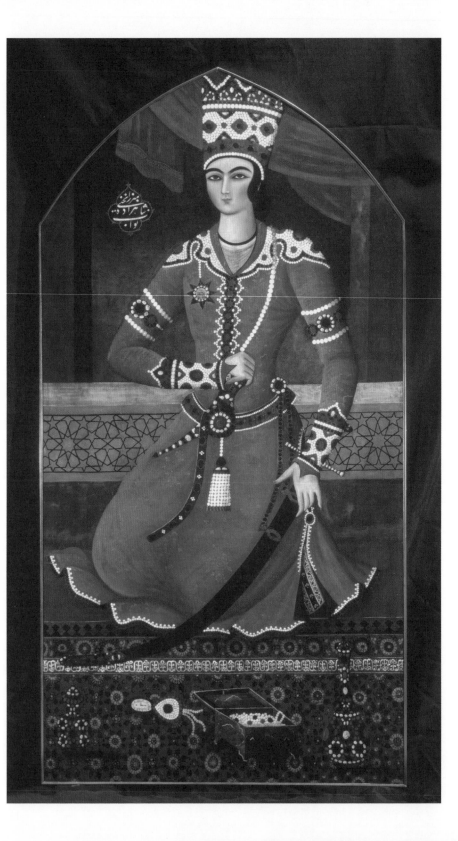

that Nadir Shah brought back from the looted Mughal palaces of India. It is now a fully developed style, a fascinating and thorough integration of the European influences that had looked merely comical a century earlier.

What in Western painting did Iranian artists ultimately find usable? First of all, the medium, oil on canvas, and the method of building up a surface through glazes. They also adopted Western conventions of picture size. And, with reservations and lapses, they accepted a Western ideal of solid form, using shading to model foreground items and perspective for landscape and for architecture when it occurs in backgrounds. But everything else is Eastern. The insistence on a painting as an esthetic object, severed from the didactic or documentary functions painting served in the West, is Persian and persists. With rare (and late) exceptions, estheticism determines subject matter—Qajar paintings are mostly ruler portraits (extolling such royal glories as Faith's slender waist and long black beard) or of girls. These paintings are made to give visual pleasure, to remind us of bright and glorious things and to be delectable in themselves, and at their best they are very, very good at it.

I remember an impassive mother and infant daughter, their poses borrowed from Christian iconography, their bodies still, suave and desirable. Like planets in orbit over the surface swim melons and cherries of incredible size. And the clothes! The clothes, with their transparent vests, massive shapes, pattern and embroidered ornament, are what makes Qajar painting possible. Good Qajar painting depends on an ineradicably Persian sustained tautness of the picture plane, and patterned ornament plays a structural role. A new concept of form is served by the old virtues of miniature painting: a magnificent control of scale that allows an artist to combine patterns with fuguelike density; a compositional firmness that can control these highly active surfaces with no loss of clarity or power; a line that can shift from contour to independent arabesque, that can change pace and vary rhythm without losing the large pictorial beat.

The solemn sensuality of Qajar painting balances on a knife-point; it is figural monumentality pulled into abstract movement that exists only on the plane, it is Léger set to music.

The only extensive museum collection of Qajar painting is in the Hermitage, but scattered examples abound—there are some in the Brooklyn Museum, for instance. These are often very uneven in quality, but Asia House could be trusted to assemble an exhibition worth seeing. Maybe it could even borrow the Teheran show!

Muhammad Hasan. Persian (1808–1840). *Prince Yahya.*
Qajar, ca. 1830s. Oil on canvas 67 x 35 in.
Brooklyn Museum 72.26.5 Gift of Mr. and Mrs. Charles K. Wilkinson

Amy Goldin: Public Life, the Intellect, and the Low Pleasures of Decoration

by Michael Duncan

If only Amy Goldin were here to dissect the inconsistencies, truisms, and obfuscations that plague today's art world. One can only imagine her skewerings of the shibboleths propping Relational Esthetics, the last few Whitney Biennials, the Ahistorical Youthcult, Jeff Wall, Jeff Koons, Globalism, Designer Marxism, Institutional Critique, and the Haunch-of-Venisonization of the commercial art world.

Writing just on the blinding horizon of Postmodernism and French academic theory, Goldin clocked a number of the fuzzy ideas that were soon largely to subsume the logic and practice of contemporary art criticism and remove it from analysis of actual art works. With cool logic and the driest of humor, Goldin dissected the meanings of key concepts engaged with minimalist sculpture, public art, mass media, and conceptual art. She used precise formal observations to serve as tools for critical distinctions. In her work, complexity and intelligence rule, as well as a notion of the importance of what she calls "human response" and "public life."

Throughout a wide range of topics, she pursued a quest to find reentry for art into the culture at large. Arguing that the collapse of public discourse in modern life was not irreparable, she advocated art able to broaden audiences and address real issues. For her, the self-indulgent hermeticism of Abstract Expressionism and the vacuous formal truisms of Minimalism and Conceptualism had largely severed intellect and rigor from the experience of art.

Beyond an assessment of the art world's status quo, the essays collected here reveal Goldin's search for alternate approaches that might re-open seemingly closed doors. In the late 1960s, she praised the "psychological detachment" offered by Leger, condemned the celebration of the "individ-

ual" as solipsistic indulgence, skewered the melodrama of expressionism, and attacked the false dichotomy usually drawn between "deep" and "shallow" art. In that tussle, she firmly came down on the side of "shallow" decoration as an alternative to the solemn inhibitions and anti-intellectualism of Pop and Minimalism.

Decoration was the key Goldin topic, examined in sparkling 1970s essays on Matisse, patterning, and Islamic art that crystallized her thinking. In an undated statement from around 1975 found in her papers in the Archives of American Art, Goldin stated that her interests in Islamic art and "the characteristics and esthetic implications of pattern" had led to "a consideration of decoration as a creative alternative to contemporary forms of high art." In "Matisse and Decoration: The Late Cut-Outs," she positioned Matisse's use of decoration as a more inviting alternative to 60s Formalism's estheticizing of painting: "The action was identical; a progressive drawing-off of interest from subject matter and a simultaneous concentration on the flat, color surface and other formal properties of art."

In "Patterns, Grids, and Painting," Goldin analyzed the philosophical and formal implications of patterning, contrasting them with the assumptions of Minimalism and the principles of abstract painting. Precisely defining its formal parameters, she examined patterning's "indifference to self-assertion" and "nonhierarchic" reliance on viewers' scanning. In charting the distinctions between art and decoration, Goldin hinted at a route for artists that would completely bypass the narrowing constrictions of Minimalism and Conceptual Art.

A transcript of a lecture on Near Eastern art—also found in her AAA papers—summarized what she saw as the role of the decorator:

> Seeing what Islamic artists had produced, I became convinced that there is, in what we call decoration, an artistic alternative to art ... that latches onto the world in a radically different way. Decoration involves the maker in a relationship to the world around him that is much more intimate and practical than the specialized, alienated world of professional art. Decoration doesn't lend itself to artistic ego trips or to scientific abstract thought. Instead of seeing yourself as the unacknowledged legislator of the world, you face the requirements of your own environment, the setting of your own life and the feelings of people around you. Your job is to clarify and heighten the impact of objects and occasions that already exist, that already have meaning. And that function requires quite different kinds of attention and sensitivity than you usually find among artists.

Decoration's social engagement—its interaction with tradition, spectacle, and taste—spoke to Goldin's desire to shift art's attention away from personality and confession.

Goldin's ideas underlie many key notions explored in the works of the Pattern and Decoration artists who emerged in the mid-1970s: the esthetic role of beauty and utilitarianism; the intersection of high and low cultures; the appropriation of tribal, outsider, or Third World cultural motifs; and the consideration of crafts or traditional "women's work." These ideas have continued to be critically discussed in the past decade and reveal P&D as the neglected parent of the current vogues for globalism and the melding of art and design.

United in a desire to transcend the austerities and taboos of Minimalism, the P&D artists proposed a radical overthrow of the Modernist notion of progress in the arts, inspired by the traditional ornamentation of everyday objects and architecture. Broadening art discourse to include a truly global perspective, P&D drew on an incredible range of sources and ideas, at once embracing, for example, the metaphysical structure of Islamic textiles, the handmade populism of William Morris, the textile and industrial designs of Sonia Delaunay, the symbolic geometries of Native American and African art, and the unabashed decorative painting of Matisse. P&D conflated the Minimalist grid with the formal properties of the pattern—the repetition of forms at measured intervals. Ornamenting the austere geometries of artists like Sol Lewitt and Donald Judd with polka dots and paisleys, the movement brought to the surface all the contradictions and formal conundrums of twentieth century art. Its magpie appropriations of motifs from all of decorative arts, its interest in the cross-pollination of global cultures, and its de-emphasis on psychology, de-mystification of the creator, and de-sanctification of the art object made it an early, essential expression of Postmodernism.

While a visiting lecturer at the University of California San Diego (1969–1971) Goldin inspired two precocious art students, Kim MacConnel and Robert Kushner, with upstart ideas about pattern and design. These wildly inventive acolytes began making work that challenged the sanctified world of abstract painting, setting out with what they called a "nomad consciousness" inspired by oriental carpets, eighteenth century French textiles, and Third World tribal weavings.

Meanwhile, Goldin's writings had come to the attention of other artists across the country. In the mid-1970s, Amy Goldin attended several of the meetings organized by artists in New York that helped coalesce the P&D movement. As one of the key critical supporters of the fledging movement, she published essays that referred to works by Kim MacConnell, Joyce

Kozloff, and Robert Zakanitch and pursued interests that dovetailed with those of the artists' group.

For example, Goldin's observation in the "Patterning" essay—"The conceptual richness of pattern can be fully realized only through the juxtaposition of related patterns"—seems to speak directly to the enterprises of P&D artists, MacConnell, Kozloff, Kushner, and Miriam Schapiro. Similarly, the formal implications of rug, textile, and wallpaper design that Goldin explored relate directly to the ideas implicit in works by Valerie Jaudon, Zakanitch, Tina Girouard, and Cynthia Carlson.

Despite the current critical amnesia surrounding P&D, the ideas explored by Goldin have relevance for a host of contemporary artworks. Her writings address ideas about design and patterning that relate to the oeuvres of contemporary artists such as Philip Taaffe, Yinka Shonabare, Lari Pittman, Jorge Pardo, Polly Apfelbaum, Roy McMakin, Jim Isermann, Jean Lowe, and Ryan McGinniss. Now that antiquated taboos against design are again being shattered, it is time to sort out the convoluted history of the intersection of art and decoration. Goldin's work plays a crucial critical role in that history.

Art in America, July/August 1975

Matisse and Decoration:
The Late Cut-Outs

Matisse's last works, huge architectural-scale compositions of painted and cut paper often conceived as studies for ceramic murals, represent more than the last creative surge of an aged master—they are the final fruits of a lifelong fascination with the task of harmoniously ordering the environment.

Although the importance of decoration in Matisse's work was never overlooked, it is currently the object of increasingly critical attention. Even when we bravely disregard the pejorative implication of "decoration," we must still, however, decide how to use the term. Should decoration be treated as an aspect of Matisse's entire production or as a separate category of work within it?

In the first case, we can still call on the artist's own assertion that providing visual comfort, calm and pleasure is a proper artistic goal. We can refer to Matisse's subject matter and note how frequently decorative objects are a part of it. We might even suggest that he was rejecting the dichotomy between nature and culture. All this is very mild and correct, and it in no way jeopardizes Matisse's position as a "proper" artist with other, more transcendent aspects and other, non-decorative concerns.

The second alternative takes a narrow view of decoration. It would specify Matisse's decorative projects to include, first of all, those things he produced which are not usually called "art" at all: rugs and hangings, the ceramics, the etched glass. Then his architectural decorations would have to be considered—pieces commissioned or intended for particular architectural settings. This is a large group and includes many of Matisse's strongest and most ambitious works. To assess this material, established

esthetic theories for large-scale decorations have long been available. These theories were derived from and for mural painting, and, as we shall see, Matisse echoed them in his public statements more consistently, perhaps, than he did in practice. The general theory was that for architectural decoration, as opposed to easel painting, was supposed to be flat, to respect the physical and social character of the setting and to show emotional restraint rather than elicit sustained and intense response. These rules would obviously have been acceptable and even welcome to an artist of Matisse's temperament—and they do not depart very radically from the goals he set for himself as an easel painter. Those aims, emphasizing repose and seduction, may be called for short, the armchair syndrome; they align perfectly with the traditional requirements of decoration.

The armchair syndrome clashes with other of Matisse's avowed aims at only one point: his insistence on truth to nature as the very basis of his (and every artist's) activity. If we decide to deal with decoration as a specialized activity within Matisse's production, we postulate a disjunction between the easel pictures and the decorative projects that, on inspection, does not seem to exist. If it does exist, it is thoroughly overshadowed by the larger continuities, for Matisse's forays into decoration are usually consistent with the pictures he was painting at the same time. Thus the Rockefeller overmantel is closer to the 1939 painting of *Music* than it is to Shchukin's *Music* or to the Barnes *Dance* mural. Special classicizing subject matter suitable for decorative projects had been dropped out of Matisse's artistic vocabulary early on. Nymphs and satyrs in an outdoor setting do not reappear in his work (although, interestingly, they do turn up in Picasso's late painting).

This second alternative—to treat Matisse's decoration as a kind of sideline—is further thrown into question by the peculiar fact that Matisse spent the last years of his life producing almost nothing but decorations. Most of the late cut-outs (1950–54) were studies projected for execution in ceramic or glass. There are exceptions—works like *Zulma* or *Coquille* remain pictorial and prove that Matisse's concentration on decoration was not merely enforced by his medium. And he continued to draw from the model. But it seems obvious that toward the end of his life Matisse virtually abandoned art *in favor of* what anyone would call decoration.

I propose to discuss Matisse's late cut-outs as decoration, free from the link to truth (or reality or nature or the absolute) that is usually claimed for art. Thematically, emotionally and structurally, this work is normal as decoration and anomalous as art.

It is generally acknowledged that art satisfies demands decoration cannot fulfill; I believe the reverse is also true—that decoration satisfies needs that

art inhibits. Moreover, I take the "mereness" of decoration to be intrinsic, generally independent of the attitude of the observer. Decoration is "mere" because it is intellectually vapid. But perhaps it can elicit and sustain its own artistic range all the better for limiting itself to the immediacy of he present moment, being seen here-and-now.

As Matisse's cut-outs sometimes remind us, decoration can be solemn. The mindlessness of decoration does not deny its considerable emotional range. There is a rhetoric and a décor for religious as well as secular occasions, for funerals as well as birthday parties.

Art stands as the locus of spiritual and moral experience transmitted by visual means. Decoration is beyond that pale insofar as it does not imply any aim other than beauty, pleasure or the delight of the senses. I would like to suggest two extraformal requirements of decoration that mark its difference from art.

First, decoration is non-intimate. It requires a low level of emotional involvement and the absence of psychological tension. Decoration can be surprising, dynamic and exciting, but it must not trespass on drama or elicit projective emotions like pity or fear.

Second, decoration is conceptually bland. The iconography of decoration can be very complicated, but its symbols cannot be so disguised that their conventional, schematic character becomes obscured. Themes normal to decoration like the Zodiac or the labors of the months can be treated as art by being set into a depicted world, as in mythological or genre scenes. Such a procedure removes them from their usual role as conventionalized emblems whose content need not be scrutinized. The subject matter of decoration is usually recognizable as an intellectual and visual cliché, inexpressive and unindividuated. Ideally, the motifs and the topics of decoration *should* be conventional and boring in themselves, so that the cognitive and rational aspects of visual experience are unstressed. (The rule about the banality of decorative motifs is ultimately related to the decorator's need to keep the viewers attention mobile and diffuse.)

The major formal units of decoration are not forms but fields and frames. A chimney piece may consist only of framing elements, and a slab of marble set into a plaster wall is only a field, but the most common type of decorative organization uses both, interest is often focused on the frame/field relationship.

Flat, extended areas within pictures—a floor, say, or a sky–are not decorative fields. The decorative field has no intrinsic shape or position of its own. It is seen as directionless and centrifugal, its presence marked by a specific density, texture and coloration. The important thing about a field is that it reads as a single unit, with artistic interest equally distributed

throughout the surface. As a unit, it must be seen fast, and its identity as a unit must persist through closer inspection—a quality that can be reinforced by adding a framing element or a pattern.

The grid is the abstract basis of all patterns; any pattern can be reduced to some particular grid, though it may not be explicitly stated. Unlike pictorial composition, all-over grids disperse visual attention throughout the entire surface and are indeterminate of dimensionality. That is to say, grids can be used on regularly or irregularly shaped areas, and they can be applied to planar or three-dimensional forms. To perceive a grid is to identify the gridded area as a *unit*—it asserts continuity and equalizes the importance of all parts of the gridded field. Like compositions, grids organize perception, but they do so in a way that inhibits the single, stable visual focus that is the normal aim of composition.

Framing elements need not be actual frames. By "framing elements" I mean to include all compartmentalizing devices, without respect to materials or methods. A spotlight, for instance, is a framing device, and so are the paired ears of a vase or marks at its rim or foot. The molding around a window and swags of drapery, real or depicted, are framing elements. So is most headgear. Framing elements limit and focus perception. They act as mediators between an area and its visual environment. Framing elements are fascinating in their variety. They can be empty margins, zones of visual silence, or they can be the major object of visual attention, like the elaborate borders of solid-field Oriental rugs. They can suggest the transmission of forces from the outside in, or they can extend the energy of a space outward. They can isolate parts or wholes.

Neither fields nor framing elements, however, are topics in conventional art schools. Despite Matisse's early interest in decoration, they are almost never found in his early paintings. (Even *Dance* and *Music* are not as flat as the late collages, and I do not think that the all-over color acts as a field.) He shows no radical grasp of decorative principles except, or course, for his reliance on color to achieve the classically balanced compositions that are more frequently sought by the elaboration and distribution of forms. Until the last 10 years of his life, framing elements are rare, though the *Joy of Life* is a major exception. The clearest example, the patterned border painted on the original canvas of *Interior with Three Eggplants*, 1911, was later suppressed, perhaps by the artist himself.[1] (Only in decorative commissions, like the etched-glass design for Steuben in 1938 or the 1936 tapestry cartoon for *Window at Tahiti*, do we find him producing elaborate frames.)

Patterned areas, on the other hand, are frequent in Matisse's work almost from the beginning. In 1906 and 1907, highly agitated patterns appear in some rather expressionist drawings and linoleum cuts of nudes. Later, pat-

terns are used to compartmentalize and structure pictorial space by implying flat planes—walls, floors, the sides and tops of tables. Throughout the '20s and '30s, patterns establish plasticity and give directionality to planes and surfaces that would otherwise be more or less static. While the function of the pattern remains stable over these years, the patterns themselves change. Early examples use elaborate, curvilinear motifs and avoid exact repetitions. By 1935, simple freely-drawn stripes, zigzags and checkerboards predominate.

Grids and framing elements begin to be investigated in two major undertakings: *Jazz* (published in 1947 but begun at least three years earlier) and the Vence chapel (sketches for window designs appear from 1948 on).

As an architectural problem, Vence demanded attention as an ensemble of wall elements, and almost every visible surface incorporates gridded units. The windows, which Matisse said grew out of his work on *Jazz*,[2] are rectilinear grids activated by color disposed in a series of simply varied shapes. The floor, the confessional door, the tile ground on which the Virgin and the Stations of the Cross are painted—all of them are grids, more or less fully integrated into the visual whole.

As book illustration, *Jazz* was a more familiar task that could have been handled much more conventionally than it was. *Jazz* is an important transitional work. It confirmed Matisse in the cut-paper medium of the last years, and it inaugurated a revision of his ideas of artistic form. No matter how we approach it, as an example of Matisse's work, as a work of art or as a book, *Jazz* is peculiar.

It is peculiar because, in the first place, Matisse undertook to provide himself with a text that is simultaneously a non-text. He wrote: "these pages are only an accompaniment to my colors, just as asters help in the composition of a bouquet of more important flowers. THEIR FUNCTION IS THEREFORE COMPLETELY VISUAL."[3] He is warning us that, although he wrote and designed the text to complement the images, it offers virtually no commentary on them. Both the text and the images are agglomerations of themes without linear or mosaic continuity, some of them, like "Lagoons," inexplicably appearing more than once. The subjects are generally more theatrical that those he usually chose. The cowboy lassoing a horse, the sword-swallower, the funeral car and the Icarus are all, in various degrees, mythic. They are emotionally or ideologically loaded themes, appearing in a form that defies analysis and in a style that suggests nothing more weighty than a valentine.

Formally, the color of *Jazz*'s illustrations is so powerful that it breaks out of the book and drowns every other element. You can't look at the plates comfortably from a normal reading distance. With the exception of a hand-

ful of them, there is nothing in Jazz that would not appear more properly situated outside it. The illustrations, which illustrate nothing at all, are unresolved in scale—the large informal handwriting that was supposed to balance them does not really help much at all. Contours are alternatively coarse and fussy, and the abstraction is so perfunctory that it gives a corny/childish quality to many of the forms. Yet if *Jazz* lacks Matisse's usual virtues, it also offers an unusually candid view of a search for novelties of form.

In 1915 and '16, Matisse had painted a series of strongly compartmentalized pictures. *Bathers by a River, Goldfish, Piano Lesson, Gourds* and *Moroccans* are all based on sequences of large-scale vertical bands of color combined with diagonals or partially overlapped by secondary, curvilinear shapes. The same composition can be seen in schematic form in the *Jazz* "Cowboy," with one important change: the vertical bands do not go all the way to the edge but overlap each other, so that the ground takes on a shifting relationship to the white page. *Jazz* is full of overlapped rectangles of solid color. Only in the earliest plates, like "Icarus" or the "Sword Swallower," however, are the white margins of the books completely excluded from the pictorial field. The sudden disappearance of a single saturated ground plane seems to have had far-reaching consequences. Ultimately it led to a radically simplified palette in which earth colors were dropped and other hues keyed into the starkness of the white ground. The pictures became flatter than they had ever been before. The new ground rises to the surface and generates the most completely abstract pictures Matisse ever produced, *Snail* and *Memory of Oceania*, both 1953. In them the curvilinear "organic" forms disappear or are reduced to a few discontinuous lines; the colored rectangles, freed by the newly active ground, shift their axes and become the active components of the pictorial image. (I don't think he really had much drive to abstraction; indeed, he had a resistance, but decorative and formal concerns drove him to it.)

Jazz is unlike any of Matisse's earlier illustrations, which were executed in line with very sparing use of color. Colored papers transformed *Jazz* into a painting situation. Unlike the canvas or the wall, however, the surface of a page is not usually coextensive with the surface of the image it supports. Books mostly have margins. Even *Jazz* has margins, though it reproduces Matisse's handwriting very large, a few words to the page, so that the margins become intermediate. *Jazz* does not give the normal, orderly appearance of a page of text, and this affects the character of the illustrations. Perhaps Matisse found that regularly framed illustrations looked tighter and less aggressive than written text, or perhaps the text format was chosen to balance the lawless effect of the images. At any rate, in

Jazz a picture on a page poses the ambiguity between the image's physical surface and its pictorial ground in the sharpest possible way. Framing elements, which define the boundary between two kinds of space, become Matisse's major concern.

In a group of plates like "Nightmare of the White Elephant," the image shrinks to a small, rather perfunctory picture which is partially surrounded and overlapped by an active, intermittent leafy border. In others like the "Lagoons," curvilinear silhouetted shapes, which are separate from each other or very loosely linked, float above the white paper and the colored rectangles. Plastic relationships between figure, ground and frame are radically loosened. Each of these elements is standardized and disengaged, then freely recombined, *Jazz* becomes an orgy of syntactic investigation. The mold of Matisse's classicism, with its hierarchic apportionment of interest to figure, environment, and ground in that order, is broken for good.

As units of decoration replace hierarchic compositional order, Matisse becomes a beginner, deploying familiar forms in unexpected ways. He had often used leafy borders in decorative commissions. They appeared in the 1907 panels produced for Purrman and intermittently continued to appear all the way to the St. Dominic design for Assy in 1948. Now the original bay or grape leaf becomes a highly mobile and distinctive Matisse-leaf, somewhat like a split-leaf philodendron but allied to marine plant forms, too. This motif takes center stage in several of the "Lagoons" from *Jazz*, it dominates a 1951 rug design called Mimosa, and it is even transformed into a human figure in *Negro Boxer*, 1947. Matisse's leaf joins company with the stars, hearts and flowers that were first seen in *Jazz* and now begin to appear everywhere.

With the loosening of the pictorial structure, framing elements become Matisse's chief device for asserting the unity of the visual field. Without them the white ground tends to get out of control. In *Acanthus* or *Ivy*, for example, where he counts on the white ground to frame fan-shaped or centrifugal motifs, the image weakens and thins out at the corners. Alternatively, the ground can shrink to a mere interval. Many of the blue nudes are uncomfortably crammed into their implied spaces. He needs framing elements to close expanding radial images or to stop the infinite repeatability of pattern. At first he goes wild with them: *Thousand and One Nights*, 1950, is a riot of borders, including clouds of hearts, leaves and zigzags, and two lines of ornamental text. Sometimes (*Memory of Oceania*) the reinforcement of the framing edge is a slight variation, mobile and subtle. At other times it is startlingly awkward. An odd blue-derby-on-a-column motif is used like bookends in *Apollo*, the unfinished *Decoration–Fruit* and in *Decoration–Masks*, with varying success.

A formal alternative to framing devices is the use of an irregularly shaped format. *La Piscine* (*The Swimming Pool*), where the surrounding wall area is sometimes a frame and sometimes a ground for the forms, is a magnificent example of this solution. Another irregular format can be seen at Vence, where the frame of a door bites into a corner of the Stations of the Cross.

A gridded organization of the visual field appears in all Matisse's window designs, the floor of the confessional at Vence, *The Parakeet and the Mermaid, Decoration–Fruit* and *Decoration–Masks*. Although he had used pattern all his life, it must be admitted that Matisse's attempts at monumental versions of it can seem somewhat coarse and static. The rhythm falters and perhaps the continuity of the surface is not always held. But, after all, what nerve the man had, to jettison his hard won skills! From 1950 until his death in 1954, Matisse struggled to meet and define the new territory of decoration. In the face of grids and framing problems his mastery of draftsmanship counted for nothing—and he threw it away. He believed that nature was the artist's truest guide[4]—and decorative squiggles came to replace his subject matter.

In claiming the late work of Matisse as decoration, one meets the objection that art is intrinsically expressive because it is the expression of the artist's individuality. If whatever the artist produces is art, the late cut-outs cannot be isolated from the total body of Matisse's work as different in kind. I see no reason why artists should not produce decoration. Still, for many people art *is* self-expression, and my refusal to concede art a role in the late cut-outs must be justified. Several strategies are open to me:

I. The argument from tradition. The distinction between "pure" art and decorative art commissions was never particularly forceful in France, where artistic status was normally conferred by the state through the Academy. In 1889, for example, Cheret received the Legion of Honor for "creating a new branch of art by applying art to commercial and industrial purposes." Consequently, Matisse could change his professional goals form art to decoration without any loss of artistic or personal integrity.

II. The argument from old age. The element of decoration was always strong in Matisse's work. As he became older and weaker, he grew increasingly detached from human passions and ideas. The last work was a simplification of artistic problems proper, expressive of his departing, enfeebled "self". Alternatively, the last work represents an old man's disdain for reality and enchantment with artifice, demon-

Henri Matisse.
La Perruche et la Sirène.
1952–53.
Gouache on paper cut and pasted,
134 ¼" x 305 ½" (337 x 768.5m).
Collection Stedelijk Museum, Amsterdam, The Netherlands.
Photo credit: Stedelijk Museum, Amsterdam
© 2010 Succession H. Matisse / Artists Rights Society (ARS), New York

strated with parallels from Yeats and Shakespeare's *Cymbeline*, with footnotes from *Death in Venice*.

III. We can't imagine Matisse's work to see whether it does indeed encourage us to make inferences about his personality. That proposition is flatly denied by Andre Levinson, who writes: "… l'oeuvre de M. Matisse [est] entièrement réalisé et détaché de son créateur, dont il ne nous révèle rien"[5] [the work of Matisse is entirely realized and detached from its creator, of whom it reveals nothing to us]. If, as I believe, the injunction to seek the artist in the work is not fruitful in Matisse's case, we may plausibly look elsewhere without worrying about the general validity of self-expression. I intend to look at this possibility.

IV. We can examine Matisse's statements to see what ideas he held about art and decoration. There are several problems here. The evidence may be inconsistent or inconclusive. Also, an artist's ideas are not necessarily a better guide to his work than another person's ideas. The artist has privileged access to his intentions but not to his accomplishment, and his own assessments cannot free us from the necessity of making our own. Nevertheless, I shall discuss some of Matisse's published statements to show an evolution in his views on the function of art.

The argument from tradition, which I shall not make, is probably sound. The problem of decoration arises in 19th-century English and German controversies about the compatibility or incompatibility of art and industrial production. These controversies are not paralleled in intensity or frequency in France; secure in France's position as an arbiter of taste, few intellectuals there felt the same need to reconcile modern methods of production with traditional artistic values. Moreover, the same socio-economic problems did not arise in France, partly because French industrialization was a slower process and took place in a different political context.

The argument from old age is not interesting. Nothing in the work suggests senility to me, or even a lessening of artistic power. I interpret its occasional weakness to the consequences of the artist's involvement in personally unfamiliar and culturally unconventional problems. In general, Matisse was not a fast worker and he evolved his solutions slowly.

The third argument leads one to inquire whether Matisse's paintings allow us to infer his private orientation to the world. Do they show us introversion or extroversion, a tendency to turn inward or outward? Windows

and window-like doors are a regular motif in Matisse—he was always jux-
taposing interior and exterior spaces. Yet they are so variously and freely
handled, with the emphasis falling now one way and now another, that it
doesn't seem plausible to consider him temperamentally disposed in either
direction.

Most of his figure paintings and almost all of his nudes are female, yet
the unambiguous evocation of sexual awareness is rare. True, an erotic note
is not uncommon in the drawings. There, women are seen from a close or
low viewpoint and are depicted lying in serpentine poses, sprawled on the
floor or posed near mirrors. In the book illustrations, too, images of parts
of the body appear, implying something different form esthetic contempla-
tion. Such intimacies are unusual for Matisse in the more formal medium
of oil painting, where figures take traditional poses and the artist uses con-
ventional full- or half-length figures. An all-over intensity of color balances
the impact of figures, which is absorbed into an environment of generalized
sensuality. An equal stress is given to strongly characterized costumes, fab-
rics, flowers and artifacts. The expansion of eroticism beyond the figure
gives Matisse's women a neutrality that becomes more noticeable when we
compare them to the women of Delacroix and Ingres, where we focus on
the energy and tactility of the flesh. Matisse's painted women sustain an
atmosphere of desire which neither embarrasses nor arouses them. At most,
they share our awareness. Usually poised and self-contained, they are mod-
els before they are women. They communicate through their physical
attitudes and, except in the portraits, withdraw their personalities.

Sexuality does not ruffle Matisse's vaunted calm: witness the infrequency
of figures relating to each other, the rarity of depicted movement, the large
number of still-life subjects. Do we sense a passive temperament, an arm-
chair voluptuary?

Only in part. *Dance* and the late *Piscine* resist the idea of passivity.
Matisse's largest, most ambiguous works release the greatest flowering of
energy. His repertory of nature is the realm of change and movement, of
sky, water and growing things. He considered mountains unpaintable and
had no interest in suggestions of eternity: geometry, night, the desert or
long visits.

A controlled and workmanlike professionalism can account for Matisse's
subjects, and his calm is less a matter of temperament than an artistic ideal.
In print and public interviews he praises himself for the craftsman's virtues,
a steady will and a clarified mind. He does not claim unusual insight or
dwell on the story of his life. When Matisse paints or draws himself, he reg-
ularly gives us the figure of an Artist, not the inner man. He maintained his
reticence and never violated his own privacy.

In meeting the fourth argument, however, it must be admitted that Matisse always claimed that his art was self-expression.[6] That claim should, I think, be taken in a sense Americans are unlikely to imagine—that is, as a rejection of the adequacy of artistic rules and laws. Matisse habitually struggled with his own conservatism and his own respect for traditional discipline and authority. I suggest that "self expression" for him was a hard-won assertion of artistic autonomy without the intimate psychological associations the term carries for us. Matisse saw his production as a personal accomplishment based on temperament and feeling, although he left to others the task of evaluating its theoretical and historical implications. In the end he was working in a territory he had forbidden to art, far from nature and personal identity. But his departure from "art" remained largely unverbalized, and he always claimed he never left home.

I have claimed that Matisse shifted his attention to decoration as a result of artistic experiences generated in *Jazz* and at Vence. Neither task seems to have acted as an intellectual catalyst or to have given him any fresh theoretical ideas. In part, Matisse seems to have considered both tasks as illustration, and his idea of illustration was very simple and concrete. His unit was not the page but the open volume and his task the play of text on one side against a graphic image opposing it. He used the metaphor of a juggler tossing up a black ball and a white one: the traditional concern to balance opposed forces, equalizing weight or density. The idea was useful enough for him to apply it to the very different situation at Vence: "The tile walls ... are the visual equivalent of an open book where the white pages carry the signs explaining the musical part composed by the stained glass windows."[7] In Matisse's mind the tidy Cartesian distinction between the intellectual and physical aspects of the artist's work becomes a material separation: meaning and expression, score and music, words and pictures.

Only in his early statements did Matisse refer "expression" primarily to the character of what he painted. "Feeling" came to indicate the artist's response to his theme. When interviewers equated "decorative" with "superficial," Matisse protested, saying all art was decorative, just as he claimed at another time that all art worthy of the name was religious.[8] Still, he did recognize what I have been calling "decoration" as a special sort of thing. He considered painting that is independent of sentiment and formally determined by its physical context to be mural or "architectural" painting. The concept is fully articulated in Matisse's letters to Alexander Romm, the Soviet art critic. Romm had observed that the "human element" was less pronounced in the Barnes *Dance* mural than in the Moscow *Dance* belonging to Shchukin. Matisse reples:

> In architectural painting, which is the case in Merion, it seems to me that the human element is to be tempered, if not excluded.... the spectator must not be arrested by this human character ... which, by stopping him there, would keep him apart from the great harmonious living and animated association of the architecture and the painting.... The Moscow panel still proceeds from the rules governing an easel painting (that is to say, a work which can hang anywhere) ... the Merion panel was made especially for the place. In isolation I can only consider it as an architectural fragment.... [The painting in architecture] must give an atmosphere like that of a wide and beautiful sunny glade which, in its plenitude, surrounds the spectator with a feeling of expansiveness. In this case, it is the spectator who becomes the human element in the work.[9]

"To be appreciated," he writes in another letter to Romm, "an easel painting must be isolated from its milieu, the viewer must be concentrated especially on it, go 'in search of it.'" In short, a painting must be sought out "like a book"[10]; architectural painting takes its place as part of the environment.

In 1934, then, when he wrote that, Matisse clearly distinguished between easel painting and the painted wall; they initiate different kinds of response. Although "human character" is appropriate to easel painting, the lack of it is not felt as a significant restriction on the expressiveness of architectural painting.

To trace the various meanings Matisse gives to "expression" (if such a thing is possible) would be to follow the shifts in his idea of art, a process that occurs at a geological pace with almost geological stealth. It seems more fruitful to look at his metaphors. More clearly than do his abstract statements (which are often repeated in a suspiciously habitual way), the metaphors suggest that by 1945 the concept of architectural painting has begun to invade his painting in general.

"The characteristic of modern art," Matisse said that year to an interviewer, "is to participate in our life....[it] spreads joy around it by the color, which calms us.... a painting on a wall should be like a bouquet of flowers in an interior."[11] The painting hung on a wall is no longer a book requiring close and deliberate inspection. It enters the atmosphere, radiating color like perfume, and the space in which it exists, like the glade, is one in which we are physical participants. Also in 1945, and in a more acid mood, the "human element" is brusquely rejected as being a preoccupation foreign to painting. Matisse even suggests that the very idea of "human" painting is an illusion, depending on the psychological capacity for projecting the self

onto the environment.[12] By this time, nature, which loomed so large in the 1908 "Notes of a Painter," has definitely left the arena of artistic concern. Matisse's focus is now on art as the creation of an ambience.

Thus the conception which Matisse finally calls "art" is one which the younger Matisse would have called "decoration." As he describes it, the artist's work elicits a public and social experience rather than a private and intimate one. It aims at creating a sense of well-being and expanded, intensified space, a space in which the human being feels in harmony with his environment, without having to think about anything in particular.

Matisse called Vence his masterpiece, the culmination of his artistic career. He felt religious about it. When Aragon playfully proposed turning it into a dance hall after the advent of Socialism, Matisse was pleased to retort that he had made certain that nothing of the sort could occur. Should Vence fall out of use by the church, he had provided for its endowment as a museum! Certainly it is possible to doubt, however, that the religion Vence celebrates is Christian, no matter how surely it is Matisse's. For Vence glides over the Passion of Christ and the Fall and Redemption of man, to provide a place where the nuns and visitors can be happy and serene. If thinking about Christ is one's pleasure, that, too, is permitted. Above all, it is an interior decorated to provide joy.

The fact that Matisse chose a Communist exhibition hall as the site of a public presentation of his plans for Vence should perhaps be taken to imply something more than malicious determination to make sure that neither the Church nor the Third International could claim him as its own. Perhaps it was a bid for his own conception of a universal human ideal, an ideal that does not transcend the human condition but remains firmly esthetic.

If we anesthetize ourselves to Vence's sensuous appeal, its abstract, aniconic character becomes blatant. Matisse could easily jam together the Stations of the Cross, obscuring the cosmic drama that Barnett Newman found irresistible. In Matisse's treatment, narration and extension are virtually obliterated. He illustrates no story, provides no visual climax. The only face in the whole chapel belongs to neither a god nor a man but to St. Veronica's veil, where it rests on the borderline between superstition and miracle. Representation is thus allied to tradition, convention and an old, unbelievable story. Almost as abstract as the cross itself, the "real" images in the chapel are blank-faced ovals that confront us without any implication of address or dialogue. The religion a celebrant finds here is his own. The chapel at Vence makes a first-class mosque.

A mosque is not a consecrated building. Like Judaism, Islam is a congregational religion, and the community of worshippers sanctifies the site. The mosque supports religious activity, but it does not symbolize God's house.

A Moslem would find the very idea of a house of God sacrilegiously cozy, though it is orthodox in many forms of Christianity. Like a mosque, Vence is primarily a decorative ensemble.[13]

Matisse has said that he included the black-and-white habits of the sisters as one of the elements of his composition and that he discarded the organ as providing music "too explosive," preferring "the sweetness of the voices of women." Here two tendencies of decoration that we have touched on emerge actively as esthetic principle: the extension of artistic considerations beyond the bounds of the object into the physical environment and the suppression of tense or dramatic elements. Both of these characteristics of decoration are significant in helping us to distinguish between the craftsman and the decorator. A craftsman can conceivably work for an abstract goal or for God, but a decorator works for men and women. It is *their* satisfaction, not the fulfillment of abstract requirements, that is the decorator's aim.

Christian iconography presents the garden as the antithesis of the wilderness. Man's task, in terms of nature, is to bring forth a garden from the wilderness; in terms of architecture, to build the City of God. Perhaps Vence might be fitted in there somewhere, but I think critics are mistaken in taking the earthly paradise as the content of Matisse's art. The earthly paradise as a vision or conception is, indeed, a traditional artistic theme, appearing in forms as diverse as those of Titian and Edward Hicks. But Matisse is not projecting an ideal or following any identifiable iconographic program. He is providing an immediate experience. Matisse leaves your mind alone. The experience he provides is sensuous and emotional, and intelligence impinges only when you resolutely invoke it to discover the causes of such order and delight. The experience of decoration is typically celebrant and content-less, like the psalmist's praise beyond reason. That is seldom true of artistic experiences.

The impulse to decoration was strong in Matisse from the start. The development of that impulse entailed a process I shall call the estheticizing of art. When Matisse undertook to provide increasingly intense visual pleasure he unconsciously accepted the primacy of decoration. Then, proceeding "naturally," out of is own preferences and distaste, he detached his art from the expression of self and from the drama of human existence, with its implications of struggle, pain and death. He got rid of visible moods, atmospheres, seasons. In the '30s something he called "intimacy" drained away. In order to keep visual pleasure unalloyed Matisse had to undercut his subject matter, separating it from recurrent human occasions and turning it into studio furniture.

That is why the still-lifes don't suggest meals or the bounty of nature or collections of precious or meaningful objects. He combines all the major still-life traditions, preserving none. That is why his women are neither sex objects nor individualized people but models, studio furniture. The artist's working space is an island, an art-box where nothing truly exists except light, art materials and art. Within the studio the differences among a nude, a sailboat and a pineapple become negligible. They are all, here, vaguely *artistic*—nice things, agreeably arranged.

Insofar as it represents a private enclave in a public world, Matisse's studio is the art-box the Dadaists wanted to smash, that the Abstract Expressionists wanted to turn into a spiritual gym. Its isolation, banality and pretentiousness infuriated both groups. Matisse was not unaware of the problem, but he had another solution. "Revelation came to me from the Orient,"[14] said Matisse, and he turned the personal art-box into an open gazebo, an empty ornamental pavilion that anyone can enter.

The process of estheticizing painting occurred in America in the '60s under the aegis of Formalism. The same process presented itself to Mastisse as decoration. The action was identical: a progressive drawing-off of interest from subject matter and a simultaneous concentration on the flat, colored surface and other formal properties of art. Major steps toward the assimilation of painting to decoration had already been taken by the Impressionists, and Meyer Schapiro is surely correct in insisting on the importance of the development of Matisse:

> The leap from "Impressionist" realism to a theory of abstract design was easy because the subject matter of Impressionism was already aesthetic…. For the first time in the history of Western art aesthetically valued objects had become the … dominant subject matter of painting…. For the Impressionists the meaning of the painting pertained to its whole and was primarily aesthetic.[15]

If we compare a Matisse to any Impressionist painting we see that decorative force has considerably increased. His range of topics is even narrower than theirs, and he has equalized figure-ground relationships (not by dissolving the forms, which would sacrifice line, but by getting rid of air altogether); backgrounds are given such saturation and visual density that they equal the weight of the figure motif. The ultimate degradation of subject matter into a mnemonic sign corresponds to a radical flattening of space and a new stress on frames and grids.

By the end of his life Matisse's art was transformed, but the transformation does not seem to have aroused much critical curiosity. Perhaps the shift

was too slow. That the function of art differs from that of decoration is a commonplace. It is less clear that the difference encourages divergent mental activities and different ranges of subject matter.[16] Artistic themes are clusters of linked ideas and feelings. With their pull toward introspection and memory, they have little place in decoration, which is produced for immediacy and social or public occasions. Art enjoins contemplation and self-involvement; decoration forbids isolation by insisting on the feeling-tone of our surroundings, the decorum of ephemeral situations.

Even less fully have we understood that the divergent functions and topics of art and decoration entail different conceptions of form. Decoration, aiming at a unified environment, discourages isolated wholes. The painting as a microcosm, projecting the whole world into a single, unified vision—the ideal of Renaissance perspective—is inimical to decoration. Whatever tends to stress the format and the picture plane points to the fact of the image as part of the world, continuous with the immediate environment. The intensification of awareness of physical space supports a decorative function. Framing elements and grids offer formal alternatives to balanced compositions and harmonized color, which are esthetic ideals intrinsically bound to the imaginary reconciliation of mass and void, light and darkness.

The development of a distinction between decoration and art is paralleled in the historical separation of prose and poetry. Decoration and poetry are older and more basic. No culture seems ever to have existed that didn't produce songs and body ornament, or artistically elaborated utensils and buildings. There are, however, civilizations that never developed the conception of formal prose. Legal argument, the essay and the novel are prose forms, special usages of language bound to institutions and technologies that are far from universal. Art is to decoration as prose is to poetry insofar as both art and prose are specialized and ambiguous products, closely linked to specific cultural conditions.

What purpose is served by making the distinction between decoration and art? It doesn't make for a neater world. New and ambiguous forms will continue to appear, answering to more than one set of criteria.

For one thing, the differentiation can clarify our perception and understanding of non-Western art. Chinese and especially Japanese art evade our mimetic theories, while Islamic art repudiates them. Then, too, marginal forms of artistic production—folk art, costume, landscape architecture, for instance—may use art elements but better repay assessment in terms of decoration. An intelligent appraisal of decoration may also clarify our relationship to art. The interpretive expansion of meaning proper to art is confusing and irrelevant when applied to decoration. Decoration may lack intellectual freight, but it's not stupid. It does yield to rational investigation.

Finally, we need to think about decoration for practical reasons. Our standards of decoration are deplorable, even as we begin to define the amenities of life in terms of perceptual order as well as consumption. The impulse to decoration is a will to esthetic satisfaction independent of ideology. There is no reason why Matisse's revelation should not become our own.

1 "Rever a trois aubergines," Dominique Fourcade in *Critique*, Vol. XXX, No 324, p. 474.

2 *Matisse on Art*, Jack D. Flam, Phaidon Press, 1973, p. 147.

3 *Henri Matisse; Ecrits et propos sur l'art*, Dominique Fourcade, Hermann, Paris, p. 235.

4 See, for example, Fourcade, ibid., p. 318, from a statement to this effect from 1951. At times, however, Matisse's statements imply that artistic creativity is autonomous and totally independent of nature. For example: "The importance of an artist is measured by the number of new signs which he has introduced into the artistic language" (Fourcade, ibid., p. 172).

5 "*Les soixante ans de Henri Matisse*," André Lévinson, *L'art vivant*, Jan., 1930.

6 Fourcade, ibid., p. 332. "*Créer, c'est exprimer ce qu'on a en soi*" (1953).

7 Ibid., p. 260.

8 Ibid., p. 267.

9 Ibid., pp 144-150, passim.

10 Ibid., p. 148. "Comme le livre sur le rayon d'une bibliothèque ne montrant qu'une courte inscription qui le désigne, a besoin pour livrer ses richesses, de l'action du lecteur qui doit le prendre, l'ouvrir et s'isoler avec lui–pareillement le tableau encercle dans son cadre...."

11 Ibid., p. 308.

12 Ibid., p. 308.

13 It is closer to a Turkish mosque, where the exterior is plain and the tile and color are on the interior, than to an Iranian mosque.

14 Ibid., p. 204.

15 "Matisse and the Impressionists," Meyer Schapiro, *Androcles*, Vol. I, No. 1, Feb., 1932.

16 For example, the relegation of mythological subject matter to decorative art was worked out in practice in the 18th century. Iconography does not distinguish between art and decoration or between the seriousness or fancifulness of literary meaning. A full artistic experience requires belief— the viewer's, not the artist's—and subjects perceived as serious.

The Content of Decoration

by Emna Zghal

Reading Amy Goldin's "Pattern, Grids and Painting" was an aesthetic shock. I immediately wanted to read all she had written, and figure out how she came to be so insightful about matters that always animated me as an artist, but that I could not articulate. Her voice was penetrating, and feels relevant to this day over thirty years after she wrote her amazing essays. The opposition between the composition of conventional easel painting and the grid has always been a gripping question for me; Goldin offered a thorough and wide-ranging inquiry into the matter.

I was trained as an artist in Tunisia, where some of my professors were then interested in geometric abstraction, Islamic motifs, and Berber signs and symbols. With them, I had my first exposure to an educated appreciation of the endless walls and floors of tiles I grew up around. They also transmitted with urgency principles of composition. We were supposed to create unique and autonomous images and not uncontained surfaces that could go miles on end.

Years later I started making woodcuts, and woodgrain quickly became the image. I then realized that what made pattern interesting to me was precisely the infinity it conveyed, and it was ironic that it was infinity I was taught to discard. I was interested in the patterns of nature, which unlike the manmade grid, conveyed extension without being totally predictable.

In her article "Patterns Grids and Paintings," Goldin opposed composition and grids as follows:

> However complex the execution of a composition may be, seeing a composition is easy. It is a deliberately engineered reprise of ordinary looking. Whenever we face some corner of the world, we are likely to find some parts of the display more interesting than others, to move our attention there and to check out the rest as subordinate

setting. The hierarchic, relational aspects of pictorial composition simply displace and harden the usual process of floating, intermittent attentiveness.

Scanning is a much more specialized, anxious kind of looking. It contains an element of search, and unsatisfied search at that, since it implies a restless refusal to focus and an attempt to grasp the nature of the whole. The characteristic response to pattern and grids is rapid scanning.

What I was pursuing and still pursue with my random organic pattern is to compel the viewer to float, scan, and search. Goldin also makes this piercing observation: "Few things on earth are more pointless than a grid seen through a temperament...." That resonates on more than one level.... Much of the Islamic visual aesthetic is about abnegation and humility-the absence of temper. This is often conflated in Western writing with censorship, lack of self-expression, if not outright oppression. It does not matter if Muslims understand it as a step or a method of accessing what looms above us and beyond our immediate comprehension. It is touching that she actually saw it as *dumping vision in favor visibility*.

Goldin studied what is called Islamic art, which she did not wish to divorce from the political and cultural realities of its perception. As a Tunisian, when I read Western analysis of my culture, I arm myself with a healthy measure of skepticism in order to separate out genuine insight from Western fantasies. In "Islam goes to England," she notes: "Yet the Festival also embodied the re-emergence of an old, half-real, half-imaginary 'Orient,' an abstract Islam, disembodied and devoted to exotic luxuries: carpets, incense burners, manuscripts written in gold." She was well aware of the pitfalls that surround Western fascination with the subject. The emotional knockout that a Persian carpet at the Met or a Matisse cutout might have had on her was celebrated by questions and rendered with verve. At times, however, her assertions are disconnected from reality, i.e.: "The mosque supports religious activity, but it does not symbolize God's House." That is flatly untrue. The mosque is frequently referred to as the "House of God" in Arabic; meanwhile the building fulfills different social functions in India than it does in Tunisia. It is worth noting that such observations stand out still by their intention. She wanted to explain that the sacred is experienced differently, and implicitly advising the reader to shed her accustomed associations to key into the work. This is rather uncommon in art magazine articles. Customarily, it is rather the familiar exoticism, pity, guilt, or some

eroticized combination thereof; that are elicited to justify interest in the art of the "other."

"The enjoyment of patterns and grids, so often linked to religion, magic, and states of being not-quite-here, requires an indifference to self-assertion uncongenial to most Westerners," wrote Goldin. It was however congenial to a notable Westerner: Matisse. Goldin's thesis is that the cutouts are a culmination of Matisse's life long work. However Matisse's late works look divorced from the conventions of easel paintings, Goldin notes that the content of his earlier nudes, still-lifes, and interiors were already about something else than that which we are accustomed for such paintings to be. She contends "that is why the still-lifes don't suggest meals or the bounty of nature or collections of precious or meaningful objects. He combines all major still-life traditions, preserving none. That is why his women are neither sex objects nor individualized people but models, studio furniture.... Within the studio the difference among a nude, a sailboat and a pineapple become negligible." This article is animated by a quest to reconcile "self-expression" and "decoration." I frankly never perceived them as contradictory—and Matisse didn't—but I appreciate how tense their coexistence is in the minds of many. Decoration, she asserts, "is mere because it is intellectually vapid.... Second, decoration is conceptually bland." She also observed: "As Matisse's cut-outs sometimes remind us, decoration can be solemn. The mindlessness of decoration does not deny it a considerable emotional range." I find it hard to reconcile her appreciation of that emotional range and the assertion that decoration is content-less. I read most of her work as precisely bringing to bear the content of "decoration." What she refers to at the end as "Matisse's revelation," is precisely finding content into what seems vapid and bland. Moreover, it is bland and vapid, as she rightly observed, in order to make room for other kind of engagement. It is engagement nonetheless, and if art is expression, communication, and persuasion, then decoration is something to contend with.

Perhaps the most intriguing statement she made in this article is:

> The development of a distinction between decoration and art is paralleled in the historical separation of prose and poetry. Decoration and poetry are older and more basic. No culture seems ever to have existed that didn't produce songs and body ornament, or artistically elaborate utensils and buildings. There are, however, civilizations that never developed the conception of formal prose.

If her observation is true, the dismissal of decoration would originate from the same impulses that find poetry so threatening. Plato wanted to

banish poets from his *Ideal City*. It should be noted also that the Qur'an was equally mistrustful of poets and warned the believers of their seductive powers. Matisse was much derided for wanting his art to feel as restful as an armchair. It is reasonable to assume that an art that does not wish to engage one's temper, as she put it, and aims at delighting one's senses is looked at with the same disdain and mistrust as poetry. Reason compels us to keep imagination and the senses in check; what a waste when is dealing with art. "Decoration may lack intellectual freight, but it is not stupid. It does yield to rational investigation," Goldin wrote. That is exactly what she did. She carved out, in rational terms, room for visual poetry.

Artforum, September 1975

Patterns, Grids and Painting

Pattern, for Americans, has never even been an esthetic issue. Our artistic self-consciousness developed out of painting and, perhaps, architecture. Associated with decoration and the machine, pattern was always outside the area of legitimate artistic concern. The stylistic revisions of the last decade or so—remember the defense of boredom?—might have been expected to alter that situation. Yet to artists now working with pattern (especially women, who may feel it as something particularly their own), it still seems to imply a lack of inwardness and freedom, and they are often defensive about it. Pattern carries the aura of craft and contrivance, although many individual aspects of pattern—its affinities with number, rationality, mechanical production and depersonalized imagery—have been reclaimed for art. Pattern itself remains unanalyzed, its salient characteristics unknown. Unlike painting, pattern has no mystique, and it has been underground so long that thinking about it reveals surprising complexities. I'll try to start at the beginning, although that is already a lie. There is no beginning, middle or end to pattern. Its boundaries are vague, or, at least, I frankly don't understand them. Perhaps I should just say that what follows seems to me to be generally true.

It is ordinarily supposed that pattern is the repetition of a motif; it isn't. The crucial determinant of pattern is the constancy of the *interval* between motifs, a fact easily demonstrated by anyone with access to a typewriter. If you preserve the spacing between sequences of letters it doesn't matter what letters or marks you use, a pattern will appear. On the other hand, a single motif, like a rubber stamp, irregularly applied to a sheet of paper does not yield any sort of pattern at all.

Two warnings are in order. First, we must distinguish between the creation of pattern and allusions to it. Early Matisses, like *La Desserte,* refer to patterned cloth as a pictorial element, but the motifs are so large, inter-

rupted and dispersed that pattern does not actually appear. At the beginning, Matisse's painted pattern no more *is* a pattern than the painted lemon is a lemon. And when he does begin to use true pattern, he is very cautious. He chooses small, simple linear motifs: stripes, diamonds, squares.

Second, a pattern only comes into phenomenal existence when there are enough repetitions of the space/interval to establish it clearly as a unit. On a typewriter, four or five rows are needed if you are using the short side of the page and varying the "motif" (which, of course, engenders small-scale differences in the shape of the intervals). To clinch the demonstration, introduce a new sequence of spacing in the next four lines. The result will be legible as *two* patterns, regardless, again, of the marks you have actually made.

The naïve assumption that pattern is the repetition of a motif is fatal to any sophisticated understanding or use of it. That assumption ignores the possibilities of pattern because, in effect, it allows the pattern-maker to vary only the way in which his motif is stated. This does not necessarily vary the pattern itself. The truth of that statement depends on what you decide to call "the pattern itself." It seems natural to say that one pattern can have variant forms or that you can perceive a whole range of changes as presenting alternative forms of a single pattern.

Taking interval as a constant, then, a single pattern can be maintained through changes in motif, through changes in color, and through changes in density (the scale of the interval relative to the size of the patterned area). Of course the "feel" of the pattern will be different as it passes through those changes, but the juxtapositions of variants will usually, under scrutiny, support a sense of family resemblance. The mutations will seem internal, genetic. On the other hand, if you change the interval while any or all of the other variables remain constant, the difference feels radical. The new pattern appears as a transformation, a system change. *The conceptual richness of pattern can be fully realized only through the juxtaposition of related patterns.* That is why pattern books and fabric stalls from Bloomingdale's to the souks exercise their perennial fascination. While a single pattern may be boring, traditionally offering nothing beyond its own sensible identity, the confrontation of related patterns inevitably teases the mind, evoking the presence of hidden laws and an infinity of legitimate, unexpressed possibilities.

In the context of pattern, the elements of drawing take on an unexpected weight. Thicken a line here, flatten a curve, deepen the tone—it's not simply a form that changes. The rhythm of the whole alters. The effect of variants in pattern, sometimes subtle, sometimes violent, is hard to describe in the usual

formal terms. Our esthetic vocabulary was built for unique forms and close aggregates, and in pattern nothing is unique or closed. Orchestration is all.

Pattern can be so enthralling that the convert, disengaged from the usual pleasures of painting, begins to feel that only the most outrageous prejudice keeps pattern from receiving the artistic enthusiasm it deserves. But this, too, is naïve. Pattern is not an extension or variant of picture-making, although bits of it can be pressed into serving pictorial purposes. Pattern is basically antithetical to the iconic image, for the nature of pattern implicitly denies the importance of singularity, purity, and absolute precision.

A lot of painting—perhaps most of it—aims at perfection. The enthusiasts of pictures continually call our attention to the impossibility of changing a single stroke or nuance. Like a brimming glass of water, a painting full of meaning or feeling cannot easily tolerate any addition, subtraction, or displacement. Pattern, on the other hand, once established, is incredibly tough. Islamic artisans traditionally put "mistakes" in their patterns as a religious renunciation of perfection, which belongs only to God. Their mistakes disturb nothing. A demonstration of the irrelevance of perfect form.

A more crucial threat rises out of the relationship of pattern to iconic meaning. Many people believe that the interdependence of ideas and forms is what gives art its intellectual dignity. Pattern vitiates the impact of form and turns thought into ritual. The link between a perceptual form and its extraformal meaning is normally fragile, and requires support from the context in which it occurs. Mere repetition is dangerous enough—repeat any word ten times in a row and it becomes pure sound. Pattern is lethal and can kill the power of any image. Simply regularizing the interval between pictorial elements makes forms lose their individual meaning. They become motifs whose similarity overrides any differences among them. It is here, in the difference between motif and subject, that the true "mereness" and "abstractness" of pattern lies. Pattern trivializes and degrades its themes by turning them into esthetic details within a larger, more inclusive form.

In effect, patterned repetition in space has the same consequences as the repetition of symbols over a long period of time. To see the same image over and over again in a variety of situations disengages the control of context and erodes meaning. Without institutional control, religious symbols readily become lucky emblems and ultimately "mere" decorative motifs, as we can see from the fate of many pagan and Buddhist themes. From a strictly artistic point of view, the absence of referential meaning is not necessarily a loss.[i] The artistic impulse is promiscuous—it doesn't necessarily take a

respectable idea to turn an artist on. Like the gilded fly, he'll go to it on any occasion.

Consider Warhol's early use of repeated images. They presented the paradox of an emotionally loaded subject (the car wrecks, riot scenes, electric chairs) which flickered between carrying and failing to carry its expected emotional response. That paradoxical effect was attributed to Warhol's schlocky color, the coarseness of handling, or the associations to mass media. Yet perhaps the crucial step was just the regular repetition of the motif, which suddenly made it possible to see the picture as a pattern and its subject as a motif. Certainly, similar themes and treatments never had the same flattened, brutalized effect in Rauschenberg's hands. They remained stubbornly, if vaguely, *poetic*—his sensibility is implacably intimate and nuanced. When Warhol began to use sentimental images, flowers, cows, portrait heads, the same pattern format sabotaged the sweetness as effectively as it had previously undercut the horror.

I think it is impossible to respond *simultaneously* because each evokes a different mode of perception and different kind of esthetic experience. Each engenders a specific kind of attention and particular sets of expectations. The sets are psychologically incompatible and the kinds structurally distinct. The fundamental structure of pattern is the grid; any pattern can be reduced to some grid. I suggest that grids and compositions are cues to different mobilizations of self. It may seem excessively magical to claim that in choosing one type of organization or another, the artist establishes a fundamental relationship to the viewer that no later artistic decision can abrogate. Yet we all learn to mobilize our attention in a variety of ways, and have undoubtedly learned how to respect and set aside the cues for various sorts of attending. This is true even though we may not be able to say exactly what those cues are.

Compositions breed involvement, intimacy and references to self. Grids generate a greater emotional distance—a sense of the presence of objective, pervasive law.

Composition arises when an artist wishes to snare somebody into sustaining attention to a complex whole. He must keep his forms and form elements together without overloading or impoverishing his field. Any composition has focal areas, and locally intensifies and submerges control over the perceiver's activity as he moves over the work as a whole. In the nontemporal arts, sequence and tempo are established by exploiting the similarity and contrast of forms.

However complex the execution of a composition may be, seeing a composition is easy. It is a deliberately engineered reprise of ordinary looking. Whenever we face some corner of the world, we are likely to find some parts

of the display more interesting than others, to move our attention *there* and to check out the rest as subordinate setting. The hierarchic, relational aspects of pictorial composition simply displace and harden the usual process of floating, intermittent attentiveness.

Scanning is a much more specialized, anxious kind of looking. It contains an element of search, an unsatisfied search at that, since it implies a restless refusal to focus and attempt to grasp the nature of the whole. The characteristic response to patterns and grids is rapid scanning.

Why should an organization that is instantly recognized as regulated and lawful evoke so unquiet a response? I think it is because the linear grid, whether it is expressed or implicit (as in pattern), is disorienting. It has no intrinsic shape, no body or geography of its own. It is a featureless field of equally stressed marks, a sea of notation that demands justification as a form before it can be investigated in detail. The first requirement in any unfocused situation is to locate the boundaries of the field, since the boundaries alone can provide orientation. Thus any pattern or grid is initially scanned in order to establish its relationship to the physical world. It demands location as a physical unit. Does it also provoke justification in terms of a larger situation? If so, that "requirement" initiates the philosophical aspect of pattern.

Unless framing elements are stressed, grids are centrifugal. The possibility of unframed grids arises because the regular juxtaposition of repeated units itself establishes a unitary area or field. Thus, exhibitions of series art and Conceptual art (both of which are normally hung to equalize the importance of their component parts) very often yield visual, unframed grids. Sometimes the arrangement is more than just practical. In Robert Ryman's work, for example, the grid is eminently suited to his subtle, static fields. They require such a close focus that the grid extends beyond the range of peripheral image and thus functions as the context of the viewer and his visual field simultaneously—a zone of silence. In Helen Frankenthaler's recent show of ceramic tiles at the Guggenheim, on the other hand, the presence of the grid was baffling. Were the tiles supposed to be tiny pictures of disjunctive units of a complex whole? In the immensity of the Guggenheim's dynamic space, the question seemed less urgent.

Grids are nonhierarchic and nonrelational, but that is not because relationships among its components of the grid are necessarily equally stressed. A grid is nonrelational because its internal spatial relations are marked out as invariable and therefore inexpressive and disregardable. Its shapes are thus not shapes at all, but authoritative markers, indicating the space and rhythm by which we are to perceive the whole.

Alfred Jensen. *According to the Numbers, Per III*, 1973.
Oil on canvas, 72 x 84 in (182.9 x 213.4 cm).
Photograph by Ellen Page Wilson, Courtesy of the Pace Gallery
© 2011 Estate of Alfred Jensen / Artists Rights Society (ARS), New York

By denying informational value to shape, the normal carrier of form and content, the grid offers nothing more (or less) than a seamless experience of measured space, the experience of visual order itself. A grid is an isolated, specified, unlocalized field, as close as we can come to perceiving pure being, free from any added rationale or emotional activity.

This being so, it is not surprising that artists who begin with the grid usually proceed to destroy it. The step most commonly taken is the reintroduction of shape, either by breaking into the regularity of the field (turning the grid itself into a stressed shape) or by interrupting the unbroken equality of its internal relations. Turning the interval into a structural module naturally entails a return to shape and composition. The toughness of patterns, in which the grid is normally unstated, is utterly reversed by actual grids, which are extremely vulnerable to inflection. They easily lose their unitary, nonmaterial character and become a kind of composition—usually called constructions, lest the module escape your notice. Like all other constructions, grid-derived works are more or less tidy, more or less arbitrary. Subjected to the hazards of illusionistic perspective, illumination and material process, grids lose their metronome effect and return to the everyday world of things and symbols.

Few things on earth are more pointless than the grid seen through a temperament. Like an artificially illuminated sundial, it dumps vision in favor of visibility. The *experience* of the grid can be interesting, but the form itself is noninformational. An "interpretation" of it is somewhat more vacuous than handwriting analysis. As an aid to art-making, the grid is trivial, a mechanism out of Creative Playthings that guarantees neither order nor ingenuity. It has no more claim to intellectual significance than correct anatomy. Nevertheless, if you start with a grid, it would seem merely intelligent to stay with it and investigate its own odd nature, turning your materials into a substantiation of *it*. Surely the strength of artists as diverse as Alfred Jensen and Agnes Martin lies significantly in their unwillingness to subvert the grid.[ii] On the other hand, artists like Ryman and Kelly, whose strength lies apart from rhythm and intuition, are sufficiently sensitive to interval to keep their relationship to the grid submerged, holding it as an unstressed backstop. It keeps their views locked into relating to the sameness of their different surfaces.

Most semidestroyed grids are pretty boring. Preserved grids, if the artist can hold you to them, are pretty interesting. Grid structures with submerged asymmetries, of the sort found in Near Eastern carpets and some Buddhist paintings, are notoriously esthetically satisfying in a way that even good paintings are not. The enjoyment of patterns and grids, so often linked to religion, magic, and states of being not-quite-here, requires an indiffer-

ence to self-assertion uncongenial to most Westerners. When I suggested that grids evoke the experience of law, I did not mean to speak metaphorically. It is one of our cultural quirks that we find law and creativity an odd pair. Charismatic personalities are another story—we expect creativity from *them*. Our art history is the history of big artists—yet little artists, making small contributions to a collective articulation of form, embody an equally real creativity. An enormous amount of the world's artistic production has been made as the process of discovering possibilities within rigid frameworks, like the requirements of the crafts or the structure of the grid. We are only beginning to think about such things.

i When the audience for a work doesn't share a wide range of attitudes, the lack of stress on iconography can be a positive advantage, freeing it from sources of possible resistance.

ii I find Martin's titles over-concrete. They are undoubtedly part of the history of the work, but they are irrelevant to its immediate lyricism.

Art in America, January/February 1974

Zuka at Betty Parsons

Zuka's paintings are decorative portrayals of the present day heroes of American liberals—those nineteenth-century figures whose lives and work are interpreted in terms of blackness, femininity and ecological awareness. Since these are not portraits, but icons, the figures are presented as ritual simplifications, spiritualized dolls who stare at us hypnotically. Often they clutch their printed legendary names which sometimes hover around their heads, like those of Byzantine saints. Yet we are not permitted to worship— the stiffness, banality and ornamental energy of flat gaudy color and collaged patterned paper forbids it. The double bind of moral seriousness thus claimed and simultaneously denied resolves into irony.

The irony is there, all right, and of a peculiarly up-beat kind, but for me it doesn't explain the fascination of this show. What makes an art exhibit interesting? Artistic quality? But that isn't necessarily involving; work can seem pointless no matter how well it's done. The stimulation of personal feelings? But why should I care about your personal feelings, or you about mine? No. Art is objectively interesting, I think, when it binds public and private matters into undigestible lumps and threaten our pigeonholes. Zuka's show is interesting because of its relationship to a recently shattered pigeonhole: women's art. Almost everything about her work—its stress on ornament, its concern with personality, the deliberate naiveté of color and line—fits perfectly into that bit of condemned housing.

Two years ago its blatant femininity would have marked it as trivial and obliterated its art. Now the same feminine identification will signal "women's lib" and dues will be paid to its political position. It is still not likely to be seen as art. Decoration—more particularly, pattern—is rarely conceived or understood as an artistic resource.

The point of Zuka's patterns is not that they're there but what she does with them. Until we learn to pay attention to *that*, women's lib is artistically

irrelevant. After all, if the usual artistic clichés continue unchanged, it hardly makes any difference whether the perpetrators are male or female. Equal pay for equal work is not an artistic goal. In relation to art it doesn't mean revolution—at best a changing of the guard at the same old palace.

I'm not suggesting that women are genetically, socially or morally obligated to make art that can be called "decorative." But for some peculiar set of reasons, decoration is presently associated with women, and correspondingly excluded from artistic seriousness. The role of the decorative elements in "serious" art, therefore, can be exploited by women to their double advantage: it can work for them politically, and it can expand the range and power of their work.

Zuka's show is drawn from her work of the last year and a half, and it covers the period in which she first began working with collaged areas of industrially produced pattern. It is instructive to see how the integration of pattern in her paintings has affected her color and drawing, and ultimately even the ideas she works with. She has always been a highly decorative painter as can be seen in *Cheyenne Braves*, one of the best as well as one of the earliest paintings in the show. Here the pattern-bearing elements are used architectonically and are absorbed into the subject matter. Flat, regularly repeated small-scale shapes of feather and costume are clearly decorative. They serve as color accents and create rows of rapid horizontal flicker against the slower repeats of the three standing figures, establishing a basic grid format for the painting as a whole.

To compare the *James Brothers* with *John Muir and John Burroughs* on opposite sides of the doorway, however, is to see the formal development accompanying the inclusion of collaged pattern. The painting of the two naturalists is conceptually more ambitious, aiming as it does at the integration of figures and landscape. Yet the *James Brothers* look less illustrative and less frivolous. Here, in order to meet the requirements of collaged areas of commercial wallpaper, the artist has been forced to tighten her control of line. Edges don't bump around so much. They function more precisely as contours and less as arabesques. The range of small- and large-figured pattern has also entailed an increased sensitivity to scale. Since painted details are no longer the sole elements of rhythm and decoration, Zuka can forego their cosmetic effect and begin to integrate them.

In the earlier work, surfaces are uniformly flat and dense, except for the treatment of faces and hands. There a broken, painterly surface suggested the vulnerability of flesh in contrast to the inorganic solidity of the objective world. Now that areas of collaged pattern add new variations of density, the surface begins to open up and breathe. The color becomes more exact, less raucous, for it must be adjusted to an alien palette and a more flexible space.

With the series of small heads and *Young Lincoln and His Wife*, a near transfusion has occurred. The pervasive textural variety and the wider psychological range make these true portraits instead of cut-out faces. The patterned papers have come to express emotional overtones as well as formal values. With *Susan B. Anthony, Virginia Woolf* and *John Muir II*, spiritual intensity no longer depends on staring eyes. Diffused, it is carried by the thrust of a head, the tension of juxtaposed patterns and the new sobriety of color. The paintings are no less decorative than before: ornament itself has broadened the way.

Art in America, January/February 1976

Abstract Expressionism, No Man's Landscape

Abstract-Expressionist painting has often been linked to landscape themes, by critics and by the artists themselves, who have used landscape titles or have included suggestions of landscape in the total image. Twenty years later, that conjunction of style and theme seems particularly piquant, as nature and artistic spontaneity seem to be receding into an irretrievable past. Yet I don't believe that American painters in the '50s had any real interest in landscape, although I admit that the regularity with which the topic arises poses a problem.

In their own time, Abstract-Expressionist painters and critics had recourse to the idea of landscape for reasons that probably had little to do with imagery. The association then depended primarily on scale. Today, big paintings have become so much a normal expression of artistic seriousness that size seldom measures anything but the artist's ego. It meant something more, or at least something different, in the '50s, when the Abstract Expressionists suddenly expanded the normal size of a canvas.

For them, the big picture signified a rejection of preciousness and skill. It repudiated the viewer-connoisseur and solicited a situation in which the power of the work would reach everyone in its vicinity. The new paintings looked as big as all outdoors, and they aimed to present overwhelming forces, evoking the grandeur of nature itself. Only after the psychological consequences of size had been digested did esthetic consequences appear. These have been so frequently discussed that there is no need to go over familiar ground. We need only notice that size affects esthetic elements differentially. It makes the biggest difference in relation to color, where a really big area can change your sense of the total amount and quality of light

around you, and in relation to line, whose kinetic forces increases geometrically with the amount of the visual field it covers.

For those of us who saw Abstract Expressionism arrive, the impact of the new scale was unmistakable. We had never been flooded out by paintings before. And it still makes sense to distinguish among the Abstract Expressionists on the basis of the decision to make line or color carry the emotional freight. The major artists who chose line, Pollock and de Kooning, now appear as the central figures of the style, while Rothko, Still and Newman fall out of the "Action Painting" faction and move easily into the more quietistic field-painting that followed. Yet politically and ideologically the latter belong with the Abstract Expressionists. They aimed at an emotional transcendence of the painting as much as any of the "wiggly-line" addicts—those who chose color also saw a painting as a spiritual vehicle, not at all as a thing in itself.

The Abstract Expressionists tried to keep their paintings open to reference even after the Surrealist phase, when referential imagery became taboo. The total disappearance of the world in a featureless unity of being came later; imageless painting without lumps or all lumps only showed up in the Lyrical Abstraction of the late '60s and '70s. For the Abstract Expressionists, the marks they made on a canvas and the way the picture surface retained or absorbed the evidence of that making were crucial elements of the experience the picture provided. Each of the major painters produced images recognizable as his own. Those images were individual as speech patterns and physical gesture are individual—biologically, temperamentally. But the personal identifiability of their pictures was not the point. It merely testified to the authenticity of their "statements." In Abstract Expressionism, both the objective world and the subjective self were supposed to be consumed in the fiery experience of encounter. Exactly that fusion of the separate parties in a quasi-existential encounter was what set them apart. It was also what their audiences were meant to achieve. The aim was a contagion of ecstasy, carried by the image that resulted from a passionate absorption in the painter's immediate, contingent situation. The encounter between a world and a self was thought of as a nearly obliterating flow of force and energy. That experience was sublime and poised for Newman and Rothko, inconceivably complex and tumultuous for Pollock and de Kooning. In any case, the stress on irrationality was artistically reasonable. It was essential if the artists were to express and elicit the melting together of subjectivity and objectivity that they sought.

Given that central vision, landscape could not be a painterly topic. Indeed, in Abstract-Expressionist painting, the presence of landscape space was a sign of failure, since it carried the stigma of emotional distance

between a thing perceived and a perceiver. Similarly, within the style, land-scape forms, like human forms, could only be suggested. Their vagueness reflected the flickering light of Plato's cave, for the Abstract Expressionists denied the validity of cool, rational observation. Under such metaphysical conditions, landscape, like everything else, can be no more than an uncertain, ephemeral thought.

In poetry, simile is a weaker, more tentative device than metaphor. Literary metaphor, by asserting or implying that A is B, not merely *like* B, grabs you by its violation of logic. When a poet hands you a metaphor you immediately know that you are no longer in the commonplace world where boys will be boys and things cannot both be and not-be at the same time. You are in the eye of God or the poet, sharing a realm of essences and mysterious unities, where the assumption that separate things have distinct, separate identities no longer holds.

In painting, however, the difference in esthetic power between simile and metaphor is reversed. Paradoxical or illogical images, which set out to depict two things at once, are inevitably tricky, as we see in Escher and certain Dali paintings. The claim that something you are looking at *is* something else is symbolism, the visual analogue of metaphor. Symbolism presents difficult problems for artists, because its effectiveness depends not only on the viewer's prior knowledge of the symbol but even more crucially on his bringing appropriate attitudes to both the symbol and the idea symbolized. And once it is understood that the painted lady is Liberty or Fertility or Death, she loses immediacy and becomes an emblem or a figure of speech. Her symbolic status can inaugurate uncertainty as to how other, non-symbolic elements in the painting are to be interpreted. There is a tendency to turn the whole scene into allegory.

The painted image can be vague, but, unlike poetry, it cannot easily embody ambivalence, a given-and-withheld decision. We probably never lose sight of a picture as a thing made, a fulfillment of somebody's intentions. The usefulness of talking about the artist's work as a "statement" depends on its insistence on the omnipresence of will and intention in the visual arts. But the idea of a visual "statement" is always misleading if we fail to recognize the inalienably concrete there-ness of a perceived image.

Nevertheless, the Abstract Expressionists tried to abandon intention and to reach a no-man's land where the ephemeral and the eternal became one. Because objective "things" and "scenes" were illusions for these artists, to talk about landscape in Abstract Expressionism perverts the premises of the style. Moreover, once the artists agreed upon the need for abstraction their titles, even when these embody a landscape reference, confirm its peripheral status. Pollock's *The Deep* and *Sounds in the Grass,* Newman's *Horizon Light*

and *Tundra,* as titles, evoke supravisual environments, "landscapes" you can sense with your eyes closed. De Kooning's titles (*Montauk, Gansevoort Street*) are often place names, but they suggest the gesture or life-style of a time and place much more than a local "look." Often, as in de Kooning's newest works, the naming of paintings is a process that begins only after the work is completed. Number 20 in his recent exhibition was nameless in the catalogue and was christened *Screams of Children Come From Seagulls* during the exhibition. Thus a landscape title like *Two Trees on Mary Street ... Amen!* does not imply that a landscape idea preceded the development of the work. The name of the painting specifies the artist's recognition of what has emerged, and the title he gives the work becomes something like T.S. Eliot's objective correlative ... it is a verbal cluster that corresponds to a non-verbal complex, a parallel invention that implies no logical or causal relation to the first creation.

For a viewer, the title of *Two Trees on Mary Street ... Amen!* focuses attention on those elements in the painting that the artist sees as essential. De Kooning's color is now as much a part of his subject matter as are his intimations of form; for at least ten years he has been working to make his originally linear style encompass fully saturated color. "Amen" in the title urges us to see "Mary Street" as a path to glory as well as a street, and the bright, clear blue may propose an allusion to the Virgin Mary's robe as well as being a passage of paint. The title helps us to see the lambent seashell-pink vertical between the ropy gray tree trunks as a spiritual ascent. As for the trees, one trunk is dissociated from its green crown, which has slid into the painting's central zone. The trees are neither here nor there, neither symbols of life nor representational forms but incidents along a path of movement. Given the title, the one vermilion spot in *Two Trees* takes on associations of blood rather than, say, fire. De Kooning's titles themselves warn us that landscape ideas do not exhaust the implications of his work. Like female imagery, landscape is for him an ever-present but passing allusion in a perennial experience's transformation and flux.

Abstract Expressionism reminds us that visual artists achieve complexity of meaning by multiplying allusions and associations. This is true whether the work is abstract or imagistic. The style's heroic, impossible claim was to assert the possibility of shared meaning in a world where units of meaning had become frayed and stale. It would be sad if our own longing for "nature" was to lead us to narrow and harden an artistic idea that these artists worked so intensely to keep open.

Willem De Kooning. The Netherlands/United States (1904–97).
Two Trees on Mary Street ... Amen! 1975. Oil on canvas, 203.8 x 177.8 cm.
Purchased 1985 with the assistance of the Queensland Art Gallery Foundation Collection: Queensland Art Gallery
Credit: © 2011 The Willem de Kooning Foundation / Artists Rights Society (ARS), New York

That Such Writing Could Be Done

by Holland Cotter

I never met Amy Goldin, but she had a big influence on me. She showed me a way to write about art. I'll try to explain. I grew up in and around Boston, Mass. I was steeped in local museum culture at an early age, which meant that I was immersed in Asian art, particularly Japanese art: the great carved Buddhas at the Museum of Fine Arts, and the painted screens.

I was a literature major in college but had a science requirement to fulfill. I scoured the course catalogue and finally found, listed under anthropology, a course called "Primitive Art." I signed up. Classes were held in an ethnology museum among masks in Victorian vitrines cases with hand-typed labels. I loved the art, the reading, the place. I wanted more. One summer I ended up in Istanbul, and on a visit to the Hagia Sophia saw a man high up on a scaffold intently examining mosaics. Someone said his name was Kitzinger. Back at school in the fall I saw that a professor Ernst Kitzinger was teaching a course in Byzantine art. I took it, loved it, wanted to get back to Istanbul right away. Being in school during the late 1960s, I was seeing a lot of contemporary art. Pop art—Warhol, James Rosenquist, Robert Indiana—was everywhere in galleries, museums and magazines. And Abstract Expressionism, with all its myths, was still a presence. Who could not be enthralled? I was. But I didn't have a print of Andy's "Elvis" on my wall. I had an Indian calendar art print of the blue-skinned god Krishna that I'd been given at Hare Krishna love feast, a big swath of cheap imported Indian cotton fabric with a busy but symmetrical allover pattern hung like a canopy over my bed. A few years after college and after a year in Europe, I came to New York and started writing about art almost by accident for magazines. This was in the mid-70s. Someone, for some reason, out of the blue, asked me to write up a show. I did; the review was printed; and I was asked to review something else. Then something else. And so it went. Like most young writers, I took the word "criticism" quite literally, as meaning that

you were supposed to say negative things at least some of the time, and the more acerbic the tone the better, the sexier. I also associated art-writing, at least for mainstream magazines, strictly with contemporary art. It seemed to me that everyone did, and that no one knew or cared about anything else.

I cared a lot about "anything else," but writing about it as an art critic, as the same critic who wrote about video, or performances, or the latest Soho shows, just didn't seem possible. After a year or so I started writing less; thought of, maybe, going to grad school; thought it as time to ditch art and go back to literature.

Then I came across "Islamic Art: The Met's Generous Embrace" by Amy Goldin in *Artforum*, a review of the Metropolitan Museums new Islamic galleries. This was in 1976. Without knowing anything about Goldin, I could tell, from her style and tone, that this was contemporary art critic, as opposed to an academic, writing about non-contemporary art exactly as she would have if it had been brand new. And she was writing about non-western art the same way she would write about western art, or any art. And she was writing critically. She had problems with fundamental concepts underlying the installation. So a critic could do old and new, familiar and exotic, after all.

But was this a one-shot thing for Goldin? A departure from her usual fare? I found out she wrote mostly for *Art in America*, so I started to look at back issues: in 1974 and '75 she wrote successively about contemporary American public art; Qajar Painting from Iran; and late Matisse cutouts. In 1976, the same year she published the Islamic piece, she wrote about Fauves, then Frank Stella. Then Islamic art again, then Calder, then African-American art.

At *Art in America* she was fortunate in having a great editor in Betsy Baker, a large thinker and a dream of a reader. But it was Goldin who did the writing, which meant such writing could be done. Of course, no one at that time could know that her work anticipated the multiculturalism and postmodernism of the future. What I knew was that Goldin was a writer for me: a source of information, wisdom, and pleasure; a sensibility with a wide-open range; a model to shoot for. She is all that still.

Artforum, March 1976

Islamic Art:
The Met's Generous Embrace

The Metropolitan's new Islamic galleries give us the gorgeous East we always hoped to find. Could any audience fail to be awed by McMullan carpets and charmed by the Houghton miniatures? Art, we know, comes in many flavors, and we learn that Islamic is just as delicious as the rest.

We may not learn much more, for the installation is nondidactic, except for the rooms containing finds from the Metropolitan-sponsored dig at Nishapur. This section is gratifyingly crowded with words, fragments and things. Here you will find almost all the Metropolitan's stuccos on view and better labels than elsewhere. Otherwise, no garnish slide show ticks away, nor are we confronted with giant textual expositions of geography or history. Almost everything about the spacious Islamic galleries proclaims this art as a feast, a come-as-you-are party that requires no special effort.

In the Metropolitan installation, the most obvious puzzle of Islamic art, its ability to flourish without painting and sculpture and without attempting to interpret the visible world, evaporates. We are gently wrapped in an atmosphere of gracious living. In Islam, it seems, art is about *that.* But isn't it everywhere? Dependence on elite patronage and the allocation of most artistic energy to the production of luxury goods are characteristics that Islamic art shares with the West. Are we so different, after all? Perhaps not. Yet the most fascinating thing about Islamic art is just those differences that, in the new galleries, all but disappear. What is missing here is the public, quasi-political dimension of Islamic art, an elimination sharpened by the exclusion of architecture.

That exclusion contributes immeasurably to the general impression of a consumer paradise; it also makes nonsense of Mr. Hoving's claim that the galleries offer "a complete survey of Islamic art." Nobody seeing these

galleries could possibly guess at the existence, much less the power, of Islam's major contribution to the world's repertory of visual form, its monumental use of architectural stucco and tile. Given the absence of large-scale painting and sculpture in Islam, architecture takes on singular importance as the only public art form we know today. With the omission of this public face of Islam, the purity and Puritanism of its art disappear from view.[1] Western assumptions about decorative art (which we associate with wealthy, secular, individual taste) obscure the special role played by decoration in Islam.

Islamic art began, developed and continues as the expression of a universal religious community in a politically unstable world. Its ability to support the identity of that community without itself becoming politicized is a curious accomplishment. In both China and the West, an initially religious art divided into secular and religious forms, and each form tended to become identified with the interests of special classes or groups. Such developments never took place in Islamic art. Its sustained identity and abstractness illuminates, by contrast, the sensuous and polemical content of the idealism in Western painting and sculpture. A heavy exposure to Islam suggests a startling view of ourselves as devoted to propaganda and lust!

Even if we grant the socio-esthetic importance of Islamic architecture, however, it must be admitted that no art reveals itself in a single form. A grasp of art-making as a regular process is necessary if we are to distinguish the general characteristics of a style or culture from the particular qualities of a sample. This is the special task that a permanent museum installation undertakes. It is not an easy job.

Western ignorance of Islam is so profound that isolated facts and broad clichés, however true, are not likely to be illuminating. To say that Islamic art shows unity and variety, and to remark that its unity is derived from religion, is not enough, if only because the very same things could as truly be said of art in the West. The continuity and discontinuity of Western art are different from the same phenomena in Islam. But an appreciation of that difference requires us to take a novel view of Europe.

European art grew from a common source: the Roman empire distributed classical ideals and imagery amongst tribesmen with little material culture of their own. The barbaric invaders from the East and the establishment of Christianity acted on the same territory. Then the Renaissance, reverberating outward from Italy, reconciled Christianity and classicism throughout a community whose economic and social interdependencies had been established through 1,500 years of shared existence. Such a gross oversimplification of the development of European art offends our normal

sense of European history. It neglects the painfully established distinctions that delineate the special identity of each European nation. For us, a predominately political discontinuity obscures the cultural community—indeed, the very idea of a European "community" seems to us no more than a vague, still unaccomplished idea.

If, however, we enlarge our view of art to include Islam, we must be prepared to reinterpret the West. Islam, exploding into existence in the seventh century, began almost immediately to spread over vast territories. Within a hundred years of Muhammad's death, the empire has reached almost the widest range it could achieve. Nowhere did the Arabs encounter culturally virgin territory; the areas into which they moved had already developed their own traditions of form and imagery. Since no such traditions were available in the Arab's own, predominately literary, culture, Islamic art began with the borrowed skills of hired hands and the strict requirements of religious converts. Its achievement of a coherent, unified style is thus quite unlike the regularities of Western art. Its unity appears as something more questionable, fragile and surprising, more closely bound to a sacred book and the traditions associated with it. It is important to keep in mind that for Islam, God has manifested himself most directly, not in Jewish flesh, but in Arabic script. The analog of the Koran is not the Bible, but Christ himself.

The iconic aura of Arabic script is important because our best clue to Islamic art comes from remembering that it is medieval. Like Western art during the same period, it has a great deal to do with skill and collective creation. (The very un-Islamic idea of the artistic genius did not flourish in Europe until the 16th century, and its value did not outprice the value of skill until the 18th.) Neither in the East nor the West, moreover, was medieval art concerned with the imitation of nature. Aristotle, otherwise so highly regarded as a sage by both Islam and Europe, was in that doctrine flatly rejected—in both cases, on religious grounds. The Christian church, having an iconic tradition to defend, came up with the idea of art as education. No theory was ever offered for Islamic art.[2] It just grew, without the benefit of ideology or rationales. If we want to claim that the unity of Islamic art depends on a shared esthetic, it becomes necessary to take the radical expedient of extrapolating one!

The absence of theory intensifies our interest in Islam's ordinary methods of artistic production.[3] As was usual in medieval times, Islamic artists were trained, rather than educated, men and apprenticeship was the normal form of training. But Islam had no guilds or any similar institution until the 15th century. Even more vulnerable than his European counterpart, an ordinary Islamic craftsman worked for a boss and did his own particular

job. Accepting the fragmentation of production, he tended to see the given aspects of form as unquestionable necessities. Change had to slip in or be imposed from above. This circumstance, combined with the political instability of the Islamic world throughout much of its history and geographic range, contributed to a constant of Islamic art: its tendency to compose artistic wholes out of a very limited repertory of simple units. This observation seems to apply to Islamic poetry and architecture as well as to the visual arts, and it is an extremely important consideration for criticism and appreciation. It is usually fruitless to look for Islamic inventiveness in the structural units or modules of its art. They are generally banal or borrowed or both. The beauty and power of Islamic art cannot be seen in wholes or individual details or in part-whole relationships, but in extended passages. (This sounds like a very arbitrary dictum and I cannot defend it. It is offered as practical advice to a Western viewer who is used to setting himself other spans of artistic attention.)

Think of carpets, so standardized in both their compositions and motifs. Or you may notice that there appears to be one way to make a good candlestick. For more than 300 years, Islamic metal candlesticks had roughly the same profile, and ceramic ones followed the metal prototype.[4] No 12th-century examples are shown at the Met, but they exist, and four complete pairs from the 13th and 14th centuries are scattered between two rooms. One late 14th-century Syrian example does not follow the old scheme, but the others typically preserve a formula. One takes a single form in two sizes. The large version serves as a base while the smaller one functions as the actual candleholder. It is fastened to the base by a short cylinder whose diameter is that of the candle. The finished product, depending on its surface treatment, can be used in the mosque or the home.

The repetition of clearly articulated parts virtually guarantees the craftsman a reasonably well designed product, but it also means that Islamic forms fall into types and get boring very fast. Usually only the treatment of the surface offers interest and vitality. The artistic attention demanded by Islamic art is, therefore, the sort that we give to highly conventionalized Western forms, for we have such forms too. With structurally rigid and standardized products like soap opera, an Albers painting or television commercials, artistic interest lies in seeing how the usual thing is done *this* time. We do not expect a single instance of the form to tell us much of anything. Yet such forms are not meaningless.

Meaning is easily found in a Shakespeare play, which can be mined for intellectual themes. Cosmological, moral and social theories are stated or implied. We can read such references inward, toward the action of the play, and outward, toward the Renaissance world and beyond it to the human

condition. The Elizabethan or Jacobean masque, on the other hand, is, like soap opera, a highly conventionalized art form. It is no less deeply implicated in the society that produced it than Shakespeare's plays are, but its immediate justification lies in the ephemeral delights of spectacle, dance and song. The dramatic action and the text are secondary, and one masque is very like another, all of them being elaborate flatteries of the royal audience. Yet the masque is far from meaningless. It is more directly related to the most ancient ritual drama than Shakespeare's plays are. It is, however, an art object whose intellectual implications must be sought in large-scale inquiries, in wide-range or long-term examinations of its habitual themes, forms and motifs, for meaning cannot easily be inferred from the object itself. [5]

Islamic art needs *that* sort of examination if we are to look for ideas in it at all. Thus it is fair, I think, to set the inalienable pleasures of this art aside and to consider the new Islamic galleries by asking whether they support a viewer's attempt to understand Islamic art. The answer must be that while the galleries are marvelous for artists, they are not terribly helpful to amateurs and people in general.

The great advantage for artists lies in the wonderful scope of the Metropolitan collection, in the range of kinds and quality it makes available. An artist will immediately see that the silver-gilt plate and the bronze vase in the corner case at the right inside the entrance to Room 3 belong to another formal sensibility than do the figures, so misleadingly described as "examples of Iranian sculpture," which flank the entry to Room 4B. Islamic Iran never really produced sculpture in the round. The dead, overgrown lion incense burner remains an overgrown object. In Islam, the full plasticity of Western sculpture is to be found chiefly in architecture and intermittently in a few types of small-scale objects.

But such considerations will not bother contemporary artists. They are not going to be upset by the stylistic discontinuities or flat-looking sculpture. For them, the Islamic collection is likely to present a marvelous pool of untapped resources for abstract art, not only because of the geometric bias of much Islamic art, but chiefly for the peculiarly Islamic relationship between structural form and surface treatments. Western art regularly subordinates decoration to form—a principle deeply embedded in our norms of "good taste." Islamic decorative surfaces have processes and powers of their own. In architecture, decorative forms have even initiated novelties of structure.

The very possibility arises because Islamic artists do not seem to conceive of the surface as we do. They see it as a physical rather than a purely visual entity. Western attention to pattern emphasizes its mathematical principles

and sees its salient characteristics in abstract process: pattern is a self-generating, infinitely extendable form. But equally vital to artists is the Islamic conception of the surface as dimensionally ambiguous, that is, as simultaneously pointing to the extension and the particular density of the material being worked. Surfaces are permeable, vulnerable matter. Grillwork and openwork are visually analogous to the modulation of the surface by light and dark, a principle vividly demonstrated in a 13th-century Kashan jug. The painted harpies, dogs and deer are perfectly absorbed into the flickering forest of openwork vegetal ornament. Here it would be very difficult, if not impossible, to derive a mathematical formula to account for the pattern. Its regularity is unmistakable, but flowing and organic. The jug's formal unity depends primarily on the regularized visual density of its very sophisticated surface, so neatly adjusted to the simple architecture of its folksy plastic form.

Islamic art seems to me to be deeply concerned with visual density, an esthetic element that has only very recently been identified and stressed in the West. We arrived at it by way of tactility or texture, which became a radical "issue" with the work of Morris Louis and its interpretation by Clement Greenberg in the '60s. Greenberg saw Louis's saturated surfaces as a mark of historically progressive form, a logical development of Cubism's explosion of plastic form into shallow, surface-hugging fragments. The canonically modern "preservation of the picture plane" that every art student learned in the '40s required close attention to the interactions of figure and ground, lest the activity of the former destroy the continuity or "integrity" of the latter. By the '60s, this concern became even more stringent. The surface was drawn into ever greater tautness, until the abstract picture plane dropped out of artists' conversations, to be replaced by t he color-saturated physical surface itself.

As we noted earlier, Islamic art has no known theoretical component, and thus no concept so abstract as the picture plane. Yet sensitivity to a need for controlling surface density can be documented throughout discussions of the only art form early Muslims recognized as such: calligraphy. Abu Haiyan al-Tawhidi, in a manuscript dated 1328 A.D., remarks: "Handwriting is a difficult geometry and an exacting craft. If it is elegant, it is weak. *If it is solid, it is easily washed off.* If it is big, it is coarse. If thin, looks scattered, if round, is thick ..." (my italics). "Easily washed off" is a baffling objection unless we think of the surface as requiring artistic reinforcement of its physical continuity so that it can "hold" a cluster of marks. Indeed, the regularized, allover density of Islamic decorated surfaces has often been noted. It is usually "explained" by scholars as a quasi-genetic characteristic of the Oriental mind, a native *horror vacui*, or primitive dislike for unmod-

ulated surfaces. No artist is likely to agree. We no longer find it so hard to understand that an Islamic artist might see strongly contrasted surface densities as disintegrating visual form and causing undesirable spottiness and fragmentation. Only bad Islamic decoration looks *merely* dense. Good examples play virtuoso games with scale shifts and contrapuntal sets of linear rhythms.

In Islam, an unmodulated surface seems to be read, not as space or air, but as solid matter. An empty surface is thus a closed mass which can and often should be opened and aerated by introducing marks or patterns. The use of enveloping fields or patterns represents Islam's basic technique for estheticizing and spiritualizing an object, dematerializing it by evoking different quantities and qualities of light.

For a Muslim, neither patterns nor images are intrinsically spiritual, but light is. Contemporary Persian shrines (which most Westerners find decadently flashy and formless) are composed entirely of faceted mirrors–pure, directionless light.[6] It may be plausible to consider Islamic pattern as the evocation of filtered light. (This interpretation was suggested by Persian art, and even if I'm right, the notion may be specific to Iran and depend on Shi'ite or Sufi concepts inapplicable to Islamic art in general.) The fact remains that almost no investigations of Islamic pattern as an esthetic element have yet been made. Art historians are still in the process of sifting motifs to establish sequences of objects and to distinguish between local stylistic developments and foreign borrowings.

Like the surface itself, Islamic line continually flirts with materiality. It flips between reference to its maker's hand and reference to depicted form with an insouciant wit matched in the West only by Saul Steinberg. You can trace its ambiguity in the cut-glass beaker or the ivory *chasse*. For part of its length, a single continuous line will serve as an independent decorative element, then become the contour of a form, only to return placidly to two-dimensionality as a nonreferential, self-determined mark. In the ivory casket, with its interlaced framing circles, forms are set now behind, now in front of hoops, in a continuous two- and three-dimensional play of closed and open, advancing and receding space. The extreme fluidity of Islamic framing elements, so marked in the miniatures, is a corollary of this peculiarity of line.

One could go on, pointing out fascinating novelties in Islamic usage of formal elements, most of them still unremarked in the literature. In the modern West, disrespect for decorative form denies its expressiveness, but little visual sophistication is required to perceive the "voices" of different styles of script. Anyone can see that it would be difficult to make Kufic script buoyant or Shikastah grave.

It must, however, be admitted that this sort of stimulus is primarily available to artists or people whose eyes are already connected to their brains. Most visitors to the Islamic galleries are in a more passive state, awaiting delectation and enlightenment. And even artists are well advised sometimes to step aside from looking at Islamic art as a possible professional acquisition. To remove completely any art from its human and social context is a kind of barbarism. In grateful acknowledgement for the splendor of its Islamic materials, the Metropolitan was honor-bound to try to restore that context. Getting it to look nice was clearly a lot easier.

The Metropolitan does not appear to find Islamic art particularly problematic. Metropolitan Islamic begins promptly in the seventh century, there all at once, like a djinn popping out of a bottle. Its apotheosis is reached in room 7, the fully lit, high-ceilinged room with Safavid carpets. It travels then, in its voluptuous maturity, to Turkey and India, and comes to a screeching halt in the early 18th century, its ethnicity destroyed by the industrial modernism of the West. "Islamic art" becomes a mythically monolithic entity, now pinned against 10 roomfuls of walls like a giant, dismembered butterfly. Some corrective information is given in the two second-rate texts that the museum provides, but the general assumption of intrinsic coherence never falters.

Islamic art is anything but pure. Early and late, there are things in these galleries that also "belong" to various non-Islamic worlds.

Europe entered into the formation of Islamic art in several stages, through the pervasive, disintegrating classicism that affected the whole Mediterranean basin, and through Byzantium. Byzantium, being Christian, was Western as far as the Arabs were concerned. They called it "Rum" or Rome, though we are usually more aware of the Eastern, particularly Syrian, components of Byzantine art. (It would be chastening for casual visitors to learn that for something like 800 years the cultural tides flowed westward—a shuttle bus between the Islamic galleries and the Cloisters could be a real eye-opener!)

On the Iranian plateau the Arabs encountered ancient Eastern traditions in a purer form. Here a highly developed technology supported refined architecture, metalwork, monumental stone sculpture and wall painting—forms of artistic production which had been in regular use from the time of the Old Kingdom Egypt. The Met also has quite a lot of the fascinating and puzzling "Sassanian silver" first collected by Peter the Great. The examples included here are not labeled as such, though their relationship to Islamic art, like almost everything else about them, is irregular and complex.

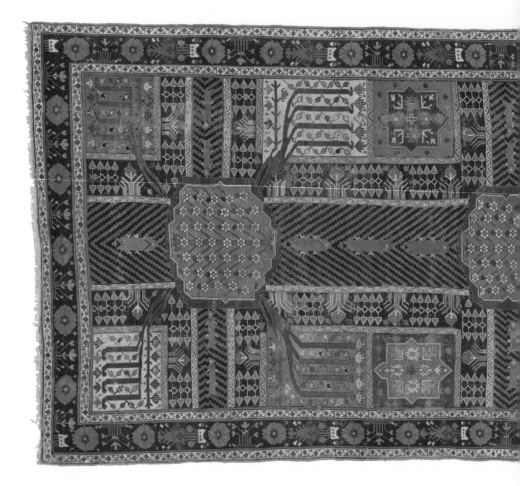

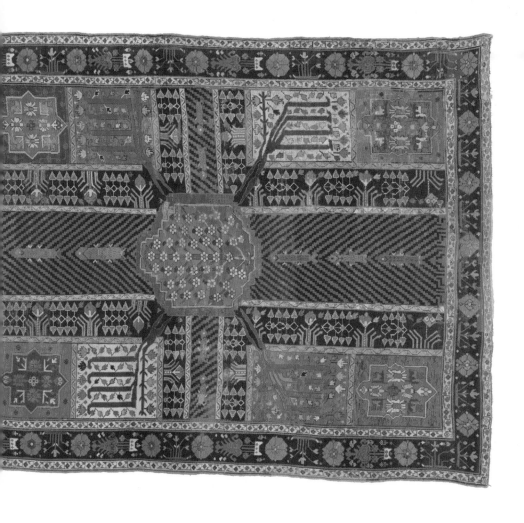

Carpet, ca. 1800. Islamic, Made in Northwestern Iran or Kurdistan. Cotton (warp and weft), wool (pile); symmetrically knotted pile. Rug: L. 223 in. (566.4 cm) W. 95 1/2 in. (242.6 cm).

A third independent artistic tradition may be embedded in Islam that we can only dimly perceive. For the last 20 years, archeologists have been hinting at the existence of a Central Asian culture with definable artistic characteristics of its own. If they are right, we may soon learn to see it in Islam, through the early importance of Khorosan, so much larger than the present northeast of Persia, and in the sequential contributions of Seljuk, Turkoman and Mongol dynasties in Iran. Central Asian sources have been cited for many elements in Islamic carpets and metalwork. In important but more specialized areas, even Chinese influences contributed to Islamic art, especially in the early phases of Persian miniature painting, in silks and ceramics. T'ang wares appear as models in the ninth century, Yuan under the auspices of the Mongol Empire, and Ming in the Oriental chinoiserie of the Safavid period. And Islamic pottery, through Spain and Italy, influenced Europe's development of majolica.

Of course the Metropolitan can't show all that, and Islamic studies are barely two generations old—there's a lot we don't know. But it is intellectually wasteful to treat Islamic art as just another pretty face. In Islamic art we feel the presence of a novel formal sense we can neither define nor assimilate into our own. Nor does Islamic art history fit comfortably into the patterns of artistic development that have been developed for Western art.

We might see it as the anachronism of medieval art that never died. Although the Metropolitan galleries strongly suggest that no significant Islamic art was produced after the early 18th century, that conclusion is, at the very least, questionable. Certainly some textile arts and some Iranian painting survived the effects of Western influence, though you have to go the Brooklyn Museum to see Zand, Qajar and Bokharan examples. Moreover, publications suggest that interesting integrations of Islamic and African traditions are visible in African architecture (I don't know of any American exhibitions dealing with that material).

Islamic art, highly synthetic from its inception, has often demonstrated how easily it can be adapted to the requirements of foreign cultures. Its history also suggests a complex relationship between the art of the rulers and the ruled, the rich and the poor, the "elite" and the "folk." The religious conversation of Seljuk, Il Khanid and Timurid chieftans resulted in distinctive forms of *Islamic* art, produced under courtly patronage. But for each succeeding wave of conquerors, the art of their predecessors, however deeply admired, was something to mark as their own. To find an analogous situation in the West, one must go back to the Roman conquest of Greece. We may note that however "Greek" imperial Roman art became, continuing

production in Greece was thenceforth irrevocably provincial, non-elite and "popular."

Barbarian conquerors quickly discover that art adds beauty, dignity and social tone to their works and lives, and they are able to afford the best that money can buy. Their art comes to define the highest type of production available, although the respective contributions of imported experts and local workmen may be hard to disentangle. Quality of workmanship and materials distinguishes between economic levels of patronage, but our categories of "high" and "popular" art imply more complex distinctions. In the West, artistic change is generally studied as a manifestation of high art. Our art is then perceived as characteristically dynamic and iconic. We interpret it as changing in accordance with shifting perceptions of a reality whose philosophic, religious and esthetic norms were codified and promulgated by elites. Popular art followed at a slower pace, dropping many high-art elements in the process. It was less "serious" and style-bound, and more consistently decorative. As a source of inspiration or innovation, it was negligible until the 19th century. Non-elite art—folk art, popular art and later, mass art—hardly figures in Western art history until the Romantics and the Impressionists. However, given Islam's extraordinary geographic range and its rapid turnover in ethnic elites between the 10th and 16th centuries, popular traditions may play a more vital role in Eastern art history. Apart from quality of execution, can we even distinguish "high" from "popular" art in Islam, where orthodox tenets deny that art has any significance at all?

In work produced for local or popular consumption, old symbols may retain special significance. Certainly, too, heterodox sects have risen to power and incorporated doctrinal messages in aristocratic or courtly art.[7] Such high art may be hard to distinguish from good-quality popular decoration. But more visible differences in class patronage also appear. While Westernization makes Islamic art history very complicated after the 17th century, it seems worth noting that in the first half of the 20th century the esthetic preferences of the Iranian elite led to the 18th-century French styles, while popular and middle class aspirations to modernity favor Art Deco even today.[8]

Such considerations give Islamic art a unique fascination that should at least color our admiration of its beauty. Its unity is undoubtedly complex, and cannot be explained as the expression of a religion or an ideology. Yet the mosque room at the Met surely ought to be up near the front, despite its rather pedestrian *mihrab*. Historical sequence isn't everything. The conflation of the Seljuk and Timurid periods seems peculiar, since they had quite different cultural orientations, and the strong articulation of the pas-

sage separating the rooms devoted to them is oddly, physically misleading. The large amount of space given to Mughal India also seemed strange, considering the pluralism of Indian art, and a relationship to other Islamic materials is often hard to grasp. Surely we are not to infer that all art produced under Muslim political control is Islamic. Without acknowledging the indigenous Indian miniature tradition, for example, it is easy to overestimate Indian indebtedness to Persian influence.

As for more specific matters, I wish the Met's lighting were more even, that mirrors sometimes had been placed to show bottoms and backs of things, and that the magnificent Nigde carpet had been hung vertically, so that it could really move. I wish *somebody* nearby were allowed to move the movable rug panels. There should be more carpets around anyway—all that white marble in the Syrian room is blinding.

Such objections must be balanced against treasures like the magnificent Spanish ceiling and felicities of the installation: the considerate provision of chairs and seclusion for the study of miniatures, the inclusion of the textiles hitherto relegated to special collections, the frequent availability of seating for looking at complicated, "slow" objects like the carpets. In terms of generating involvement with an unfamiliar art, the variety of the rooms, each of them distinct in shape, size, lighting and density of materials presented, is an important advantage. The strain of looking at so much detail is obviated by the repeated stimulus of a new environment.

The new Islamic galleries are unquestionably alluring, and the wealth of the collection guarantees its usefulness to scholars, who bring a parallel wealth of information to it. The galleries may be least satisfactory to amateurs, already enchanted with this art, but painfully aware of how little they know. We are, admittedly, a minority group, but we also represent a stage

of development through which every student must pass. It is the amateurs who may feel excluded from the Metropolitan's generous embrace.

1 As documented, for example, in the sumptuary legislation of early Muslim jurists.

2 The first known treatise on painting appears in 1606.

3 The reader will notice that the following section and the later discussion of the place of non-courtly production imply a hypothesis–that the characteristics of a style can usefully be related to prevailing systems of production. This must remain a very tentative suggestion. Professor Grabar, for example, in *The Foundation of Islamic Art*, proposes linking the general characteristics of an Islamic esthetic to the tastes and purposes of its early patrons.

4 Contemporary ewers in lavender plastic use forms that were firmly established by the 15th century.

5 These are the methods of investigation demonstrated in the French *Annales*. They require examining a static slice of local production throughout its social range or looking at long-run developments over a period of a century or more.

6 An old story, which is found in several sources in different forms, describes a competition organized by a king to determine which artists were the best in the world. A Byzantine and Chinese painter were given opposite walls to decorate, and a curtain was hung to separate them while they worked. When they were finished and the king came to inspect the results, he looked first at the Byzantine's wall. It showed a hunting scene, with all the plants and animals admirably portrayed. Then the curtain was raised and he saw that the opposite wall presented the exact same image, in reverse! Puzzled, he had the curtain lowered again, at which point he realized that the Chinese had painted nothing, but had polished his wall to a highly reflective surface. The Chinese was awarded the prize. A moral tale.

7 See Grace Guest and Richard Ettinghausen, "The Iconography of a Kashan Luster Plate," in *Ars Orientalis*, Vol 4, 1961.

8 See furniture, "Waziri" carpets, a beautiful inlaid wood lamp in the tiny museum at Fin, and the wrought iron doors produced all over the country.

Artforum, Summer 1976

Problems in Folk Art

The Brooklyn Museum is to be congratulated on having mounted a large exhibition of folk art—sculpture, specifically—that takes a point of view. Most folk art shows are compendia of everything from quilts to gravestones, blithely presented in a spirit of nationalistic celebration. Despite museum settings, art is moved from stage-center and set to mingling with the crafts. Herbert W. Hemphill, Jr., guest curator for the Brooklyn Museum, rejects that displacement. By mounting an exhibition of folk sculpture he makes the full claim for art. He eliminated quasi-commercial types of production, like cigar-store Indians, carousel figures and gravestones, because he believes such forms submerge the individuality of the artist. The result is an exhibition that has few pretty, fanciful and old-timey works, but many large-scale, emotionally intense pieces. Much of the art was produced by living artists, and some of it is even scary.

It is, in fact a polemic show, although at first only David Bourdon in *The Village Voice* acknowledged the fact. The museum director, Michael Botwinick, merely sounds nervous about the whole thing. His introductory statement in the catalogue retreats from official endorsement of the confrontation he himself has engineered: an exhibition by a champion of folk art accompanied by an art historian's catalogue essay, an essay which denies folk-art status to half the work presented and casts doubt on the category of folk art itself.

The exhibition reinforces the urgency of the questions raised by the catalogue debate. It turns out that limiting folk art to sculpture doesn't finally seem to help; theoretical and visual confusion remains. Some of the pieces are grouped by type: whirligigs and decoys. Two sections of the installation present objects that link American production to well-known foreign traditions. There are snake canes whose imagery and technique are of African origin, and an ambiguous, snake-wrapped female nude carved with an

African technique in a non-African style. There is a group of New Mexican cult figures used by the Spanish-Mexican Penitentes, whose origins lie in medieval Europe. There are shop figures, political emblems and dolls, including one that lifts her dress to display her genitals, probably a witch's doll. Then there is a potpourri of human and animal figures whose function, if any, is unknown, interestingly, there is almost nothing that could be classed as environment or assemblage. In his eagerness to make the claim for folk sculpture as art, Mr. Hemphill may have wanted to avoid sculpture of an untraditional sort.

In spite of the curator's ambitions, the esthetic quality of the work varies wildly. Moreover, not all things exhibited here can exactly be called folk art. I would prefer to call the displaced foreign traditions colonial art and other pieces, like the Bacchus tavern figure, provincial. Those categories are not as troublesome as three others also represented here: folk art, popular art and naïve art. (The usefulness of these distinctions will be defended in a later article.) Here I shall try to follow the example of the exhibition and the catalogue and lump everything together as vernacular art. As a category, vernacular art derives whatever unity it has from being contrasted with academic art—another loose term, as we shall see.

Mr. Hemphill claims the work he has assembled at Brooklyn is evidence of a "primal creative spirit, an urge to reproduce the image of life." Yet what Hemphill finds crucial to folk art is not its realism but its "reclusiveness"— the fact that it is produced as the expression of "outsiders, individuals or groups … free from the dogmas and restrictions that the dominant culture (and its academic art world) imposes." This argument repeats the claim usually made for folk art that technical means have been subordinated to the pressure of intense feeling, thereby facilitating the direct communication of emotion to the viewer. The peripheral importance of artistic form and consequent irrelevance of analysis or scholarship are implicit in such arguments. They suggest that intellectual effort beyond the requirements of documentation is beside the point. Trying to pin down the meaning and value of work may be an evasion of folk art's emotional demands, a flight into the security of pedantry.

Mr. Hemphill's statement of his position is brief, coherent and anti-intellectual. The catalogue essay by Daniel Robbins is its opposite. He contradicts Mr. Hemphill on almost every particular. An examination of Robbins's position will not tell us much about folk art, but it may explain why questions about it are important.

Because folk art is neither completely accepted not rejected as art, it has an equivocal relationship to normally accredited art. Esthetic legitimacy is primarily conferred by art historians and an art market, but the defenders

of folk art deny that art historical criteria are relevant. Folk art challenges the process of legitimization itself. In the days of the Academy, avant-garde art carried the same challenge. At the beginning of the 20th century, the rapid multiplication of styles and theories made legitimacy a matter of unmanageable dispute. Amid esthetic confusion, art historical ordering took first place. Then it entered formalist theory and assumed full responsibility for declaring what art of the past, present and future would be valid. An intimate alliance was created between the practice and theory of art. That alliance, unprecedented in modern times, gave the art world an increased cohesiveness and helped to strengthen the ties among its institutions, both nationally and internationally. It created a solidarity of authority that has outlasted the vitality of formalism. Marxist critiques are attacking that authority in Europe; here vernacular art raises many of the same fundamental questions.

As an art historian, Robbins takes his basic position from Robert Goldwater's *Primitivism and Modern Painting* where, speaking of Rousseau, Goldwater says: "It is perhaps going too far to say that true folk art is always anonymous, but at least it is always part of, understood by and reabsorbed into the environment that produced it. With Rousseau this is eminently not the case …" Goldwater's denial of folk art status to Rousseau is based on Rousseau's acceptance of academic realist goals. Robbins, writing 40 years after Goldwater, drops the question of realism. He argues that diligent art historians have traced Rousseau's compositions and themes to their sources and recommends applying the same treatment to American folk art.[i] It is strongly suggested that once the sources of apparently isolated "folk" artists were discovered, they, like Rousseau, would prove to be demonstrably dependent on high art.

One implication may be that artistic creativity is the prerogative of high art and that folk art is intrinsically derivative. Without creativity, folk art may not even be art at all, but merely the artlike product of pseudo-artists. Yet Mr. Robbins proceeds in the opposite direction. For him, specifying artistic sources and influences is a primary technique of locating art. He is willing to accept folk art as art if its themes and compositions can be derived from high art or show analogies with it.

In fact, Rousseau specialists show that he used vernacular imagery—photographs, children's books and popular prints—as well as borrowing from the Academician Gérôme. In any discussion of folk art, Rousseau is something of a red herring. He is generally called a naïve painter, but unlike most naïve painter his style develops, growing in power and refinement. His adoption of vernacular images is not peculiar to naïve art; "high" artists like Courbet and

Van Gogh did the same thing. He is a vernacular artist, however, and as such, Rousseau proves to be a red herring worth dissecting.

"Influence" and "style" are the two organizing concepts that establish the continuity of an artistic tradition. They are fundamental axioms of art history, and they underlie the profession's claim to its being a rational, even scientific activity. Once the art historian has specified a connection (i.e. "influence") between established artistic traditions and an apparently novel work, he has done his job. He has validated the new object as art and confirmed the organizing power of existing categories. It could be suggested, however, that in relation to vernacular art in general, the explanatory value of influence is questionable.

The concept of influence, which attempts to describe stylistic change over time, is not particularly vital to folk art, for it is generally agreed that folk art is more static than high art and less responsive to hanging historical conditions. Moreover, the idea of influence points to the repetition of specific artistic elements in changing artistic contexts. As Jean-Claude Lebenzstejn has pointed out, the art historian's assumption that "influence" and "no influence" exhaust the possible forms of artistic relationship is false. An artist can accept or confirm a pictorial element by repeating it— "borrowing" is the mark of influence. But an artist can reject or contradict a pictorial element, and he can also remain ignorant of it, by not seeing it or by not noticing what he sees. In practice, 20th century art history is frequently interpreted as a sequence of deliberate rejections, while folk art is usually investigated as a manifestation of ignorance. That is why Arnold Hauser's 85 page discussion of it in *The Philosophy of Art History* is headed "Educational Strata in the History of Art: Folk Art and Popular Art."

Ignorance is supposed to be characteristic of all vernacular artists, though they are not necessarily ignorant of the same things. Even Rousseau's ignorance raises problems Mr. Robbins prefers not to face. With apparent arbitrariness, he endows Rousseau with an abstract vision of art. An artist's self-image is usually treated as one thing and his ideas of art's relationship to society (if he has any) as another. Mr. Robbins conflates the two: "We encounter here another constant and deeply moving characteristic of the naïve artist: Rousseau's belief in the importance of painting in his own life, his 'unselfconscious acceptance' of the value of art in the life of the community. This is the only unselfconscious aspect of Rousseau's work. Everything else," he concludes triumphantly, "—the ideals and the means— was derived from the conventions of high art."

Rousseau's belief in himself as an artist was confirmed in his own lifetime. Dora Vallier repeatedly insists on the essential fortuitousness of Rousseau's ability to live out his chosen role as a painter. Only the estab-

lishment of the free, nonjuried exhibitions of the Indépendants allowed him to present himself as a professional, an artist among artists. The annual salons undoubtedly sustained Rousseau's self-image. The mockery of the critics could be borne as part of the artist's life.

Artistic self-confidence does not entail belief in "the value of art in the life of community." All we know is that Rousseau obviously saw that official recognition of artists brought them wealth and honor. Why does Robbins invest Rousseau with social consciousness and a role for art within it, as if that ideology were an aspect of any robust artistic ego? The answer is that as an art historian Mr. Robbins has a stake in something he calls "tradition." For him, art is not simply the product of Mr. Hemphill's creative individual, but production of a special type attached to an intellectual system. Without conscious participation in a system perceived as universal, didactic and impersonal, the artist can claim no "content" for his work beyond play or egotism. Robbins wishes to annex Rousseau for high art. Therefore, Rousseau *must have had* such a vision of art, even if he had to have it unconsciously.

Robbins rejects the idea that any isolated artist can "represent the vision of the common people, that through him, mysteriously without the intervention of guides from the instructed classes, the common people have found plastic and permanent form." On the other hand, he adds: "But the artist who can take [non-art] material and invest it with civilized meaning, in the tradition of great and always self-conscious art, belongs to high art." (Mr. Robbins has the preposterous notion that the use of popular imagery makes modern folk artists out of Lichtenstein, Johns, Warhol and Dine— but let that pass.) Since Mr. Hemphill would obviously claim "civilized meaning" for his folk sculpture, the theoretical difference between two men comes down to a dispute over the importance of "self-consciousness" on the part of the artist. Mr. Hemphill is prepared to grant the status of an artist to anyone who can produce emotionally powerful, esthetically satisfying form; Mr. Robbins denies that such form can be produced without awareness of the traditions of high art, though he never explains what they are or why they are so important.

"High" art generally refers without distinction to work from a variety of periods, ideas and styles. It stems from the Renaissance fusion of pagan and Christian themes rationalized by a heady, Neo-Platonic idealism. That theory served Poussin as well as the Mannerists, and provided the newly formed French Academy with its ideological base. By extension, then, "high" art also covers everything produced under the aegis of the Academy, including the Salon art of the 19th century. By that time, of course, Academicians had forgotten what artistic idealism was supposed to be about.

Although Rousseau's bizarre mixture of fantasy and cozy domestic materialism hardly leaves room for idealism of any sort, Robbins solemnly insists otherwise. "His work can only be understood and appreciated in its double relationship to the high art of his time," he writes—as if Rousseau were essentially a parodist! When he adds, "the content of [Rousseau's] work is considerably less high than he thought" I am simply baffled. How high was it? Is Robbins suggesting that if an artist admires Bouguereau and Gérôme he has a serious concern with idealism or high artistic content?

The height of "high art" can only go unquestioned as long as historians do not allow the line of exalted descent to stray too far. The claim for the continuity of artistic tradition rests on style as well as influence. "Style" permits the observer to classify objects on the basis of their participation in a system of formal relations. It corresponds to the idea of species in biology and, ideally, identifies the factors which mark individual works as related or unrelated. In fact, very few art historians venture into such abstract territory. It is generally assumed that everybody knows the characteristics of traditional styles; they exist by a sort of gentleman's agreement. It works well enough as long as nobody tries to introduce odd-looking newcomers into the club.

High art serves as a guarantee of artistic values because style and ideology—form and content, roughly—are treated as a single unit. High idealism faded and high style remained, but the richly synthetic prestige of high art goes on and on. The continuity of the high art tradition depends on two factors, one practical and one theoretical.

In practical terms, art history cannot function without documentation, the trail of paper evidence that establishes the occasions of contact between objects, ideas and people. Letters, contracts, inventories, etc. ground our interpretations of art. They record art as property and as serving human purposes, as meaning. Art historical documentation, therefore, ennobles automatically, by freeing the art it serves from the mute status of anonymous objects. Because documentation is essentially an instrument of social control, it is normally produced for the socially powerful. Though records are often lost or destroyed, the high art tradition practically rests on the continuity of administrative and bookkeeping procedures.

It also rests on the continuity of elite rationales. Succeeding elites find traditional styles and symbols the most effective means of communicating their own cosmic and mundane authority. Deprived of political significance and economic support, the art of a subject population becomes folk art, although elements of it may be incorporated into the art of the elite to lend popular authenticity and intelligibility. The art of a new elite does not necessarily *create* the art forms it uses, but it does insist on drawing the forms

of civility and power into its own network of authority. "Artistic significance" is renewed by binding existing forms, whatever their source, into the rationale of the emergent establishment.

In sum, the elevated content supposedly embodied in high art is primarily a reaffirmation of the transcendent claims of political authority spelled out in the myths that support that authority. The high art tradition is minimally a rhetorical tradition, asserting the power, beauty and harmony of the ordained order. It is also a visual tradition. That concurrence is the source of the dealer's Great Lie: the claim that esthetic, economic and cultural values are all mutually implicated in "major" art. That is, great art is beautiful, it is important in terms of ideas and/or history, and it is expensive.

Folk art, made out of cheap materials by obscure individuals for incomprehensible reasons, should be palpably ungreat. Yet at the Whitney exhibition of American sculpture, where you could see, in a single line of vision, the terrifying wooden death cart against a background of neoclassical marble statuary, it *looked* great. It manifested a serious grappling with the facts of human existence and a complexity of artistic form that folk art is not supposed to have. (Brooklyn's death cart is even better than the Whitney's.) The marble ladies, with their impeccable high-art credentials, were the pieces that looked frivolous, decorative and convention-bound. Folk art explodes the great lie by demonstrating the unpredictability of esthetic values. *Not* the autonomy of art; far from it. In the discredited museumy context of the marble ladies, the death cart had an immediacy it would not have had if we were tourists seeing it in ritual use. If we saw the cart in New Mexico it would have belonged to *them*; at the Whitney its relative social distance was lessened because the marbles have become inconceivably remote. If we were medieval peasants they couldn't be further away!

Today it is generally admitted that the physical and social context in which art is perceived affects the perceiver's response. In a polite and characteristically obscure way, Mr. Robbins asks if our response to folk art may not be more sentimental than properly artistic. He relates the so-called power of folk art to "… the idea that interested society can stamp its own artistic values upon almost any kind of object, that each man who approaches life as an artist will find art and will find it to the extent that he himself is creative. This is an extension, and perhaps a particularly modern extension, of a special contribution to modernism that is focused in the work and attitude of Marcel Duchamp: the found object."

There are two ideas here, not one. First Robbins is saying that we see all artifacts as expressing the values of the culture that produces them, which, true or false, has nothing to do with Duchamp. He is also saying that all

objects can carry esthetic values for those seeking such values, which *is* the "message" of the found object and readymades. "Found objects" are not necessarily artifacts. They include the interestingly shaped rocks the Japanese use in their traditional gardens, the ostrich eggs found in medieval sculpture, the pieces of driftwood that were fashionable ornaments in the '40s. Duchamp's innovation lay in extending the artistic use of found objects to include industrial products that seemed to contradict the nature of art. His found objects had no relationship to the creator's touch; they were blatantly modern, unhallowed by time; they were objects of use, even "low" use, like the urinal. Yet, in the context of art, they worked. Their forms and associations could serve artistic purposes; a polemic "discovery" that rejected genteel, precious-object assumptions about art.

Mr. Robbins seems to believe that Duchamp's found objects completely dissolved the category of art. Indeed, they do reject the idea that art is a thing-in-itself, apart from the human situation. But aside from the found object's import for art theory, such objects also point to the banal fact that everything, not only art, can be looked at esthetically, that is, from the point of view of form, color and emotional resonance. Women have often been regarded so, for instance, as attractive or unattractive objects. The found object merely confirms what has often been more dimly perceived: art is a category of social experience distinct from the experience of its components, material form and the ideas or feelings associated with it. The distinction between art and non-art *is* a matter of consciousness. There is nothing to stop us from enjoying or analyzing bird-song as music; it will simply turn out to be rather boring music.[ii] And of course the acts of appreciation and analysis themselves depend on intellectual and artistic traditions that the birds do not share.

For Mr. Robbins, however, true art is "high art," and he insists that its traditions must be a part of the *creator's* consciousness. As a concession to Eastern and African art he is prepared to accept as art work produced in a group whose beliefs and customs absorb it and can be called upon to justify its existence. However, the development of such internally coherent systems of theory and practice depends on cultural isolation, and Robbins sees cultural isolation as doomed by the pervasiveness of mass media. With the disappearance of cultural isolation, the possibility of true folk art disappears. "A folk tradition," he says, "cannot outlive a Folk."

Because artistic admiration is not an appropriate attitude toward non-art, Mr. Robbins's essay addresses itself to a question that does not arise for Hemphill: the question of how and why such anomalous art has come to be valued at all. In the first place, he says, the appreciation of American folk art was identified with America's discovery of a native, democratic source

of artistic energy. This grounded and authenticated anti-academic modernist art in America and was therefore a Good Thing. While the enthusiasm for American folk art was useful, it played a role on the basis of a claim that Mr. Robbins finds inadmissible, the notion that artistically admirable work can be produced on the basis of "nature," apart from all intellectual and artistic traditions. Such admiration is inevitably sentimental rather than artistic. Here Mr. Robbins acknowledges the possibility of true sentiment (an appreciation of the "charm and "integrity" of authentic folk art) and false sentiment. False sentiment can be based on nostalgia—a preference for "… anachronistic subjects, such as the religious parodies of Tolson or Miles Carpenter,"camp—"the strange marriage of high art themes with hobbiest [sic] techniques may appeal to a sophisticated jaded taste," or brainwashing—the influence of "… collectors, dealers, curators, or historians … all to frequently crosses the thin line separating patronage from corruption in modern society."

"Corruption" refers to Mr. Robbins's belief that folk art ceases to be authentic when the artist tries to use his work to get praise or money. This seems to raise the issue of consciousness again. Here Mr. Robbins is insisting that folk artists should be totally innocent and unaware of possible public response. Yet Rousseau, Michelangelo and every tribal sculptor in Africa expected to get something for his work, and that expectation has never been felt to invalidate the art. The folk artist's cultural virginity is nevertheless apparently as precious as it is precarious. In fact, the issue here is not a matter of consciousness but of the market or public for vernacular art.[iii] Mr. Robbins acknowledges this when he adds that at least since the '30s, nobody can fail to be aware that folk art has been "… set aside for aesthetic value and finally bought and sold in the context of high art."

So Robbins ends with the near-total-put-down of folk art we envisioned earlier: folk art is the quasi-artistic product of people trying to be real artists, but hopelessly ill-equipped for the job. At this point I hope the reader can see why traditional art history cannot deal seriously with folk art. Unfortunately, the defenders of folk art do not offer us any way to cope with the problems a folk art exhibition raises.

For example, we may find the biblical tableaus of Edgar Tolson (b.1904) puerile, his *Man with a Pony* slightly less so. Is it appropriate to complain of the failure of scale in the tableau, and to remark that the more heavily painted piece gains interest by distracting us from the plastic monotony of its form? Ought we to think about the problems of making religious sculpture convincing in the 20th century, or should we assume that Mr. Tolson works in a cultural vacuum and doesn't know what time it is? Can I as a critic conclude anything about his own religious feeling from the Barbie-

doll sleekness of his forms? In short, can we treat folk art as the work of creative individuals? Is that what treating something as art means?

If it is, the death-cart artists must be reproached for having failed to express their individuality, since neither the Brooklyn nor the Whitney figure gives us a sense of the maker. The religious feeling we sense in this work seems to be an attribute of a traditional form, and each instance of it presents the small-scale esthetic variation of a performance rather than full formal creation. Most of the snake canes seem to call for a similar approach. Yet stylistically one of them is anomalous. Snake and staff are not differentiated units—someone has made the staff itself into a snake. But wait! What if the artist has only found a nicely twisted branch and polished it? If so, does the work deserve less admiration or more?

I think all these questions could be answered, although there might be disagreements about particular judgments. It should be obvious, however, that the artistic decisions involved in answering such questions are not all on the same level of generality. Nor can a single set of criteria be used to assess the various kinds of production that have been called folk art. When you are dealing with work you recognize as an instance of traditional form you don't look for the kind of inventiveness to be found in naïve art. Not if you're sensible, you don't. On the other hand, you don't expect history painting to provide the direct access to human experience that portraiture does, or genre painting to provide the compositional variety to be found in still life. Vernacular art presents a similar variety of artistic situations.

Artistic quality is conventionally treated as a judgment based on a single set of universally applied criteria. It is not so simple. We normally tailor artistic assessment to what we can expect to find. Vernacular art requires the same willingness to discriminate, along with novel problems of style and significance. Intuition may be enough for the artist. Because the viewer's task is different, we need other tools.

i By the way of example, he proposes that St. Gauden's *General William Tecumseh Sherman*, erected in 1881, served as a model for an anonymous *Personification of Time*, which, unfortunately, is now dated between 1825 and 1840 and is not included in this show.

ii Charles Hartshorne, "The Aesthetic Analysis of Birdsong," *Journal of Aesthetics and Art Criticism*, Spring, 1968, Vol.25, No.3.

iii Vernacular art has frequently been analyzed in terms of the public for which it is made. I will try to deal with this subject at a later time.

Art in America, May/June 1976

Forever Wild: A Pride of Fauves

The Fauvist movement—roughly 1905–07—remains one of the most exciting in the history of modern art, a burst of high spirits and profound innovation. A spectacular current exhibition occasions numerous fresh perceptions, suggesting, among other things, reappraisal of the movement as a whole in relation to its revolutionary successor, Cubism.

Miraculously, the Museum of Modern Art's major spring show, "Fauvism and its Affinities," is the kind of really solid exhibition big museums used to give us. It includes a high proportion of unfamiliar paintings, and it is sensitively installed, intelligently organized and tightly focused. Above all, it is uninflated, and the accompanying catalogue (actually a book) by John Elderfield, the curator responsible for the exhibition, matches the virtues of the show. That such a thing could happen in our time, when the need for box-office appeal usually puts museum credibility right up there with Metro-Goldwyn-Mayer in the old days, is amazing.

The core of the exhibition contains the classic Fauve paintings of Matisse, Derain and Vlaminck, supplemented by Fauvist work by Braque, Dufy, Manguin, Marquet, Friesz and van Dongen. In many ways, however, the three "orientation" galleries and the final room, where the late Fauvism is modulated by the beginnings of Cubism, represent the most provocative aspects of the show.

The first hints of Fauvism are in Post-Impressionist works. The inclusion of early paintings by Mondrian and Kandinsky implies the European scope of French ideas at this period; the co-presence of Matisse's *Luxe, calme et volupté* and Derain's big, wild *L'Age d'Or* forces us to grasp the unfamiliar starkness of Golden Age iconography at the beginning of the century. We are reminded that this was the heyday of Isadora Duncan, a moment when

"Greek" meant Dionysus as well as Apollo. The second room is emotionally continuous with the first and juxtaposes the Expressionists Pechstein and Kirchner with psychologically intense examples of Fauvism, including another amazing Derain, *The Dance*, 1906. A third room reveals the broader affinities of Fauvism. One wall sets three fine still-lifes together, each dominated by a different palette and a different use of color: a gorgeous Jawlensky beside a strong Vlaminck and a curiously golden Braque. This room includes a Van Gogh and a Rouault, though Gauguin is oddly missing.

What made this whole Fauve exhibition possible is probably the blatant audience appeal of the style today. While Fauve emphasis on boisterous color and expression violated the traditional formal orientation of French paintings, it corresponds nicely to our appetites. Another helpful factor is the short life of Fauvist painting, most of which was produced between 1905 and '07. This brevity has encouraged Elderfield to give an unusually full account of the artistic politics and intellectual involvements that surrounded Fauve production and generated the artistic statements he quotes. On the other hand, Fauvism didn't produce an ideology, and it is greatly to Elderfield's credit that he didn't undertake to provide it with one. Neither has he simplified or tried to resolve all the problems that absence poses. What he did do was to use the paintings themselves to make Fauvism's aims and development intelligible. Moreover, in view of his unexpected modesty, I find myself in the unfamiliar position of feeling that he has not pushed the claims of Fauvism far enough.

As the 20th century accumulates more and more in the way of a past, our assessments of our ancestors' relative importance changes. Like any other autobiographical vision, contemporary art history is naturally egocentric, and an infant that looks like its father at birth can grow up to resemble its mother's side of the family. American painting, which first saw Cubism as the overwhelmingly dominant 20th-century style, may currently be revising that judgment. The example of Matisse, a focus on color, and open, even disjunctive surfaces now seem increasingly central to our art, influencing sculpture as well as painting. As an artistic resource, natural form is pretty well out of it. Our interest is more anxiously drawn to social interaction with nature—from earth art to Photo-Realism. Art absorbs us as a cultural theme; for us, light, movement and imagery are technologically produced *materials*, and we no longer go to nature for our experience of them. Decoration, play and social interaction are also cultural concerns independent of the natural world.

Fauvism's open acceptance of artifice makes it look increasingly like a seminal style, while early Cubism's concern with solid form appears ret?

dataire. As I suggested, Elderfield's discussion of Fauvism does not make far-flung claims for its importance, yet his examination makes it possible for us to see Fauvism's innovations and to speculate further for ourselves.

The surest discovery the viewer is likely to take home from the show is the recognition it demands for the work and role of Derain. Even as a young man, he reached for large-scale painting and handled big canvases with breadth and ease. In an exhibition of domestically scaled work, Derain stands out—before 1907, Matisse rarely attempted a comparable monumentality. Fauvism has always been identified with Matisse. Yet the idea of Matisse as a frontier-type leader of men is comical; temperamentally prudent and self-absorbed, he was virtually hauled into the future by his genius, for he was in the habit of carefully scrutinizing and testing everything he painted. The key figure in sustaining Matisse's interaction with the wider group of Fauve painters was unquestionably Derain. Intelligent and receptive, he was much more acceptable to Matisse than the self-taught, impulsive Vlaminck. Derain's mediation made possible Matisse's "single sustained period of cooperation with the Parisian avant garde," which Elderfield identifies as the historical moment of Fauvism.

Derain's *Charing Cross Bridge*, early 1905, recalls Turner's skies and Monet's treatment of water, as Elderfield says, yet it is already significantly Fauve: the strongest color contrasts are set at the edges, flattening the surface and refusing a narrow focus on the motif, and the image is constructed on the basis of freely located zones of color. This painting preceded the summer of 1905 when Derain and Matisse, working together at Collioure, clarified and confirmed the basic aims of Fauvism. Elderfield notes both Matisse's support of the younger, more uncertain Derain and the challenge he apparently found in Derain's greater daring. Elderfield suggests that in the formation of Fauvism, Derain served Matisse as a compassionate rival in the same complicated interplay that marked the relationship between Braque and Picasso in the early days of Cubism.

The 32 Derains in this exhibition were a revelation. I had thought of him as muscle-bound—who would have dreamed the man had so much bright blood in him! Surely the amazing *Bathers*, 1907, which has apparently not been publicly seen since it was shown at the Indépendents of that year, was still in Matisse's mind when he produced his *Bathers by a River*, finished some nine or ten years later.

Fauvism took its steamy "primitive" themes from Gauguin, but the handling derives largely from van Gogh. Elderfield is surely correct in laying a great deal of stress on the importance of surface treatment in the development of Fauvism. He distinguishes three phases of Fauvism: a Post-Impressionist Pointillism that retained Impressionist regularity of fac-

André Derain, (1880–1954) © ARS, NY. *Charing Cross Bridge, London,* 1906.
Musée d'Orsay, Paris, France © 2011 Artists Rights Society (ARS), New York / ADAGP, Paris.
Photo credit: Erich Lessing / Art Resource, NY

ture but added heightened, purified color and curvy, interlocking shapes; a middle period beginning in Collioure, where the consistent surface was deliberately violated with mixed techniques of scumbled and block-like strokes of color; and a last phase in which color areas become denser, flatter and, once again, consistent.

The middle phase of Fauvism gives us Matisse's least characteristic paintings like *The Gypsy* and the small *Flowers*, both 1906, where excited handling and very heavy impasto make for a gutsy kinesthetic effect. *The Gypsy*'s figure, especially, is set (for Matisse) indecently close to the viewer, crowding the canvas space with a violent intimacy that reappears in German Expressionism and Jawlensky's anonymous portrait heads. The Elderfield text calls our attention to Donald Gordon's recent (1966) demonstration of Fauve influence on the Brücke artists, which establishes an art-historical link where intuition had always wanted one. Indeed, Jean-Claude Lebensztejn, in a two part text written in 1967, argues that "expressionism" incorrectly unites the Blaue Reiter and Brücke painters. He claims that Brücke artists for Fauvism on the basis of their common tendency to abstract the elements of form from subservience to nature while refusing to go all the way. Because of that refusal he calls the Wild Beasts "disguised watchdogs of bourgeois humanism," but, like Elderfield, he does not fail to acknowledge the radical importance of Fauvism's formal synthesis.

The significance of Fauvist paint-handling techniques lies in the transformation of the conventional ideas about pictorial structure that such techniques entailed. Lebensztejn cites a remark: "Fauvism—that's when there's red in it." But strong color alone does not define Fauvism. Fauve color serves structural purposes that line and composition fulfill in other styles. Because Fauvism is not just color added to otherwise conventional painting, the way color is laid on the canvas takes on central importance. What makes Fauve paintings of the second phase hold together (when they do) is not the normal composition of balanced, integrated shapes. Rather, they are sustained by color repetition and the presence of canvas ground showing through alternating passages of scumble and discrete, mosaic-like brushstrokes. This new kind of unity is reinforced by the continuity of gesture through shifts of contrasting color (not necessarily complementaries: Matisse quickly learned the value of "split complementaries"—for example, green versus mauve-and-orange, rather than versus red—to reduce flat-footed oppositions, though lesser colorists continued to lean heavily on complementaries).

Although Elderfield seems to disagree, I think Derain was quite right in saying that Fauvist color entails parallel problems in drawing. When the

eye's movement over the surface is created by color repetitions rather than by composition or the gesture of individual forms, and when those forms take on a variety of colors, contour lines appear in a new isolation. If, like color, they are drawn into pictorial movement, the result is easily a sort of general, unpleasantly characterless rubberiness, a weakness often found in Vlaminck. Yet if contour lines remain separated from both movement and color areas, then they can become isolated and unconvincing. In the hands of lesser Fauve artists like Friesz and Dufy, that isolation of line can become a mannered device. For Derain and Matisse, line remained a problem to be overcome.

The structural importance of painterly gesture and the sustaining of awareness of the white canvas surface are Fauve discoveries generated by the use of pure color. Van Gogh's strong colors did not give birth to these discoveries because in his paintings each remained bound to a local shape with its own gesture. The shift of visual interest from the qualities of the painter's subject to the undomesticated qualities of the object he creates is the essential force of Fauve painting. Because Elderfield takes the focus of Fauvism to be a "joyful celebration of landscape's light and color," he sees the seeds of its demise in the renewed interest in figure compositions that showed up in the 1907 Salon d'Automne. His conclusion seems unnecessarily timid. Figure painting was important in Fauvism from its beginnings. Having analyzed Fauvism primarily in formal terms, why should he suddenly account for the retreat from Fauvism as a withdrawal into "… something more calculated, conceptual and restrained," i.e., Cubism? He acknowledges the "… quality of openness—of painting that spreads itself outward across the viewer's field of vision [which] characterizes the best of Fauvist art," and he recognizes the logic of Matisse's next step into the fully flat, decorative compositions of *Music* and *Dance*. Is it not plausible that what finally frightened the temporary Fauves was exactly what had terrified Matisse at the beginning, a premonition of painting cut loose from the coherence of the natural world, of painting free but possibly stranded in autonomy?

Elderfield's careful discussion ends disappointingly with the cliché of Fauvism and Cubism as polar opposites: "… the instinctive versus the reasonable; color versus monochrome; free form versus structure; the fragmented versus the stylistically coherent; wildness versus sobriety." Such textbook "characterizations" seem to be largely associations around Fauvist color and the early-Cubist lack of it. The association of color with emotion is surely simple-minded—the fact that it is expressive and carries a high charge of energy makes it difficult to manage, but obviously there is nothing

irrational or sub-conceptual in facing the task. (It is worth noting that the critics originally objected to Matisse's Fauvism as being too systematic!)

Setting color aside, don't Fauvism and Cubism arrive at very similar formal positions? The Cubist invention of collage risked the same discontinuities of the surface that the Fauves had dared with their mixtures of paint technique; the integration of figure and ground, though differently executed, involved a comparable dissolution of mass and a parallel adoption of rhythmic structural modules.

Seen independently, the welter of consciously modernist styles that appeared in Europe between 1905 and World War I may offer an unnecessarily fragmented idea of 20th century art history. Surely artists everywhere were looking for a way of working that would confirm art's tie to a deeper reality while loosening its bondage to nature and to inappropriate conventions. Once "form" was detached from nature, it had to be reinvented, and the longing for something "solid" made it inevitable that there should be frequent retreats into familiar form. Among the many modernist artists who made significant contributions and then retreated into old-fashioned styles are Kupka, de Chirico and Archipenko, as well as Derain and Vlaminck.

Perhaps what sustained Matisse's confidence in the availability of form was his involvement with sculpture. The installation of this show reminds us that Matisse's last great Fauve painting, the *Blue Nude*, 1907, is a pictorial version of the *Reclining Nude* of the same year. Incorporated in many paintings of the next five years, this figural theme reappeared in his sculpture in the late '20s and clearly represents a motif he found exceptionally powerful.

One of the virtues of this exhibition is its inclusion of sculpture, a decision which marks Elderfield's insistence on considering Fauvism as a movement as well as a painting style. By giving individual attention to the artists who participated in Fauve exhibitions, he also deals with the Fauves as a group, and he explicitly cautions us to recall two often neglected facts: first, "... even within the most narrowly defined Fauve period ... not all the paintings produced by those we call Fauves can truly be described as Fauve paintings," and, second, "... the cooperative group status was absolutely central to Fauvism." Both these warnings begin to question the common assumption that the concept of style provides an adequate explanation of artistic production.

The autonomy of a historically complete, unified style implies the existence of systematic working processes, identifiable with the perception at which these were aimed. That is to say, the "style" assumes a fulfilled correspondence between form and content. Yet the brief history of Fauvism

surely suggests that it developed as a search for new form and that its "content" emerged indistinctly. For Dufy and Manguin, for example, Fauve content may never have distinguished itself sharply from the content of Impressionism. Elderfield sees the content of Fauvism as a pantheistic celebration of energy primarily visible in landscape. For Derain and Matisse, however, the Fauvist vision obviously included a newly forceful and sometimes hectic figurative imagery, especially of women. Isn't that what finally marks the *Blue Nude* as a Fauve painting? Those of us who have never before been in the concentrated presence of Fauvism are likely to feel it started something that is still going on.

Art in America, January 1977

Islam Goes to England

*The "World of Islam Festival" filled major London (and a few other)
museums last summer with a provocative array of objects that,
beyond delectation, raised a wide range of questions and issues, many
discussed here, and also prompted the author to an examination
of the art of the Islamic book.*

It has been said that in Islam war was the continuation of theology by
other means. Since international art exhibitions these days are usually a
continuation of politics by other means, the "World of Islam Festival" held
in London last summer was bound to draw on an unusually wide range of
issues. Characteristically, the official literature of the festival denies this.
According to the London *Times*, the Festival's initiator, Paul Keeler,
described its intentions as purely cultural.[i] Planning for the Festival, he
explained began over four years ago—that is, before the energy crisis.
Islamic culture (which presumably excludes politics) was to be fully pre-
sented; the Festival encompassed religion, music, science and art, and it cost
those Muslim countries which bore its expenses around $3.5 million. Thirty
countries participated, with the notable exception of Turkey, which has
recently passed a law against sending its national treasures abroad.

The last major international exhibition of Islamic art was held in
Munich in 1910. The ways in which the 1976 Festival differed from it mark
the presence in the art world of new patterns and new definitions of culture.
In 1910 the exhibits were precious objects drawn from private collections,
primarily in Germany and Russia. Today fewer important pieces are in pri-
vate hands; in London, collections of urban and national museums or
libraries predominated. This was true not only for British holdings but also
for the Muslim world, the cultural ambitions of which were represented by

new national cultural organizations in Syria, Iraq, Iran, Egypt and Lebanon, as well as by such ancient religious foundations as the thousand-year-old University of Cairo.

The shift to public ownership entails other changes. Connoisseurs' treasures are now supplemented by ethnic and vernacular materials, and this in turn leads to a broader focus for scholarship. At least four of the Festival's major exhibitions—the "Art of the Hausa" at the Commonwealth Institute, London; "Music and Musical Instruments" at the Horniman Museum, London; the "Nomad and City" at Burlington Gardens, London—were dominated by sociological definitions of culture.

The Festival's extensive coverage of architecture, wholly absent from the 1910 Munich exhibition, was perhaps an even more significant novelty, made possible by a full use of photography. Libya, in cooperation with Britain's Architectural Association, mounted a broad, impressive survey of her ancient and contemporary buildings, and medieval Muslim monuments in Jerusalem were presented in a combination of photos and archeological drawings. Slide shows were everywhere. An exhibition of photographs of 19th-century Iran taken by Ernst Hoeltzer, a German engineer employed by a telegraph company in Isfahan, was engendered by the discovery of 1,000 of his glass plates in Westphalia. The Festival also sponsored six half-hour films, of which I saw only two. A popular art form in themselves, they provided the gaudiest examples of the Festival's own rather schizophrenic style—restrained British voices reciting praise-poems in celebration of Islamic unity.

This schizophrenia was considerably deeper than the mere oddness of blending Eastern forms with Western style. Exhibitions of popular arts and the life-styles of modern Muslims suggested small, unmodern worlds dominated by local history, geography and climate. Yet the Festival also embodied the re-emergence of an old, half-real, half-imaginary "Orient," an abstract Islam, disembodied and devoted to exotic luxuries: carpets, incense burners, manuscripts written in gold. Islamic metalwork at the Victoria & Albert, Korans at the British Library and Indian miniatures at the British Museum revealed the beauty of traditional Islamic treasures. And if cars have supplanted candlesticks and hanging lamps in the metalwork category, Oriental carpets and books are still eagerly collected.

The fabled wealth of the Orient was as impressive as ever at the April auctions of Islamic items, with Iranian buyers much in evidence. A 17th-century Ushak medallion carpet, in mint condition, brought the highest price ever paid for an Ushak: about $34,000. (Ushak rugs are Turkish and not directly related to the traditional pinnacle of Islamic carpet-weaving, the floral and animal rugs of Persia.) Like wine, paintings are an uncanon-

ized but traditional luxury in the East: a Quajar painting sold at Sotheby's for $81,000, and Quajar enamels also went high. Yet Muslims were not only reclaiming objects from their own heritage—they also bought Western versions of the East. European pictures with Oriental subject matter, a favorite topic of 19th century academic art, found a new, enthusiastic market. John Frank Lewis' *A Frank Encampment in the Desert of Mt. Sinai* went for around $36,000, more than three times the price paid for another Lewis painting in 1973. For a Muslim, such a picture, small, brownish, moody, is a luxury because it's expensive, for it lacks the decorative character of traditional Islamic treasures.

Few Muslims have seen vernacular architecture, pottery and clothing as items of "culture." For a Muslim, culture begins with the Koran, the indissoluble unity of literacy and religion. While "luxury," "culture" and "religion" are somewhat differently defined in East and West, the Western concept of Art (with a capital A to distinguish it from the crafts) has no Islamic equivalent at all. For a Westerner, a true work of art combines formal beauty with a kind of personal, spiritual or moral validity that a Muslim denies to any human creation. Until the 16th century, when European styles and ideas became fashionable at the Persian court, Islam *had* no "artists"— only craftsmen. But "art" is also an honorific, and, as such, cannot be denied to many areas of Islamic production. Anyone attending the Festival in search of the essence of Islamic art was already in a subtly off-center ideological position. Islamic art was not created to be esthetically autonomous; but should we approach it as the product of a civilization or of a faith?

The theme of the Festival was the Unity of Islam, a proposition vague enough to shelter any number of interpretations. For many Muslims participating in the Festival, including a number of Western converts, Islam's unity lies in a community of religious belief. (This point of view is held most forthrightly by Saudi Arabia, which was said to have guaranteed overdraft facilities for the Festival—though, in the end, it was the small states of the Persian Gulf who paid the final bills.) Indeed, the word "Islam" itself is a theological term, referring to an ideal community of believers who in fact experience and practice their religion in very different ways. Islam's diversity was not entirely apparent in London, because the Festival made for a confusing range of esthetic viewpoints, and the impression of cultural multiplicity was accurate—and significantly undermined the premise of Islamic unity.

To apprehend the diffuse variety of Muslim life is to realize that much of medieval Islam's strength lay in its ability to bring new integration and color to static societies where life was being lived mechanically and indifferently. Medieval Islam spread like a dyestuff, altering the fabric of

civilizations whose structures it often seemed to leave intact. Consequently the unity of Islam, so easily embraced as a political or metaphysical principle, is much more troublesome to discuss as a fact.

Islam has changed in the last century, and this change is quite rightly attributed to the expansive dynamism of industrial Europe. But very few Muslims have had direct contact with the West. Their experience of European civilization is filtered through changes in their own conditions of life.

Take, for example, the Persian city of Isfahan, a magnificently executed instance of 16th century urban planning. One of the strongest publications to appear in London during the Festival was the May issue of the *Architectural Review*, which was entirely given over to the problems of contemporary Isfahan. The authors insisted on the folly of preserving isolated monuments while allowing the architectural context and the economic life surrounding them to decline into poverty and vulgarity. It protested against such abuses of modernism as the road recently cut through Isfahan's ancient covered market, still in use and in a remarkable state of preservation. It suggested that a local law offering three years' tax relief to Isfahanis who tear down old buildings and put up new ones should be repealed. Western awareness of the blighting effect of indiscriminate modernization has never been higher than it is now; self-hatred and nostalgia are modes of feeling we share with the East. Common, too, is the combination of sociological despair and the esthetic admiration with which we all watch vanishing styles of life. For many modern Muslims, Islamic unity, if it is retrievable at all, awaits a still unrealized renaissance. Yet historical Islam remains an essential ingredient in the consciousness of those who see the unity of Islam past—as a medieval phenomenon more or less thoroughly dissolved since the 16th century.

Even as Islamic unity is presently dissolved and dispersed, its past integrity is problematic. For Muslims, the preservation of Islam has been the preservation of the faith, and guardians of the eternal truth make poor historians. Engrossed in the struggle against change, Muslims have long neglected their own history. Their rich archives, often closed to non-Muslims, are largely unexamined; yet American and European scholars have reconstructed something of the Muslim past. At present, modern expertise in Islamic art can be acquired only in the West, and the Festival was overwhelmingly dominated by Western scholars. Such a situation is not new. When Ataturk reorganized Istanbul University and set up facilities in Ankara in the 1930s, more than 100 of his professors, fleeing Hitler's policies, came from German universities. Among them was Wolfram Eberhard, now at the University of Chicago, who came to teach classical Chinese as part of an effort to reconstruct early Turkish history from Chinese sources.

Since the Turks originally came from the depths of Central Asia, Chinese studies were a logical step toward a modern, secularized definition of Turkish identity.

We seldom realize that modern historical study is still problematic in many Islamic countries. In Egypt, for example, the official emancipation of Islamic art was pronounced as a legal decision. In his authority as the Mufti of Egypt, Shaykh Muhammad Bakhit (d.1924) defended his opinion by maintaining that, since the purpose of art in modern times is vastly different from what it was during the Prophet's time, Muslim art should no longer be subjected to religious restrictions.[ii]

Startling as it may be to recognize the pressure of medieval notions on contemporary Islamic art and art history in the East, Western Oriental studies have also been hampered by prejudice. Orientalists have been slow to discard racist concepts of the "Oriental mind," a cultural type presumed to be stable and characteristically fanatic. The first congress of Islamic studies with a sociological orientation was held at Brussels in 1961, and 15 years have not been enough to establish agreement on many crucial issues. Thus, an English scholar, James Dickie, writes: "When European imperialism, fired by the dynamic of capitalism burst upon the East in the 18th century, it took the static Islamic world of fixed and stable values unawares and unprepared. Noncapitalistic by virtue of its dogmatic foundations in the Koran, Islamic society had nothing in its own armoury to confront a ruthless and implacable adversary."[iii] In calling Islam "dogmatically noncapitalist," Dickie may be referring to the religious prohibition of usury which Islam shared with medieval Christendom. (Islam got around the problem by developing a carefully contrived range of legal fictions under which usurious transactions could take place.) A position contrary to Dickie's is argued by the admirable French scholar Maxime Rodinson, who says that the acquisition and administration of Islamic wealth proceeded without notable hindrance from Islamic submission to an inscrutable divine will.[iv] It seems reasonable to suppose that Muslim financial activities have expanded and contracted many times since the rise of Islam. A recent study of economic development in Islam notes, however, "little that we know at present either confirms or refutes this…secular changes of this kind have not been much studied."[v]

Islamic capitalism is particularly relevant to the study of Islamic art because, in the absence of middle-level social institutions, it may hold the key to unanswered questions about the character of Islamic patronage and the status of the artist/craftsman in the Islamic world. Europe's "middle-level institutions" mediated between the "folk" and the courts, and Western art history has much to say about the organization of guilds and the rise of

an urban bourgeoisie. Recent research has found that Islamic guilds are unknown before the 16th century and that the urban structures associated with the Western middle class are largely lacking. Yet at various times and places an Islamic merchant class, whose size, distribution, resources and tastes are still mostly unknown to us, must have constituted a significant clientele for Islamic art. We know from inscriptions, for example, that a merchant class commissioned the most brilliant metalwork ever produced in Islam, in the area around Mosul during the 12th and 13th centuries. Yet the imagery of these pieces is drawn from courtly life. No pieces dedicated to royal owners are known to exist, while poorer versions were later repeated with monotonous regularity in Mesopotamia, Egypt and Persia. Does this demonstrate the disappearance of a market for this luxury product? The absence of an articulated class-consciousness within Muslim society? A weakness of Islamic inventiveness—the degeneration of a style into mechanical repetition? All or none of the above?

Such questions are particularly hard to answer because Islamic creativity does not seem to have the local, episodic character of art in the West. In the West, an interval of intense invention is likely to affect many kinds of production simultaneously, creating a period style. But the arts of Islam lack such tidy patterns of development. Architecture, metalwork, textiles, calligraphy—each sphere of artistic activity seems to have an independent, non-local history of its own. Consider, for example, Islamic ceramics. The early triumph of lusterware occurred in the 9th century in southern Mesopotamia, but vessels of very high quality using entirely different styles and techniques appeared shortly afterwards in northeastern Persia. Luster painting fell into disuse, then reached its peak the third time it was "revived"—around 1200, under the Seljuks, a Turkish dynasty. Wall tiles, as opposed to tableware, seem to have remained in relatively steady production but do not attain their greatest splendor until the 16th century when separate styles appear in Safavid Persia and Ottoman Turkey. At present, Islamic art history is full of big deserts and sudden, lush oases.

It is extremely unlikely that any single large hypothesis can account for the great mass of unexplained peculiarities of artistic production in the Islamic countries. Questions about the spiritual meaning of standard images—the drinker with the wine cup, for example—must probably be answered one way for some times and places, and another way for others. Like Western art, Islamic production has served both secular and religious purposes and reflects private tastes as well as public norms, even though we often can't distinguish between them. Emphasis on the unity of Islam is outstandingly unhelpful in resolving the problems of Islamic art. It discourages the close scrutiny of differences that all esthetic judgment requires.

Double Page from the Qur'an, with pages from chapter 5 (called 'al-Ma'ida, 'The Table Spread'), verses 75–7. © The Trustees of the British Museum / Art Resource, NY

الْآيَاتِ ثُمَّ انْظُرْ

أَنَّى يُؤْفَكُونَ قُلْ

أَتَعْبُدُونَ مِنْ

The most significant beneficiaries of comprehensive exhibitions like this one are finally the scholars. The assembly of hitherto dispersed examples of a vaguely identified "tradition" permits experts to work out clearer and more precise ideas of "normal" production and to develop correct interpretations of anomalous examples. The Festival also encouraged the test of one hypothesis often put forward for Islamic art: the claim for the pervasive importance of calligraphy. One hundred and fifty-two Korans shown at the British Library and almost 200 Indian miniatures at the British Museum provided an unequalled opportunity to consider Islamic book art and the place of calligraphy within tradition.

Westerners most easily admire those forms of Islamic art which approach their own artistic traditions—the familiar glory of Persian miniatures, the hunting or floral carpets (often designed by artists apparently trained in the miniature tradition). We find it hard, however, to see any relationship between the miniatures and calligraphy, which is for us a minor esoteric area of artistic production, and we tend to see calligraphers and illuminators as craftsmen rather than artists. The Festival offered the opportunity of attempting a more Islamic point of view: can we find formal grounds for assigning Korans and miniatures to a single esthetic tradition—that of the Islamic book? If such formal continuity could be found, it would reinforce some tentative generalizations about Islamic art: the indissolubility of religious and secular production, the dominance of decoration over pictorial concepts of form. Moreover, if it is possible to locate a line of continuing formal development from Egyptian Korans to Persian romances and Indian histories—if there is an art of the Islamic book, we would have evidence for the claim of a transcultural unity in Islamic art. I propose to sketch the outline of such an attempt in the second half of this article.

It is unquestionably true that "Islamic calligraphy and illumination are centered upon the Qur'an [Koran], for the sake of which they came into existence."[vi] While the poetry of pre-Islamic Arabia was its most highly developed art form, it was a poetry of the spoken word. Eighth-century Arabic script looks cramped, hasty and ugly in a rather modern way. Once it became necessary to record the revelation given to Mohammad, however, an adequately dignified and beautiful style of writing had to be devised. The style that prevailed was Kufic, and it was fully developed by 800 A.D. It has remained the favored script for architectural inscriptions, chapter headings and most formal occasions, for it is characteristically stable and energetic, a script of right angles and implied squares and rectangles. All later developments moved in the direction of a rounder, more running script, but the continuing importance of Kufic was an invigorating influence. It set an example of grandeur and energy based on proportion and interval rather

than gesture. Moreover, because Kufic lends itself to monumental execution, it enforces attention to scale, as some of the other scripts do not.

While all five or six major writing styles had been developed by the 13th century, theoretical and practical treatises on calligraphy constitute a continuing Islamic tradition. Calligraphy is the only Islamic art that has received theoretical elaboration. The proportions of horizontal to vertical elements, the proper spacing of letters, words and lines—every aspect of form has been carefully considered. Yet calligraphic treatises are seldom merely technical; writing is never fully divorced from its religious roots. In the West, the idea that handwriting reveals the soul is a popular tradition; Eastern tradition connects calligraphy with the Koran.

The illumination of Islamic books is different from the illumination of Western manuscripts. In the West, decoration was often applied to the first letter of the first word on the page. Illuminated capitals came to incorporate tiny images, and Romanesque manuscripts might hang a string of tiny animals, figures or floral motifs on the final flourish of a letter, often at the bottom of the page. Western illustrated texts make a sharp division between the text and the picture, and illustrations have regular shapes and separate frames of their own.

In accordance with the tradition of iconoclasm, the Koran is never illustrated, only decorated. Koran illumination was at first very restrained; it developed more slowly than the formalization of scripts. Illumination is not attached to letter forms—the word is never atomized, although words or phrases may be given compartments of their own.[vii] Decoration is lavished on borders, on marginal indications of text divisions or on the establishment of a special space in which the script is placed. The chief themes of decoration are arboreal and solar, possibly on scriptural grounds. "The good word," says the 24th Surah of the 14th Chapter, is like "a good tree with root firm and branches in heaven," and the Koran itself, the best of good words, is a continual source of light and life, like the sun. The chief colors of the illuminations are blue and gold, in proper heavenly fashion.

A 14th century Koran page from Egypt and a 16th century Safavid page, probably from India, are very different and demonstrate the expressive range of one set of compositional elements. In the earlier text, the script lies lightly and freely on the page. Only the chapter headings are compartmentalized and enclosed within borders; the palmettes are tied to the script with varying degrees of firmness, and the rosettes which mark the verse ending seem to be scattered like rose petals. Centrifugal forces predominate, not as radials but as independent horizontally and vertically disposed axes.

The Safavid Koran is denser, more complicated and compact. Almost all the elements have been compartmentalized and the centrifugal palmettes

are locked into a heavy border, from which only the larger triangular *anse* and an outer row of finials have been allowed to escape. Here we notice that the borders define the edge of a depicted page that has been set upon the real one. We are given the *picture* of a page, and the central axes of picture and page do not coincide. The Egyptian Koran had already suggested a similar doubling of central axes. It might be supposed that this multiplication of symmetries is simply related to the format of books, a device to encourage the perceptual unity of two juxtaposed pages of text. Yet single-page Persian miniatures use exactly the same device—multiple axes of symmetry—to create an impression of mobility and, under some circumstances, depth.

The principle of hieratic rigidity simultaneously asserted and denied can be seen most clearly in the Egyptian Koran. There, the blocks of illuminated heading present so various a range of layout and pattern that the Kufic script, white and gold in the top compartment, pale green in the center one, is virtually absorbed in decoration, although the sacred text itself remains austerely unadorned. Persian miniatures often supplement the liveliness generated by the multiplication of symmetries by breaking through their borders in places, as if the picture held more life than its allotted space could contain. Yet a close examination of Koranic illumination shows that modulations of the regular frame and implied layers of spaces also occur there, even in the tightest, most formal designs. Thus the Safavid triangle lies under one border, escapes another and in the process establishes four distinct planes.

This is not the appropriate place for a systematic consideration of the links between Koranic illumination and Persian miniatures. My personal conviction is that Persian miniatures are better appreciated as examples of complex decoration than of illustration, and that miniatures are dominated by iconic values only after 1490 or so, when Bizhad inaugurated that shift in pictorial attention. We may note that the basic organization of Persian miniatures is independent of the scenes illustrated. Instead, it grows out of the divisions and compartments of the text, to which the scene is adjusted. In the *Battle of Iskandar with the Dragon*,[viii] the participants are assigned separate areas marked off by the pair of large "labels" in the center of the page. The dragon lives in compartment A; Alexander and his horse hold center stage and the attendants fill the right wing, while a vigorous wave of landscape unifies the scene. The text compartments set the major divisions of the page, while text and image interweave to inhibit the illusion of three-dimensionality. If the hoof of Alexander's horse didn't overlap the text below, just as the picture's title overlaps the sky and landscape, the "scene" would tend to fall behind a window-like frame. That sharp sort of illusion-

ism is not acceptable to the Persian artist, however; he prefers a continual oscillation between depicted and material reality.

The zones and grids of the classical Timurid miniature are less apparently text-bound than the above-mentioned illustration from the Demotte. Yet the serene, almost unbroken symmetry of the princess' compartment is pulled into the orbit of her lover's zone primarily by the horizontal movement generated by the lines of the text. The compartment itself is the twin in size and proportion to the princess' window, and its format, the rectangle-with-a-square-removed, is a squarer version of the shape of the illustration as a whole. The image is compartmentalized, like the Demotte, and almost covered by small-scale right-angled grids. There is a play among the gridded areas, some having different directional axes from others. The horizontally oriented grids "belong" to the princess, extend into the garden and pervade the top half of the page. Her lover is allied to the vertical. He is almost exactly the size and shape of the balcony. The extreme restraint with which diagonals and curves are used gives the inclination of the lovers' heads wholly disproportionate emotional import, though their angle is strictly parallel to the architectural diagonals of the balcony and the court in the narrow zone at the left. Such an effect is impossible with more animated drawing, since it depends on the surprise of an expressive element within a pervasive taut rigidity.

The greater freedom of Indian drawings is only one of the factors that remove Indian miniatures from any close affinity to the tradition of Koran design and the esthetics of calligraphy. Although the rulers of the Mughal courts practiced calligraphy and collected Persian books and Persian artists to staff their workshops, they received their book traditions from Safavid Iran. In the 16th century, Western influences had begun to permeate the workshops of Shah Abbas, and that energetic ruler's interest in rationalized production had already modified traditional workshop practice. (The old schematic methods of miniature composition were used in Shiraz longer than they were in the new capital of Isfahan.[ix]) The Indian aptitude for acute psychological observation reinforced the Safavid taste for the new genre of portraiture, and the old text-bound compositional grids melted away in the heat of a more intense emotionalism. Illustration itself gave way to images independent of texts; picture albums became popular.

Compared to Indian products, Persian miniatures before the 15th century show relatively little interest in human situations. Whatever feeling we find in the Timurid miniature is not a property of the almost expressionless lovers, but of the entire scene. Moreover, the *same* remote lyricism attends the classic Persian repertory of court scenes, hunting expeditions, battle scenes and personal encounters. There is also a difference between Indian

mysticism and Persian Sufism; the *Gathering of Ascetics*, 1630, is not only a more naïve composition than a Persian one would be, it implies a different kind of spirituality, even a different world. Indian miniatures have a wide range of subject matter, and they implicitly set the viewer closer to the scene, in a more intimate relationship to whatever is perceived. The Indian artist is intensely concerned with life; the Persian artist's involvement is more tentative, poised between life and art.

I believe that it may be possible to find similarities of layout in Koranic texts and Persian illustrated books. Perhaps the organizational importance of the grid may be considered a regular feature of "classic" Islamic art, linking the pervasive use of pattern with calligraphic and pictorial traditions. Despite the dependency of Mughal art on Islamic precedents, however, it discards "Islamic" compositional habits in favor of simpler schemes. At this point, one line of a unified Islamic tradition fades out and must be sought elsewhere.

i *London Times*, Special Report, April 2, 1976, p. xii.

ii Wilson B. Bishai, *Humanities in the Arabic-Islamic World*, William C. Brown Co., 1973, pp. 106-107.

iii Loc. Cit., *London Times*.

iv Maxime Rodinson, *Islam and Capitalism*, translated by Brian Pearce, Pantheon, 1976. (Original published in France, 1966.)

v M. A. Cook, "Economic Development," in *Legacy of Islam*, second edition, Joseph Schacht and C. E. Bosworth, eds., Oxford University Press, 1974, p. 241.

vi Martin and Safadi Lings, Yasin Hamid, *The Qur'an*, London, World of Islam Publishing Co., 1976, p. 12.

vii The special characteristics of Arabic script would seem to oppose the Western practice of decorating capitals. Arabic script has no capital letters, and each letter occurs in at least three different forms, depending on its position at the beginning or the end or in the middle of a word.

viii Although two miniatures from the famous Demotte manuscript were on view at the Hayward, this particular one was not.

ix Grace D. Guest, *Shiraz in the 16th Century*, Freer Gallery of Art, Washington, D.C., 1949.

Goldin's Gifts

by Joan Simon

How can you tell the difference between a message and a loud noise? If the sound disappears, it is a loud noise. If it's repeated, it's a message.

With the above words Amy Goldin opened her essay "McLuhan's Message: Participate, Enjoy!" published in the May 1966 issue of *Arts Magazine*. They pertain also to this book, which embodies her boisterous, contentious, sensuous, joyous yet doubting and pioneering address of art and audience, in moral and formal terms, in a voice both colloquial and learned, and with a reach that ranged from her own backyard to wherever her interests took her. She traveled to Iran where she touched and scrutinized the patterns of a variety of rugs and carpets; to southern California, where her debates about the qualities of pattern and decoration in classes she taught served as daily permissions for artists finding subjects and stylistic innovations outside of the moment's mainstream; and to Cambridge, Massachusetts, where her Islamic art researches were grounded further in her studies with Harvard's Oleg Grabar [see pp. 121]. Goldin's "noises" about how to look, how to think, how to be in this world, how to question and write so that there is a conversation about ideas, about understanding as well as makings, constitute, indeed, a profound message.

Re-reading her essays some thirty years after her death, I am reminded that the first conversation between a published writer and an audience is that between the writer and the editor who gives the go-ahead. During the years I knew her as a contributor to *Art in America*, beginning in 1974 when I became managing editor, that first conversation was between Amy Goldin and the magazine's editor Elizabeth C. Baker, whose many yeses continued to open the field of contemporary art criticism to a wide range of theoretical speculations and subjects as they were in formation.

It is obvious we read things differently at different times, and reading Goldin then and re-rereading her now are vastly different experiences. Then, the foremost interest for me was the subject—a report of what was going on, critiqued by someone who had an interest in and questions about a particular show, or a particular body of work, and was fearless in bringing to it an unexpected perspective. Now, I hear the underlying currents: an emphasis on understanding rather than judging, a way of opening up discussion rather than closing it down, a way of linking contemporary work to historical precedent. Goldin's was a way of looking that could erase categorical bounds, whether she directed her attention to architecture, decorative arts, painting, sculpture, folk art, or conceptual projects. It should be noted that she did not forgo critical assessment, always a strength of her writing.

One would not necessarily have expected Goldin to be writing about Alexander Calder at the time, but in her address of a life's work on the occasion of his 1976 retrospective—that also served as an obituary, as he died not long after the show opened—she offered a counter-approach to a career long established and an artist beloved to the general public. She introduced layers of open questions for a body of work she admired, and punctuated her overall analyses of Calder's innovations with outright negative assessments of parts of his oeuvre. In thinking about my work for the recent "Alexander Calder: The Paris Years, 1926–1933" exhibition, I saw that I had addressed some of the questions she posed, and in re-reading her Calder essay, I found myself in conversation with her again.

It is tempting to quote many passages of her writing here, but I have finally limited these to ones that particularly capture her voice and that summarize her expansive thinking within the frame of her chosen subject. A favorite one, and a key to her thinking, is from "In Praise of Innocence" [pp. 123], written on the occasion of the exhibition "American Folk Art, 1776–1876." While looking closely at the individual works and their contexts, she also saw the exhibition as an entry point "for those who may be still struggling to understand modern revisions of the Western artistic tradition. Folk art highlights the arbitrariness of the accepted boundaries between fine art and applied art or craft; it reveals the esthetic triviality of correct academic rendering of anatomy, perspective and chiaroscuro; and it demonstrates the compatibility of art and humor. Those who find modern art perverse, senseless or crude can hardly find an easier means of sliding towards 20th century artistic attitudes than by developing a taste for American folk art."

Her legacy also includes her writings about work itself (found in her McLuhan essay)—the kind of work done "in order for life to be bearable."

In a fundamental way, Goldin offered a dare to herself and her audiences: "How to turn one's life into form, a set of completed movements, 'real' work instead of making a living, wisdom instead of information, existence instead of survival." Withal, she did not deny the realities of earning a living, and was pleased to be paid for her contributions. (In fact, she supplemented her art criticism with teaching and other forms of writing). I imagine she would be concerned that writing art criticism continues to have meager remuneration, given that monetary reward is not an insignificant form of recognition. I can also imagine she would be pleased that her ideas —recomplicating how we think about art and its audiences—in the essays reprinted here will now have wider currency.

As a publishing colleague, I knew Amy Goldin as a senior contributor to the magazine who nevertheless had time to share her findings and many enthusiasms with everyone on the small staff, including the youngest members. I also knew her as a friend as she sparred at dinners with her contemporaries (notably George Sugarman) as well as the younger artists who adored and challenged her (Brad Davis, Valerie Jaudon, Richard Kalina, Joyce Kozloff, and Robert Kushner, among them), and at other times with Holly Solomon, another iconoclast, who as a dealer exhibited the works of many of the artists who interested Goldin.

Though she wasn't a teacher of mine as such, she was a powerful presence and an example. She worked outside of the academy, but was scholarly. She chose subjects she thought compelling, yet without a programmatic agenda that would have limited her range. And her interests ranged widely: from the brothers Prendergast to Timurid miniatures, George Ohr pots to Léger paintings, overviews of Abstract Expressionism to detailed readings of contemporary works of all sorts. She did not avoid writing about artists and others she knew, but was particularly demanding in her expectations when writing about them. She concludes her essay about George Sugarman [pp. 50] with the following: "The trouble is that he tries for so much, and so much comes through, that it is easy to forgive him nothing. Yet it would take a very solemn and innocent mind to disapprove of exuberant risks, his stringent demands on the spectator." Above all in importance is her insistence that understanding is the fundamental purpose of art writing, and that such understandings are catalyzed by the relation between a spectator and an artist's or artisan's speculations and makings. As Goldin and Robert Kushner wrote together (in the 1990 "Conceptual Art as Opera"), "Intelligence is not in objects but in ourselves, and the work provides the occasion that triggers its operation."

In re-reading her essays now, I realize I am so imbued with her influence as not to have noticed, or rather formally recognized, it. The invitation to

write something for this book allows me the occasion to acknowledge Goldin's impact and also to thank her publicly. Following her lead, I know the pleasure in looking at subjects that are not necessarily in accord with what may be fashionable as well as those so obvious as to be critically over-looked or that offer opportunities to analyze them in new ways. And if the go-aheads for the latter come more readily than for the former, repeating these requests are critically important. Goldin's words at the outset of this essay remain ever more pertinent: Repeated noises constitute a message.

Art in America, March/April 1977

Alexander Calder, 1898–1976

"The dancer is gone," James Johnson Sweeney intoned mournfully, "but the dance remains." Even at Alexander Calder's memorial service every speaker called on the gaiety, pleasure and movement that are inevitably linked with Calder's name. The association between Calder and play is, of course, perfectly valid. Nevertheless, it is odd that an art world otherwise swimming in subtlety has approached Calder with so iron a grip on the obvious. We discuss even baby artists, who have barely learned to videotape their doorknobs, with due regard to the formal complexity and intellectual implications of their work. But Calder's apparently total accessibility seems to have made him strangely opaque to the art world's professionals.

The only responsible essay on Calder was written by Sweeney in 1951. Nothing much has appeared since. There are picture books, with Calder titles, but most of them are solemnly unserious appreciations that do not set out to be analytic or critical. I expect that those books sold well, for Calder was successful in the same encompassing way that Picasso was— artistically, financially, popularly. Every move of Picasso's has been respectfully scrutinized, while Calder gets big beamish smiles and remains unexplored. Yet his simplicity is full of anomalies that would seem to demand explanation: his curious asceticism, for example.

Sculpture, involved with the divergent valences of gravity and light, has been the most physical and sensual of the arts. But even in the most monumental of Calder's stabiles, presence and gesture take precedence over material body. Calder's surfaces are uniformly untextured, unradiant, uninflected. The color he uses most often is black: the white, red, orange and blue that relieve it have the blatant aggressiveness of Hard Rock. His forms, for all their variety, are made up of a handful of individual shapes, and those shapes not even "personal," but borrowed from Miró and Arp. They serve Calder's aims while proclaiming their origin, the way kids today wear

T-shirts emblazoned with brand names. Calder's coffee-can birds of 1950, 1965 and 1972 give off exactly the same insouciant signal of belonging to a standardized culture and being able to use it for private purposes.

Calder's art is an amazing phenomenon. For years his work has demonstrated a popular vitality unmatched in the 20th century. America has taken him to its bosom. Mobiles are made in every kindergarten in the country: most ambitious public projects and half the prestigious architects working today would like a Calder to crown their efforts and to demonstrate the generosity of their intentions. If Calders could be mass-produced, he'd be as international, as universal as our popular music. The art world loves him too, but it has nevertheless made little attempt to draw him into its ideological nets.

Like no other artist, Calder evokes the spirit of play in others—but beware! We know that artists have serious problems in making us take them seriously: we forget that making us feel playful is an equally "artistic," equally serious undertaking. It is a weakness of criticism that we have not matched literature's even-handed respect for comedy and tragedy. Moreover, not all Calders are playful. Some are somber and stark, like the *Red Sun* in Mexico City; some serene, like the *Three Wings of 1963* in Göteborg, Sweden; and some full of tension, like the concentrated pounce of the 98-foot-wide red monument at La Défense in Paris.

If we take the spirit of play as pervasive in Calder's work, we should examine the matter carefully, for all games are not the same. Different kinds of play reward ferocity or patience or wit, and generate different mixes of anxiety and release. Remember that not all play is engrossing. In successful play there must be something to be won or lost: involvement must replace indifference, and the amount of involvement is a delicate matter. Games can be too easy or too hard. Participants who are incompetent or bad-tempered can ruin the fun. What hostess, faced with a roomful of guests, has not been acutely aware of the enormous difficulty in creating a sense of play? Calder's ability to evoke playfulness is not an accident of character or mood. Critics generally evade the analytic problems and attribute his power to sympathetic magic.

Barbara Rose called him "the most spontaneous of the Surrealists," and saw him as a kind of holy innocent who can invite us into the Garden before the Fall. But wasn't Eden like a playground, a privileged area only so long as the players observed its rules? Calder's achievement is surely less metaphysical than God's, but in both cases the rules of the game set up the invisible boundaries of play. We are similarly invited to look for the rules of a created world.

It is no denial of Calder's genius to remark that he did not create the conditions that made his achievement possible. Calder's sculpture is thoroughly modern—like others, he replaces the traditional concern with articulating mass by the new business of articulating space. That disembodiment of sculpture is, I believe, the essential condition of Calder's canny handling of our elation. Space is his active element. He constructed cages for it, or, rather, runways that allow us to watch its dazzling performances. He combined weightlessness with movement, real in the mobiles, virtual in the stabiles, and gave us, waking, the sense of unimpeded mobility that we had known only in dreams.

Calder's eloquence grows out of his astounding vocabulary of gestures. It is the clarity and velocity of the action, the dramatization of swoop, flutter and drag that release us from the cluttered mechanics of body and mind. His forms are flat and bare; their relations, the dynamic space created, are all. Innocence has nothing to do with it.

To my mind, Calder's jewelry, gouaches and rugs could all be cheerfully jettisoned. They are the memorabilia of the man, his footprints rather than his flight. Calder was a three-dimensional man, and two dimensions squeeze him—he becomes mannered and crude. Moreover, proceeding out of a Surrealist esthetic, Calder tried, in a sense, to work blindly, so as to encourage the approach of unseen forces. Consequently, his production was uneven and enormous. Like Picasso, he was not afraid of doing weak or silly work, and in recent years the ready market for his sculpture encouraged his natural prodigality. Refinement and clarification, as in the increasing articulation of the structural bracing as design element, can be traced through a sequence of pieces. More prudent artists, like Matisse, may sometimes document the progressive stages of a single work, but they ultimately cover their tracks. Calder did not, though it would take a different exhibition than the one recently at the Whitney to see the course, rather than the range, of his development.

Calder's death will be mourned, and his work will continue to delight large numbers of people no matter what critics do or say. But pleasure and valedictory gestures like this one are no substitute for criticism. Our failure to deal seriously with Calder hurts us more than it did him. We clamor for a public art of real quality, and then don't recognize it when it appears. Ad Reinhardt said "the eyes are in the head for a reason." Calder's work is everywhere: we have a great deal to learn from it.

Art in America, January/February 1978

"Two Centuries of Black American Art" at the Brooklyn Museum

"Two Centuries of Black American Art" was a mediocre show, but valuable all the same. Critical response to it was depressing evidence of the still-unraised consciousness of the New York establishment. Most of us remain too unfamiliar with black art to do a good job of assessing individual presentations of it. A misleading title and the failure of critical rigor in this case didn't help, though the format and the catalogue should have made the show's limitations clear.

The organizer, David Driskell, is also an artist. He believes in the autonomy of art and reproaches blacks for failing to share his colorless ideal: "The black community must come to realize that art can have intrinsic value and act accordingly." Since Driskell doesn't recognize the futility of looking for a black esthetic apart from black style and black taste, the easiest conclusion to draw from this exhibition is the one that Driskell implicitly affirms— there is no black art, there are only black artists.

That position is roughly adequate for appreciation of 19th-century production and naïve art styles, and those sections of the show won general critical approval. Duncanson, Bannister and Tanner among the academics, Pippin, Edmondson and the recently discovered David Butler among the naïve artists were given the admiration that is their due. We have seen work like this in museums before, and it was important to see it again as evidence of black participation in culture usually defined as "American" and, implicitly, white.

The drive toward a specifically black art started to appear in the second section of the exhibition, which covered artists born between 1900 and 1950 and included the Harlem Renaissance. It is here that the issue of esthetic quality was generally raised by critics of the show. The crucial fact, it seems

to me, is that a great deal of this work is not *museum type* art at all. It was not addressed to the art world and a great deal of it was not addressed to whites. White artists, too, paint sentimental portraits and use the visual equivalent of preaching and inspirational rhetoric, but such work is seldom seen in museums nowadays. It has come to be accommodated within the scope of commercial art, and when it appears in our museums (as it did, for example, last spring in the Russian show at the Metropolitan Museum), Americans are regularly shocked. Today, art that looks commercial is tainted—not so much by the absence of artistic quality as by its failure of credibility as an "authentic" style. Since the '50s, that failure of credibility has been reinforced by parodic or ironic treatments of inauthentic styles in camp and Pop. There is a real barrier between us and '30s work, but the important distinction is not one of quality or of high versus low taste. Our response is undermined by the moral discredit now attached to advertising, and by extension of all openly emotional appeals for sympathy.

It is unfortunate that enough abstract art and recent work ('60s and '70s) was included here to mislead casual or unsophisticated viewers into thinking that contemporary black artists were adequately represented. But in fact, the ethos and style of the '30s and '40s dominated the second section of the show. Images of pathos and alienation that look heavy-handed now had contemporary parallels in the work of white artists like Ben Shahn and William Gropper. Driskell's cut-off date tended to reinforce an impression of cultural backwardness—the black "conservatism" discussed in his catalogue essay. The importance of book illustration and mural painting in the artistic training of so many of the black artists represented here further modified or obscured their relationship to easel painting. The identification of post-modernist art with the "purified" requirements of painting (color-on-canvas) and sculpture (articulated space) is another development that has put most '30s and '40s work, black or white, artistically on the wrong side of the tracks.

No historical survey of American painting could avoid that problem, but Driskell's exhibition was ambiguous. It did not clearly aim at establishing either the integration or the distinctiveness of black art. There is no way of deciding whether the paucity of what one might call images for consumers (still-lifes, formal portraits, delectable nudes) represents the organizer's personal taste, a deliberate suppression of the stereotype of black sensuality or the black artist's rejection of these conventional themes. (It was interesting that two of the three nudes in a 200-item exhibition, a handsome, solidly painted figure of Archibald Motley, Jr. and a wildly curvaceous bronze by John Rohden, were sent upstairs, four floors away from the main body of the show!) The same question arises in relation to the absence of the kind

of political satire frequently found in Mexican and white painting of the '30s and '40s. At the same time, a statement like "… one must remember that the artist, a black man, is heir to both African and American traditions of painting" is simply wrong. Painting has never been a traditional African art form, a fact that is not trivial in the context of this show.

Perhaps it is time to admit that we don't go to museums only to luxuriate in artistic quality, but also to see how people have thought and felt. At the Met's show of Thracian gold, some of the work had a nouveau-riche, wedding-present awfulness that may have shifted the focus of a viewer's interest, but rarely turned anyone off. "Two Centuries of Black American Art" could have included stronger art and been a more interesting show, had its curator and corporate sponsors been more willing to challenge the limitations of taste.

Art in America, May/June 1978

Manny Farber: Reforming Formalism

Farber's abstractions weld color, drawing and material into a low-key, uniquely physical version of color-field painting, which expands our understanding both of the formalist approach and of other artists who use it.

Even small retrospective exhibitions like this one of Manny Farber's challenge us to see the artist's production as a whole. It is an easy matter in the case of artists like Newman, Rothko or Kline, who essentially evolved a single type of image. Some artists seem intuitively to zero in on one conception of artistic form. They emerge from the cocoon of a traditional style and stabilize themselves before launching into spiraling flight. They present an image of an instinctive, self-determined, unwavering life line which is unfailingly admirable and lovable; it corresponds to the Apollonian ideal of the unified self.

Most artists, like most people, pursue messier, less coherent courses, with more or less zig-zagging about in thought, feeling, behavior and style. Manny Farber's career belongs to that type, though his moves have been neither swift nor erratic. Responsive to the complexities of his own nature and to changes in the artistic currents surrounding him, he sometimes led and sometimes followed those tides. As a painter, he cannot be classified either as an oddball or as the typical representative of a style. This has had a bad effect on his reputation.

Such artists are seldom given their due. It is so much simpler to follow the crude conventions of contemporary art history, which limit "serious" art to production in a "dominant style" so that we can distinguish between the winners and the losers at a glance. The result of such frontier "criticism"

is a failure of sobriety as well as simple justice. The "winners" are credited with being the source of all creativity and the "losers" are denied any constituent role in art history. The inflation of self-propelled winners denies the communal creation of significant styles and falsifies the assessment of individual artists.

A friend and contemporary of the illustrious first generation of Abstract Expressionists, Farber produced Abstract-Expressionist paintings and sculpture throughout the 1950s which show strong affinity with pared-down Expressionism. More ambitious, his work of the '60s and '70s was in the development of monumental color-field painting. In 1974, he again changed radically and began making realistic, spatially ambiguous still-lifes that are intimate in scale and theme. At present he teaches at a university, but for years he made his living as a carpenter and by his reputation as a film critic.

Much of Farber's recent realist work includes texts and images related to films. Iconographically, these paintings are clearly addressed to an inner circle of devotees, although formally they reflect Farber's belief that the arts of any period share specific esthetic problems and devices. The color-field work discussed here was not abandoned out of boredom or any sense of exhausted possibilities, but at a point when another kind of artistic problem seemed more immediately pressing; Farber intends to return to the large painted abstractions in the near future.

As a personality, he is plagued by mutually opposed impulses. A moralist whose most vivid responses are esthetic, he is aroused by qualities of light, form and space, while intention, justice or power rarely engage him. He is an intellectual more interested in style than esthetic theory, endlessly concerned with particular differentiations of tone and form. He is deeply attached to such traditional artistic virtues as craftsmanship, refinement of surface and detail, architectonic conceptions of structure. At the same time he is outraged by the pretensions of high art and scathingly contemptuous of what he sees as "empty" form. (His 1952 essay on Matisse praises the artist's draftsmanship and roundly condemns him for his devotion to bric-a-brac and charm.) Temperamentally dogmatic and legislative, Farber has never been able to formulate an artistic program, much less bind himself to one. He is swamped by his own responsiveness and full of opinions about everything he sees, but his general statements about art are usually flippant and seldom get into print. Such observations about Farber are not made from a particularly privileged or intimate position. They are available to anyone who has read his film criticism and knows his painting.

All his work reveals the same intelligence, the same almost neurasthenically hectic response to space, light, gesture and style. But where Farber the

critic is oriented to the exact and indelible location of a given experience, the painter is dedicated to foreshadowing a visual ideal. As a critic Farber has a canny shiftiness, a sense of the requirements of the historical moment that continually revises his sensibility. As a painter he is more prudent, more obsessive. He conceals his tracks, repeats himself, the spiral turns inward rather than out. The satisfactions his paintings offer are totally different from those he provides as a critic. The writer grabs you, stuns you, turns you this way and that, overloads you with puns, aperçus, associations, points of reference. The paintings ignore you. Self-contained, brooding, low-keyed or monochromatic, they are overridingly concerned with their own integrity, with professional problems of adjusting contour, structure, light and casual incident so that no single element announces itself. Similar in every part, only wholes are different. A painting may have the indivisible crispness of an autumn leaf or the metallic shimmer of a slice of pond mirroring the sky. Despite Farber's insistence on an underlying grid structure and the frequent geometric shape of his formats, the paintings with which I shall be concerned inevitably evoke the presence of nature. They are not "about" landscape nor any natural object, but aim at becoming the objective correlative of nature itself, a manifestation of real light and real stuff: paper, chalk and paint, the artist's terrain, his lightning flash, his dusk. My chief aims in this essay are to discover how such abstract, formal work achieves this effect and to consider its relationship to recent painting.

In doing so I shall depart somewhat from the recent convention of restricting a catalogue essay to an act of personal homage. Not because the impulse to offer such respect is lacking, but because asserting the importance of Farber's work now requires a more polemical stance. The virtues of his paintings are neither fashionable nor obvious. I shall be dealing with Farber as a color-field painter and our idea of the style derives primarily from the observations of a single critic—Michael Fried—gathered to accommodate a single painter—Jules Olitski. Later writers extended Fried's ideas to other artists without questioning Fried's assumptions. Consequently the style itself appears limited and we are given no clue as to why Farber and Olitski might choose to play significantly different variants of the same game.

Furthermore, despite lip service paid to the importance of "quality" in art, artistic quality has actually played a very minor role in establishing the hierarchy of "important" painters. The selection was made on other grounds. For the last ten years our attention has been occupied with esthetic novelties, conceptual revisions of the nature and role of art. Our imaginations have been fired by notions of revolution, the total revision of sensibility, alternative realities, etc., so that the actual amplification and

development of a visual idea has hardly been recognized at all. Our eyes have grown dull and theoretical novelties alone seem new. Yet only if artistic quality really matters can Farber's significance be defended, since he did not invent a style, but "merely" extended and expanded one. What requires attention is the grounds of his artistic quality, in particular the great importance of drawing in a style that supposedly eliminates it. Any serious assessment of Farber must therefore investigate the norms and criteria of color-field painting.

According to canonical accounts of modern painting, the late 19th century flattening of the picture plane was developed by the Cubists and fulfilled its non-figurative destiny in the work of Jackson Pollock. After Pollock, up-to-date pictorial space was equated with "opticality." "Optical" space was the only arena in which pictorial elements were allowed to move and have their being, for illusory mass and air with their concomitant "tactility" were explicitly repudiated. The painter's problem with the new de-mythologized "space" was to get something happening that felt "necessary" and native to that space alone. The elimination of figuration was interpreted as entailing the banishment of drawing with a consequent stress on color and "deductive structure"—shapes derived from the physical characteristics of the paintings support, the canvas itself. This is how the situation looked in 1965 when Michael Fried mounted an exhibition of Kenneth Noland, Jules Olitski and Frank Stella, representatives of "formal intelligence of the highest order."

Published in an important catalogue essay for his "Three American Painters" show, Fried's definition of the artistic situation at the moment drew a great deal of strength from its consistency with Clement Greenberg's pronouncements. Greenberg claimed that the historical development of painting required its progressive purification—its withdrawal not only from extra-artistic concerns (like depicting "reality") but even from esthetic goals that could conceivably be fulfilled by the methods and materials of arts other than painting.

The foregoing account of the formal development of modernism is based on the assumption of the increasing autonomy of painting—but what actually happened was directly the opposite. Yet to discuss Farber's work of the 1960s without recognizing the pressure of formalist strictures in those years would be absurd. Without confirming the individual assessments that accompanied it, formalism's broader position will be accepted here, since Farber clearly granted the formalists' definition of the artistic situation in which he found himself. Yet even if he had wanted to use the Louis-Noland-Olitski solution—developing an image based on high-keyed color contrast—that direction was no use to him at all. Farber doesn't like

that kind of color and, for an artist, the sort of color one likes is as irrevocable as one's sexual preferences.

Farber likes color that looks as if it's been through a lot: abraded, drowned, rising to the surface, floating. Light-sensitive color that has been subjected to natural phenomena. He hates cosmetic color, color as artifice or coating, color that announces itself as pigment. "Organic" color is a distinctly old-fashioned taste today, but Farber is stuck with it. Fortunately, his love for chromatic subtlety does not exclude the possibility of intensity, which he can achieve by choosing a fully saturated hue and suffusing it over his entire surface. But Farber's color sense prohibits it from assuming an independent role. Because he will not treat color as *stuff*, it does not define his form but pervades it.

This is exactly opposed to Olitski's practice. Color-to-color shifts are the prime incident of Olitski's canvases, the factor that distinguishes one painting from another. Farber is thus a color-field painter in whose work color does not play a highly structural role. As I suggested before, his chief resource in the solution of the post-Abstract Expressionist problem of animating "optical" space is line, and his use of line is so subtle and varied that recognizing it forces us to revise our presently inadequate conception of drawing. In Farber's work, line plays three distinct roles: the cut line defines contour (the single function assigned to drawing in Fried's essay); it establishes the structure of the surface (the grid produced by the pasted, layered papers that make up the painting's physical surface); and it serves as a small-scale, gestural detail within the color field.

It is important to notice that only the third type of line is actually drawn. The virtuoso's delight in delicately modulated speed, force and weight of line is here confined to the place of detail—one of the Abstract Expressionist's major instruments is reduced to a frill. The only parallel I can think of for Farber's use of the cut line in defining the contour of his form is Matisse's scissors line in the late monumental cut-outs. Overtly handmade, the irregularities and discontinuities of this cut line advertise the certainties and hesitations of the man holding the tool. Here the knife or scissors becomes a drawing instrument as responsive as chalk or pen. So, of course, each man's cut line shows the traces of his own personality. Farber's cut line is more austere, more self-effacing than Matisse's, just as his symmetries are stricter, as one might expect from an artist with a marked taste for geometry and abstraction.

What the overtly hand-produced cut insists upon is the difference between architectural and pictorial surfaces, and it is this characteristic of Farber's contours that separates his use of unconventional formats from the shaped canvases of Zox, Mangold or Stella, among others. Regardless of

their adequacy to serve decorative purposes, Farber's painted papers reject assimilation to architecture or architectural detail. His unconventional formats do not support a figure/ground situation—that is, they don't make the wall a part of the image, the way shaped canvases usually do.

Farber's insistence on axial symmetry insures that his shapes will look self-supporting; his wide sweeping curves imply a tendency to circular form that reinforces a sense of closure and separateness. Like some of the early sculptures which were made to hang at right angles to the wall or support, the paper paintings have a structure and frontality all their own. These are unmistakably paintings, firm, fragile surfaces independent of the architectural context. Almost from the beginning, Farber's paintings had bones. These "bones" are provided by Farber's second sort of drawing, the half-concealed grid generated by his method of preparing his working surface.

In making a painting, Farber's first step is to get an area large and flat enough to work with. This means cutting segments off an industrial roll of wrapping paper and pasting or gluing them together. While the lightness and informality of paper is important for Farber's anti-monumental conception, paper's tendency to warp and curl (usually controlled by mounting) must be eliminated. His solution to the problem comes from working with wood; adjoining sections reverse the direction of the "grain," so that the composite sheet hangs straight and flat. While Farber doesn't measure the sections, he does have an idea of the general size and shape he wants. Thus the size of the unit components and the rectilinearity of the grid they form are already being adjusted to the final conception. In most cases, Farber will use three abutted strips of wrapping paper (which yield two long, straight interior lines) and as many shorter cuts as he feels necessary to serve as a counterpoint to them. Whether the format is horizontally or vertically oriented, the dominant direction of the grid repeats the dominant axis of the final form. Strictly speaking, these grid lines are not drawn, any more than the contour was. They first appear because the light strikes the surface of the pasted paper unevenly. Later the linear grid will be partly obliterated and partly reinforced by paint. As a characteristic of the artist's working surface, the grid conditions and modifies all later decisions.

After the paper has been pasted up into a rough square or rectangle, Farber proceeds with the single most decisive step in his process: cutting the contour. Making the contour is not a single gestural act but a sequence of delicate, intuitive decisions. It can take a day or two of adjusting the big surface against the thin slivers of paper that modify a curve or angle before Farber is satisfied with his format. If the allover shape isn't right, if it's too full or too arbitrary-looking or flaccid, lacking energy, the painting will

never come off. Notice, however, that at this stage, before there is any paint or ordinary drawing on the surface whatsoever, Farber is already working in a formally defined situation. The grid components set a pace and rhythm against which the spring and tautness of the contour line can be measured.

Now Farber releases the third role of his line, a constellation of mostly high speed events that splash, snap and dance across the space so carefully prepared for them. These drawn lines are produced with a variety of techniques and materials and appear on both sides of the paper. Despite the fact that all this detail will be at least partially drowned by the applications of paint that follow, Farber's underdrawing serves two purposes. First, even when obscured, the drawn elements will be glimpsed as presences within the paint, creating distinct pockets of activity. Second, the rate of linear incident over the surface establishes a pictorial density that the paint will supplement and reinforce. Farber often thinks of his painted papers as setting up a certain kind of density against a certain kind of contour—an oddly sculptural notion. Yet even without the underdrawing, Farber's grid, allover shape and contour interact to present a situation of considerable internal complexity. The blandness of the traditional pictorial surface has already been obviated.

Much has been made of Noland's and Louis' achievement in developing a stain technique that makes thinned pigment visually identical with the woven canvas ground. Supposedly, stained color is an unequivocal artistic advance because it reinforces the purity and integrity of painting itself. Like a lot of other people, I don't see why painting *should* be all that logical and pure. But it does seem clear that if the artist's working surface is no longer to be treated as a referent for or an equivalent of any other sort of space, that intention—to assert the physical immediacy of the surface—must be made visible. The most economical and elegant way of doing so is to make the characteristics of the surface an integral element in the perception of the image.

Older readers will recall the 1960s elevation of texture from minor to major status as an element of esthetic form. Yet the texture of canvas is, after all, relatively uneventful. For me, Louis was the only painter whose images were spare, vivid and open enough to make the banal texture of canvas seem relevant to his painting. Most of the efforts to activate the painterly ground without reducing its "opticality" took the form of messing up the surface, introducing discontinuities in it. Pollock had cut shapes out of canvas and backed them (*Cutout* and *Out of the Web*, both 1949); Burri ripped it, Fontana slashed it, Marca-Relli and many others collaged their surfaces. In general, these experiments were unsatisfactory. The coalescence of visual form and technical device failed to take place; the results looked gimmicky.

Manny Farber. *Untitled,* c. 1960–75.
Acrylic on collaged paper, approximately 51" x 62".
© Manny Faber Estate
Photo courtesy Quint Contemporary Art

This is the context in which Farber's constructed surfaces would be seen. Without breaking the essentially flat, extended character of the pictorial surface, he eliminated its seamless neutrality. Because his paper was unmounted and unstretched, its native fragility was up front; because cutting and pasting sections of paper automatically produced lines on the surface (especially after the paper was painted), the taint of artificially added "interest" was avoided.

If we follow the formal development of painting along its actual course rather than to the one formalism projected for it, Farber's conception of the pictorial field was considerably more coherent and sophisticated than Olitski's. Olitski, who discarded internal shapes in his paintings around 1963 to place differentiated forms at the framing edges, continued to think of the painter's arena as an immaterial, abstract "space." His stained and sprayed color fields were initially centralized and, as Fried said, his compositions were never "deductive." Neither the boundaries nor the shape of the canvas made much difference to the flow or density of his pictorial space, which was given primarily by the peculiar quality of his melting, drifting color. Emphasizing the painting's edges, as he did after 1963, was thus a strangely arbitrary thing for him to do. On the other hand, Farber's conception of the edge/field relationship grew out of his experiments with sculpture and, ultimately from his experience as a carpenter.

Farber began producing the shaped, painted papers in 1967. Initially, the contours were designed to introduce a contradiction to the grid, and the first new shape he used was a trapezoid, typically, one tall, heavy and close enough to a rectangle to make the slicing-down of its sides something of a shock. Soon after, he added the football and the irregular polygons. The mushroom cap, the fans and barrels did not appear until 1972–73, the ovals and saw-tooth shapes even later. In 1973 he began treating the paper as a sculptural as well as pictorial element. Instead of changing the picture's shape by carving out a format, he gave it a new one by varying the picture's relation to the wall. Very long rectangular panels were folded over a rod, so that the "picture plane" consisted of two surfaces, one partially overlapping the other. He also experimented with pulling a corner of the paper away from the wall, attaching the equivalent of a guy wire to the floor, so that the paper took on a sail-like character.

The unifying factor in all of these paintings is the growing tendency to think of all works of art in terms of artifacts or constructed bodies instead of "space." By the mid-'60s, paintings were no longer pictures as much as they were unitary pictorial objects. While touch, drawing and composition were supposedly withering away, matters of scale, allover shape and texture took on unprecedented importance.

Farber's insistence on contour as a tangible, physical edge rather than a frame or the limit of a ground was clearly forward-looking. It set him apart from the Washington color painters and paralleled the work of another major color-field artist, Ellsworth Kelly. Farber's work looks completely different from Kelly's, chiefly because the two artists have utterly different feelings about color. Both have used irregular formats and have moved their large flat surfaces in sculptural directions. Both have moved into new areas where color and form are more important than the work's traditional "identity" as painting or sculpture.

Farber's decision to stress the tactile, non-optical side of painting was conscious and programmatic from the beginning. His basic task was to deny the one-sidedness of the paper, which meant treating it as permeable stuff rather than as a surface. The first step, therefore, was to saturate the paper and paint the *back* of it. The color's bleed-through makes its entire mass, its back, interior and front, visible at once. Accordingly, the color Farber used on the back usually contrasts strongly with the color on the face—a creamy greenish surface will have a heavy-looking ox-blood on the back, for example.

Because wrapping paper is too tough to be highly porous, a great deal of effort is required to soak it to the point where pigment will pass through its fibers. The paper is laid upon the floor, so that the wetting process can proceed as evenly and rapidly as possible. Working with a very wet, waterbased paint, Farber attacks the back of the paper with a five-inch brush. While the whole surface is covered with puddles of watery paint, special attention is given to the edges, where bleed-through is particularly important.

Once the paper is thoroughly saturated it is rolled to speed capillary action and spread out again, this time face-up. (Through trial and error, Farber has developed a precise timetable for each step in his process.) Since it now tears easily, great care must be taken to get the paper flat again. Now three pails of paint, often light, medium and dark tonalities of a single hue, or hot to cool versions of one, are at hand, already mixed, along with large, pre-cut squares of muslin. This step can proceed in either of two ways: the pieces of muslin can be laid down and paint applied over them, or the surface can be painted upon directly and the muslin rolled out on it afterwards. In either case, the final surface will appear only after paint and muslin have reached a particular stage of tackiness and the muslin can be pulled off the paper. The muslin overlay eliminates any trace of the brush and imparts a uniquely internalized quality to the color. The purpose of the multi-valued or close-hued paint is the same as that of the muslin: to keep the color from seeming to lie on the surface, to make it feel locked into the supporting

material. The variations in color are ambiguous, interpretable as changes in the material as well as in the pigment.

Within the basic parameters of this method, Farber can bring a variety of changes: adding powdered pigments to the surface to bring in new color; picking up sections of the muslin at different stages of dryness, which changes the paint texture. He may keep the muslin flat or drape it in places, so that its folds and allover shape will leave a variety of imprints on the paint. Adding gesso to the pigment created a blond tonality on the face, since the gesso floats to the surface and kills the possibility of dark paintings.

His method presents interesting analogies to the Frankenthaler-Louis stain technique as well as to the traditional use of glazes. Like stained canvas, it insists on the inseparability of color and its support, but Farber's color is so tonal that it muffles paint's self-assertive artificiality. Its associations lead to nature rather than to art. Like glazing, Farber's method multiplies the apparent number of levels at which color is perceived. Glazes, however, aim primarily at creating depth and luminosity simultaneously. The multiplication of transparent layers of tinted light is an artificial recreation of looking at things through air—you see object and atmosphere at the same time. Farber's use of bleed-through has nothing to do with the air or the depth of a visual field; it dramatizes our sense of the density of materials.

Because so many of the formal hazards of Farber's paintings have been short-circuited by his method, decisions as to the relative quality of one painting over another are not easily made. The pictures have to be painted quickly—four or five hours is as long as Farber can count on having his paper in a proper state for working. Also, the method itself is so indirect, and provides the artist with so many surprises, that the points at which direct control can be exerted are relatively few. As in the case of Abstract-Expressionist painting, the quality of the work an artist offers the public depends a lot on the clarity of mind and spirit with which he or she defines and organizes the task. Also, as in all method-based work, the artist's editorial acuity—what is kept and what is discarded—should be a further determinant of quality.

For the most part, what will prevail with the viewer is a liking for a faster or slower visual tempo, for brooding or buoyant shapes, for fleshy, Jean-Harlowish surfaces or for the texture of night and vegetables dreaming. Farber's paintings address themselves to looking and feeling. They are slow pictures, and evoke response stealthily, but the extrapolation of principles has nothing to do with them. They could therefore be considered shallow,

a judgment that presupposes a special relationship between intellect and art.

There is presently a presumption that the intellectual aspect of art has to do either with its "content" or with its transparency to esthetic principles. Its ability to serve as a demonstration or example of an abstract proposition (which may or may not deal with art) has often appealed to academics, and art historians usually look at pictures as manifesting a historical moment in the evolving discipline they call "painting." Until formalism, however, the idea of art as the embodiment of abstract theory was not particularly appealing to artists. Now it is.

A theoretical attitude is alien to artists like Manny Farber, for whom sense and feeling are the core of art. For him, intelligence is something required of the artist, not the viewer, and artistic intelligence is itself a quasi-sensual matter. The artist must recognize a cliché when he sees one. He must understand the interaction of the artistic elements he works with, so that he doesn't violate his own intentions. He must be clear-eyed and clear-headed enough to resist the continual temptation to confuse his aims with his accomplishments. Farber's conception of art is closer to the classical one of making it (mysteriously, undefinably) *right* than the 20th century one of making it new.

Yet Farber's talent and formal intelligence led him to move into new artistic situations while dozens of younger, weaker artists are still trying to make a name for themselves with tarted-up Minimalism—baby-talk simplicities of form combined with personalized, "lyrical" elaborations of texture and surface. The great difference between Farber's work and theirs is that with Farber you can go beyond taste and into formal analysis.

"Conservative" artists, we generally assume, hold onto familiar ground while "progressive" ones move forward. But political language doesn't correspond with artistic facts. If we consider an artist conservative who has a fervent respect for art and a lively understanding of the resources of form, the possibility of a significant, unrevolutionary expansion of artistic experiences should not look so peculiar. Except in relatively minor ways, Farber cannot be considered a groundbreaker. The artistic problems he tackled were not exclusively his; he learned from Minimal and Process art. Wholly a man of his time, Farber is, I believe, a deeply conservative artist and, as such, a model of the creativity and invention that conservative artists can contribute.

Bibliography

This book features only a selection of Amy Goldin's writings. What follows is a complete list. In addition, the Smithsonian's Archives of American Art houses an outstanding collection of correspondence, diaries, writings and musings that were instrumental in the development of this book.

Early in her career, Amy Goldin wrote many single-paragraph reviews for the "In the Galleries," section of *Arts Magazine*. Referred to by the magazine as a "freelance observer of the Manhattan Art Scene," she reviewed shows of the following artists:

May/June 1965: Cavallon, Marc Chagall, Francoise Gilot, John Goodyear, Red Grooms, Fannie Hillsmith, Dan Lutz, Roy Moyer, Marina Stern, Fernando Zobel

September 1965: Carl André, Virginia Banks, Clyde Barnes, Herbert Bayer, Marc Chagall, Allan D'Arcangelo, Paul Delvaux, Rosalind Drexler,Walker Griffith Everett, Charles Henri Ford, Antonio Lopez Garcia, Antonio Giraudier, E. F. Hebner, Gene Hedge, Ralph Humphrey, Khanna, Pavel Korin, Gregory Masurovsky, Henri Michaux, Roland Peterson, Robert Rauschenberg, James Rosenquist, Herman T. Rowan, Dorothy Ruddick, Richard Smith, Bob Stanley, Richard Straley, Teiji Takai, Yvonne Thomas, Jane Wilson

November 1965: Dottie Attie, George Bireline, Jerome Blum, Robert DeNiro, Ida Kohlmeyer, Lowell Nesbitt, Kendall ShawLeon Polk Smith, Jack Youngerman

December 1965: Ilene Astrahan, Frank Boggs, Corneille, Fromboluti, Sidney Goodman, Patrick Heron, Lisa Muller, Tetsuo Ochikubo, Arnaldo Pomodoro, Man Ray, Takeo Shiiki, Harold Stevenson, Walter Stuempfig, Reva Urban, Ryo Watanabe, Gerald Willen

January 1966: Richard Anuszkiewicz, Les Freres Baschet, Francisco Farreras, Norman Ives, Isadore Levy, Jules Olitski, Nam June Paik, Peter Phillips, Riopelle, Paul Van Hoeydonck, Peter Wrangell

February 1966: Jack Beal, Elmer Bishcoff, Joan Brown, Norris Embry, Martin Maloney, George B. Nick, David Park, Dalia Ramanauskas, Michael Snow

March 1966: Arakawa, Darby Bannard, William N. Copley, Seena Donneson, Sonia Gechtoff, Paul Georges, Raeford Liles, Cesar Manrique, Rhoda McHugh, Walter Murch, Ladislas Segy, David Seccombe, Theodoros Stamos

April 1966: Jo Baer, Carmen Cicero, Enrico Donati, Julio Le Parc, Sven Lukins, Nicholas Marsicano, George McNeil, Felix Pasilis, Gabor Peterdi, Jo Roman, Raymond Saunders, Bryan Wilson, Yvaral

May 1966: Geoffrey Hendricks, Soto

June 1966: Wassily Kandinsky, V.V. Rankine, Jennet Lam, Gloria Vanderbilt,

September 1967: Walter Everett, Jane Wilson

Published essays:

"Dada Legacy," *Arts Magazine,* September, 1965

"Evolution in the Arts and Other Theories of Cultural History," by Thomas Munro [book review], September 1965

"Harold Rosenberg's Magic Circle," *Arts Magazine,* November, 1965

"Requiem for a Gallery; the Green Gallery's Rise and Demise," *Arts Magazine,* January 1966

Review, "Canvases and Careers," by Harrison White, *Arts Magazine,* February, 1966

Review, "Rodin's Cathedrals," *Arts Magazine,* April, 1966

"McLuhan's Message: Participate, enjoy!," *Arts Magazine,* May, 1966

"A Note on Opticality," *Arts Magazine,* May, 1966

"The Sculpture of George Sugarman: what has insides and outsides and comes in seventeen colors? Answer: George Sugarman's new work,"*Arts Magazine,* June, 1966

"Art Patronage Under Communism: Yugoslavia," *Art in America,* March, 1967

"Art in a Hairshirt," *Art News,* February, 1967

"Duchamp-Villon:The Cubist Core," *Art News,* February, 1967

"Antihierarchical American: The New Esthetics of Minimal Sculptor Donald Judd," *Art News,* September, 1967

"The Art Scene in America," *UMETNOST* (Belgrade), September, 1967

"Situation Critical: A Sharp Look at the Current Phenomenon of Formalist Criticism and How it Recreated Art in its Own Image," *Art News,* March, 1968

"Beyond Style," *Art and Artist* (London), March, 1968

"Morris Louis: Thinking the Unwordable," *Art News,* April, 1968

"Look Aloft: 10 New York Painters and Sculptors Working in as Many Styles Bypass the Art-Gallery Entrepreneurs and Open Their Studios to the Public," *Art News,* May, 1968

"One Cheer for Expressionism: German Expressionism in a show at Spencer Samuels," *Art News,* November, 1968

"Leger Now," *Art News,* December, 1968 [reprinted: "Leger, Our Contemporary," Institute for the Arts, Rice University, 1978]

"Art Talk and Art Criticism," *UMETNOST* (Belgrade), December, 1968

"Deep Art and Shallow Art," *New American Review* #4, 1968

"Sweet Mystery of Life," *Art News,* May, 1969

George Sugarman: Plastiken, Collagen, Zeichnungen, Kunstalle Basel, Städtisches Museum, Leverkusen, Haus Am Waldsee, Berlin, Stedelijk Museum, Amsterdam, 1970

"Conceptual Art as Opera," *Art News,* March, 1970 (with Robert Kushner)

"Coy Women, Purple Upholstery, Cosmic Landscapes: the Metropolitan's 19th Century Art Exhibition," *Art News,* May, 1970

"Californian Lives—Eleanor Antin (catalog essay) Gainground Gallery, 1970

"Words in Pictures," *Art News* Annual, 1970

Correspondence in *International Journal of Aesthetics and Art Criticism,* Winter 1970

"Harlem out of Mind," *Art News,* May, 1970

"Twenty-Three Recent Drawings by George Sugarman" (1971), 1971 (catalogue essay) [for exhibitions in Germany and Switzerland], 1971 (with German translation)

"Studio and Art History: the CAA's non-identical twins," *Art in America,* June, 1972

Book Review, M. Kadish's "Reason and Controversy in the Arts," *Journal for Aesthetics and Art Criticism,* Winter 1972

"Paris Art Scene," *Art Gallery,* Summer 1971

"A Non-Survey Art Course for Non Majors," *College Art Journal,* Winter 1972

"Art and Technology in a Social Vacuum," *Art in America,* May/June, 1972

"Diane Arbus: Playing with Conventions," *Art in America,* March/April, 1973

"The University Art School: Limbo for Alienated Youth?," *Art in America,* May/June, 1973

"The 'New' Whitney Biennial: Pattern Emerging?," *Art in America,* May/June, 1973

"The Eight's Laissez-Faire Revolution," *Art in America,* July/August, 1973

"New York, Zuka at Betty Parsons," *Art in America,* January/February, 1974

"In Praise of Innocence," *Art in America,* March/April, 1974

"The Esthetic Ghetto: Some Thoughts About Public Art," *Art in America,* May, 1974

"Teheran: Qajar Painting at the Iranian-American Cultural Center," *Art in America,* September/October, 1974

"The Post-Perceptual Portrait," *Art in America,* January/February, 1975

"Brooklyn's Comic-Book Artists" at the Brooklyn Museum, *Art in America,* March/April, 1975

Review, Martin Battersby's "Trompe L'Oeil: The Eye Deceived," *Art in America,* March/April, 1975

"Folk Art and the Academy," *Dialogue,* Vol.8, No.1, 1975

"Art History: American Art History has been Called Elitist, Racist and Sexist. The Charges Stick." *Art News,* April, 1975

"The New Whitney Biennial: Pattern Emerging," *Art in America,* May/June, 1975

"Matisse and Decoration: The Late Cutouts," *Art in America,* July/August, 1975

"Patterns, Grids and Painting" *Artforum,* September, 1975, p.50

"United Graffiti Artists 1975 at Artists Space," *Art in America,* November/December 1975

"Folk Art and the Academy," *Dialogue,* Volume 8, 1975.

Review, John Fowler's "English Decoration in the 18th Century," *Art in America,* January/February, 1976

"Frantisek Kupka at the Guggenheim and Denise Rene," *Art in America,* January/February, 1976

"Abstract Expressionism, No Man's Landscape" *Art in America,* January, 1976

"Islamic Art: The Met's Generous Embrace," *Artforum,* March, 1976

"Kim MacConnel at Holly Solomon," *Art in America,* March/April 1976

"The Brothers Prendergast," *Art in America,* March/April, 1976

Letter in response to Jeff Perrone's review "Jasper Johns's New Paintings," (with Robert Kushner) *Artforum,* May, 1976

"Forever Wild: A Pride of Fauves," *Art in America,* May/June, 1976

"Problems in Folk Art," *Artforum,* Summer 1976

"How are the Prendergasts Modern?" *Art in America,* September/October, 1976

"Frank Stella at the Knoedler," *Art in America,* September/October, 1976

"Patterning & Decoration," *The Museum of the American Foundation of the Arts,* Miami, Florida 1977

"Islam Goes to England," *Art in America,* January/February, 1977

"Report from Toronto & Montreal, *Art in America,* March, 1977

"Alexander Calder 1898-1976," *Art in America,* March/April, 1977

"Canadian Art Today," *Art in America,* March/April, 1977

'Present Tense: New Art and the New York Museum," (with Roberta Smith) *Art in America,* September/October 1977

"'Two centuries of Black American Art' at the Brooklyn Museum," *Art in America*, January/February 1978

"Body Language of Pictures," *Artforum*, Vol.16, March, 1978

"Pattern and Print," *Print Collector's Newsletter*, March/April, 1978

"Manny Farber: Reforming Formalism," *Art in America*, May/June, 1978

Books:

(with Dr. Michael Brown) *Collective Behavior*, Prentice-Hall, 1974

Acknowledgments

Thank you, Irving Sandler. When you walked up to me at a friend's opening four years ago and in your quiet, deceptively nonchalant way asked if anyone was working on a collection of Amy Goldin's writing, the wheels really started spinning.

And thank you so much, Jon Gams, for saying yes to Irving's suggestion for this book. I am so sorry that you cannot see this book in its completed state.

Thanks to Anne Bei for picking up the torch at Hard Press Editions and keeping everything going. And a huge thanks to Liz Riviere for your able research, editing, hand holding, encouragement and sage advice. This book definitely would be a very different one without your help. Thanks to Janine St. Germaine who helped organize things for me at every stage and to Paul Huston, Amy Goldin's nephew, who gave me access to family papers which proved invaluable.

An enormous thank you to the writers who kindly provided this book with their critical appraisals of Amy Goldin's writing. A colloquium of sorts about the relevance and timeliness of Goldin's writing was Jon Gams' concept, and I remain profoundly grateful to all of you for your generous contributions: Elizabeth Baker, Holland Cotter, Michael Duncan, Oleg Grabar, Max Kozloff, Irving Sandler, Joan Simon, Emna Zghal.

Thank you to the following who allowed me to conduct interviews and to those who gave me invaluable insights and historical information: Herb Bronstein, Michael Duncan, Jacqueline Herrmann Gourevitch, Paul Huston, Shirley Jaffe, Robert Kelly, Dian and Jerome Rothenberg, Anne Swartz, Zuka.

Thank you to my friends who shared their letters and manuscripts from Amy: Kim MacConnel, Shirley Jaffe, Joyce and Max Kozloff, Jerome Rothenberg, Naomi Schiff, George Woodman.

Thank you to two anonymous donors whose contribution to this project enabled the initial research and the presence of color reproductions to be an integral part of this book.

Many thanks to Marco Nocella at Feldman Gallery for allowing us to reproduce the Eleanor Antin portrait.

Thank you to Naomi Schiff for permission to use her photograph of Amy.

Additionally, we would like to thank Patricia Patterson and Sarah Trujillo at Quint Gallery, La Jolla for allowing us to reproduce the Manny Farber illustration.

A special thanks to Kathryn Kashmiri, Marisa Bourgoin and Wendy Hurlock-Baker at the Smithsonian Institution's Archive of American Art for very generously allowing us to look through the extensive collection of Amy Goldin's correspondence, notebooks, photographs and documents that were instrumental in piecing together this chronology of a lifetime's work.

Thanks to Matthew Gengler at the Cleveland Museum of Art's Ingalls Library for his inexhaustible knowledge and unerring accuracy in research.

Thank you to Steven Watson and Peter Eleey for reading early versions of this text.

I wish to thank my family for their forbearance and patience with endless unfolding details and considerations.

Most of all, my gratitude goes to Amy Goldin and her writing. In regard to life as well as art, she taught me to how to look and how to think.